P9-DVT-260

CALGARY PUBLIC LIBRARY

AN - - 2015

# Art Without Waste

**Rockport iPad App!**
Use your iPad to preview, buy, and read
the latest and greatest from Rockport.

Visit the iTunes App store to download
your free App today!

# ROCKPAPERINK

branding ・ typography ・ logos ・ color ・ design
management ・ design for change ・ posters ・ fashion
**www.RockPaperInk.com**

© 2014 by Rockport Publishers

All rights reserved. No part of this book may be reproduced in any form without written permission
of the copyright owners. All images in this book have been reproduced with the knowledge and prior
consent of the artists concerned, and no responsibility is accepted by producer, publisher, or printer
for any infringement of copyright or otherwise, arising from the contents of this publication. Every
effort has been made to ensure that credits accurately comply with information supplied. We apologize
for any inaccuracies that may have occurred and will resolve inaccurate or missing information in a
subsequent reprinting of the book.

First published in the United States of America by
Rockport Publishers, a member of
Quarto Publishing Group USA Inc.
100 Cummings Center
Suite 406-L
Beverly, Massachusetts 01915-6101
Telephone: (978) 282-9590
Fax: (978) 283-2742
www.rockpub.com

Library of Congress Cataloging-in-Publication Data available

ISBN: 978-1-63159-0-313

Digital edition published in 2014
eISBN: 978-1-62788-216-3

10 9 8 7 6 5 4 3 2 1

Cover and book design: Patty K. Wongpakdee
Page layout: Claire MacMaster
Cover images (front; left to right, top to bottom): Shawn Murenbeeld; Meike Harde; Allan Young;
Dock Artisan; Aaron Kramer. (back): Alan Williams, top; Jerry Kott, bottom.
Endpapers: Stuart Haygarth

Printed in China

# Art Without Waste

## 500 Upcycled & Earth-Friendly Designs

Patty K. Wongpakdee

**Rockport Publishers**
100 Cummings Center, Suite 406L
Beverly, MA 01915

rockpub.com • rockpaperink.com

Introduction                           6

**Personal Items & Accessories**       **8**

**Home & Garden**                      **64**

**Interior & Outdoor Spaces**          **136**

**Art & Design**                       **154**

Contributor Directory                  203

About the Author                       208

# INTRODUCTION

*Going green, eco-friendly, upcycling … these* are all terms that reference a new consciousness that has been gaining momentum throughout the world. These changes depict a cultural and economic shift away from mass consumption toward a greater conservation of the Earth's limited resources. This focus on the environment is derived, to a great extent, from people's genuine concern for the Earth and their increased awareness of the harm that is befalling the planet. But, it is also finding favor from consumers who appreciate the positive message and want to make a lifestyle statement in their purchase of products that are Earth friendly.

Whatever their motivation may be, artists and designers have come to embrace the green movement. They have readily accepted the challenges presented by this global environmental dilemma by utilizing upcycling and recycling principles in their work. It has spurred visual communicators to apply fresh concepts and create innovative solutions that encourage the viewer to see the world and its resources in a new way while creating art without waste.

Perceptive artists and designers appreciate that global, cultural values are always in flux. They must be attuned to this ever-shifting landscape in order to effectively convey their ideas. They constantly look for new ways to differentiate their work and, thus, improve their messages. This imperative allows designers to explore and document these dynamic cultural forces within their art and design. For example, by taking an utterly disposable item and transforming it into something of higher quality, artists and designers change how people view their world and their place in it. However subtle the change may seem, the impact has the potential to be enormous as each advance serves as a building block for the next evolutionary change. Today's artists and designers are breaking new ground in employing upcycling and recycling in their work. In doing so, they are ushering in a new era of entrepreneurial innovation, spurring future generations to embrace sustainability in all aspects of life.

*Art without Waste* showcases a collection of works from designers, illustrators, and artists recognized in the international arts and graphic design industry, as well as up-and-coming designers and artists from the indie-design community. They incorporate eco-friendly principles such as upcycling and recycling, with sustainability as a central goal of their work. Also included are compelling photographs that likewise demonstrate unique examples of this approach. This is not a how-to book. Its goal is to motivate and inspire the viewer to see things from a different, unconventional perspective. The edgy and provocative artists and designers showcased within have employed new concepts and techniques. They have also harnessed their creative passion into the materials they manipulate, resulting in dynamic forms that cause the viewer to perceive the world and the materials within it in ways that one could not even imagine before. ■

# PERSONAL ITEMS & ACCESSORIES

**Personal Items & Accessories** make up an important part of one's lifestyle. These pieces highlight each artist's individuality and serve to further the development of one's distinctive taste. They not only depict the artists' personal styles but also reflect their conscious efforts to support individuals in tune with living a greener lifestyle. ■

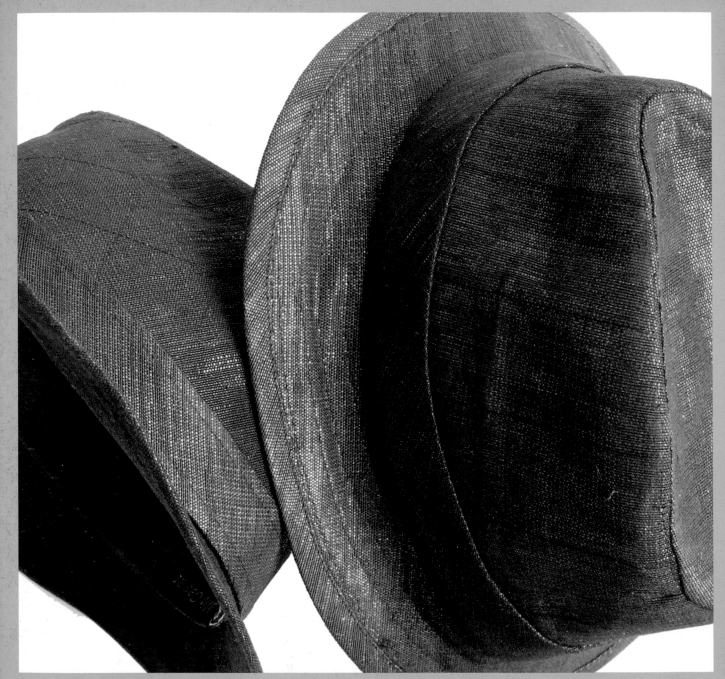

**001 I ALYCE SANTORO**  USA  Cassette Tape

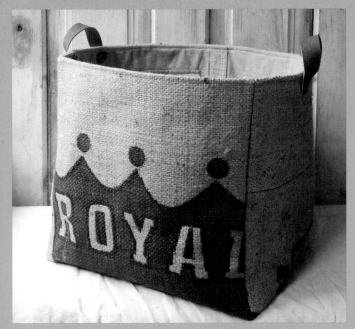

**002A I AKIKO OGUCHI** USA  Reclaimed Burlap & Clothing

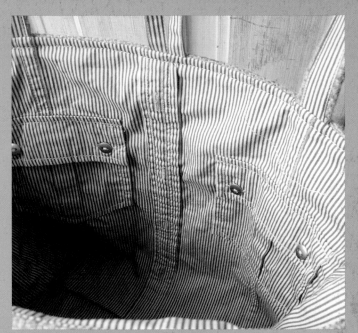

**002B I AKIKO OGUCHI** USA  Reclaimed Burlap & Clothing

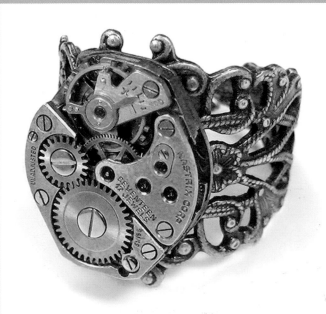

**003 I EDM DESIGNS** USA  Vintage Watch

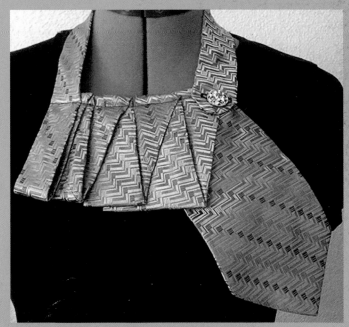

**004 I ALL TIED OUT** USA  Men's Tie

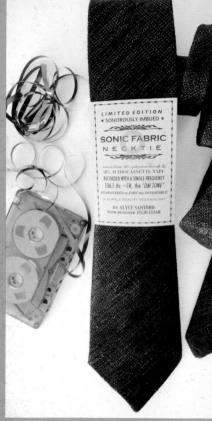

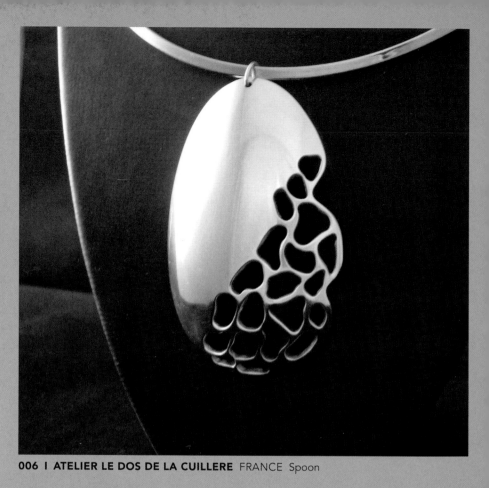

**005 I ALYCE SANTORO** USA
Cassette Tape

**006 I ATELIER LE DOS DE LA CUILLERE** FRANCE  Spoon

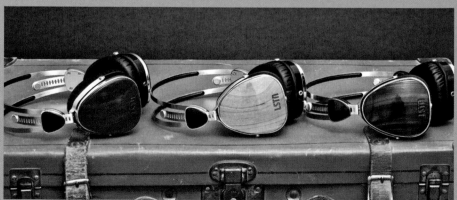

**007 I HUDSON BLUE ARTISANS** USA
Reclaimed Postage Stamps

**008 I LSTN HEADPHONES** USA  Reclaimed Woods

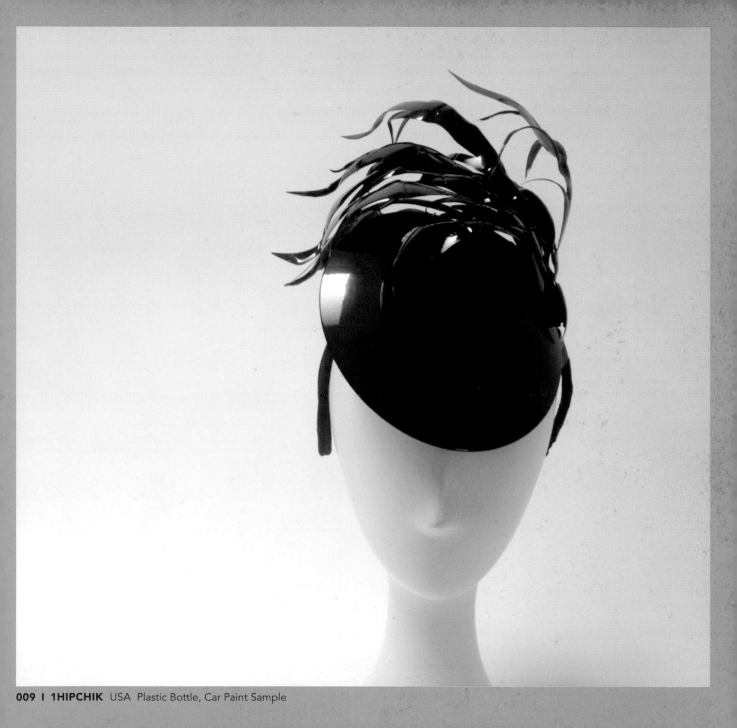

**009 | 1HIPCHIK**  USA  Plastic Bottle, Car Paint Sample

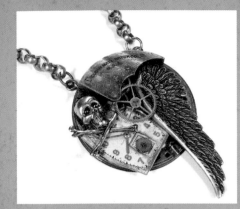

**010 | EDM DESIGNS** USA Vintage Watch

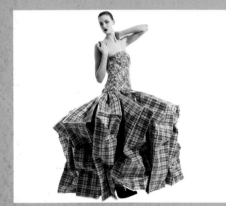

**012 | GARY HARVEY CREATIVE** UK
Nylon Shopping Bags

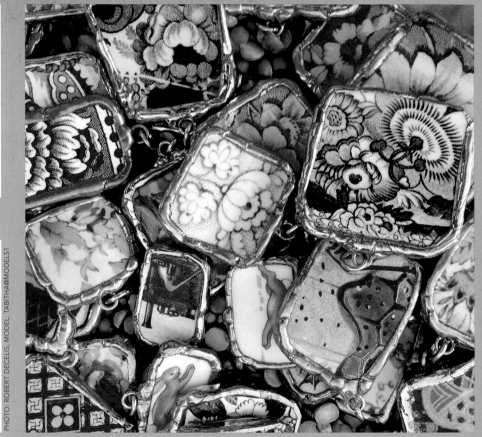

PHOTO: ROBERT DECELIS, MODEL: TABITHA@MODELS1

**011 | HILARY GREIF RECYCLED DESIGNS** USA Reclaimed Ceramic

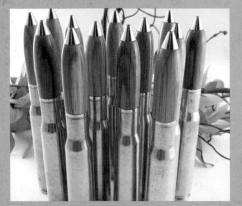

**013 | FARRELL WOODS** USA
Machine Gun Bullet

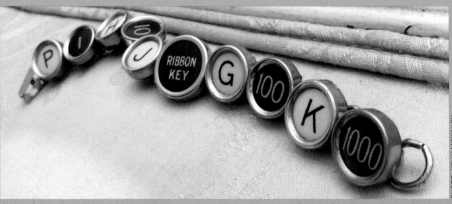

PHOTO: KELLY MCKINLEY

**014 | HILARY GREIF RECYCLED DESIGNS** USA Vintage Typewriter Keys

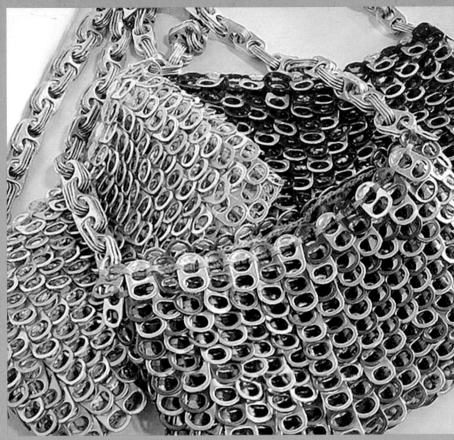

**015 I CLAUDIA ZIMMER** USA Soda Can Tabs

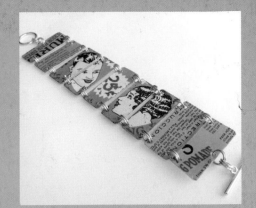

**016 I PERFECT TIN** USA
Reclaimed Tin Box

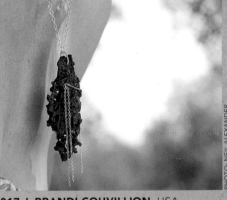

PHOTO: NEIL ALEXANDER

**017 I BRANDI COUVILLION** USA
Reclaimed Wood

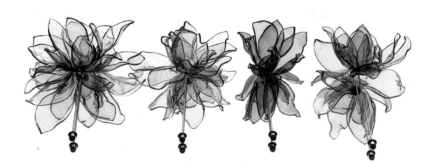

**018 I GULNUR OZDAGLAR** TURKEY Plastic Bottle

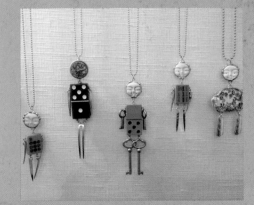

**019 I HILARY GREIF RECYCLED DESIGNS**
USA Reclaimed Objects

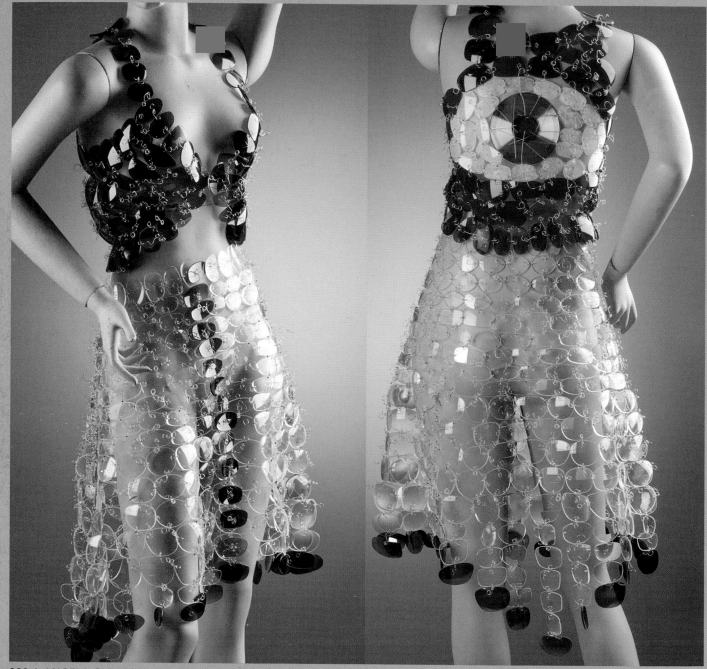

**020 I ANGELA GLEASON** USA Reclaimed Lenses

**021 I AKIKO OGUCHI** USA Reclaimed Clothing

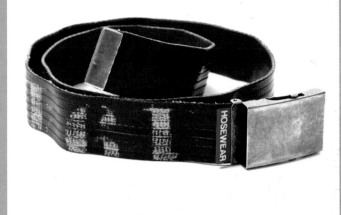

**022 I HOSEWEAR** ESTONIA Fire Hoses

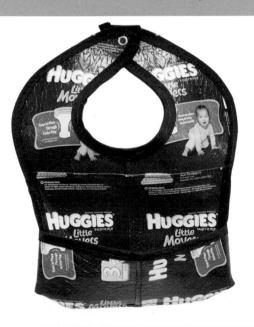

**023 I TERRACYCLE, INC.** USA Discarded Packaging

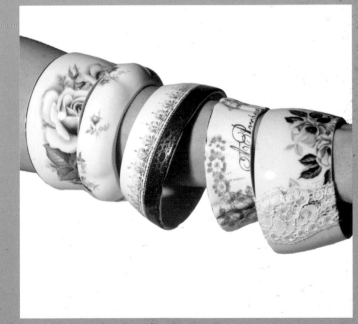

**024 I ABIGAIL CLARK** UK Vintage China

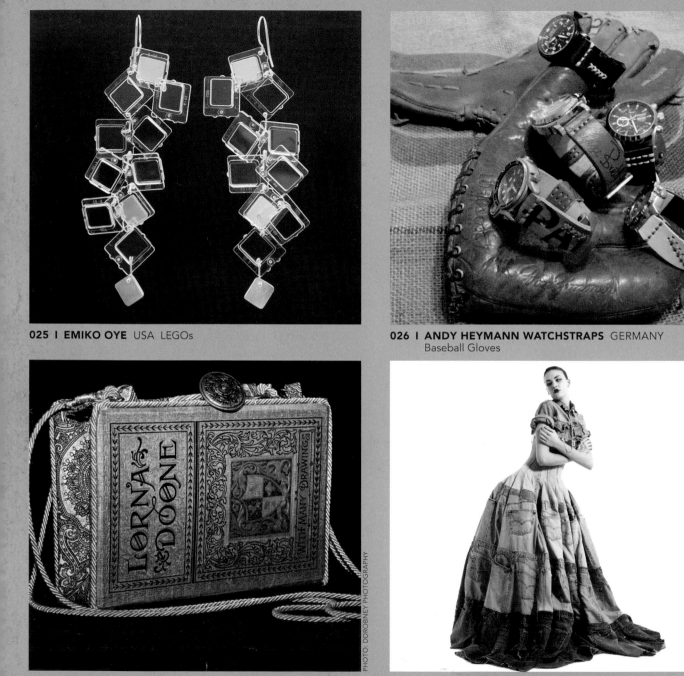

**025 | EMIKO OYE** USA LEGOs

**026 | ANDY HEYMANN WATCHSTRAPS** GERMANY
Baseball Gloves

**027 | BEEZ** USA Vintage Book

PHOTO: DDROBNEY PHOTOGRAPHY

**028 | GARY HARVEY CREATIVE** UK Reclaimed Denim

PHOTO: ROBERT DECELIS

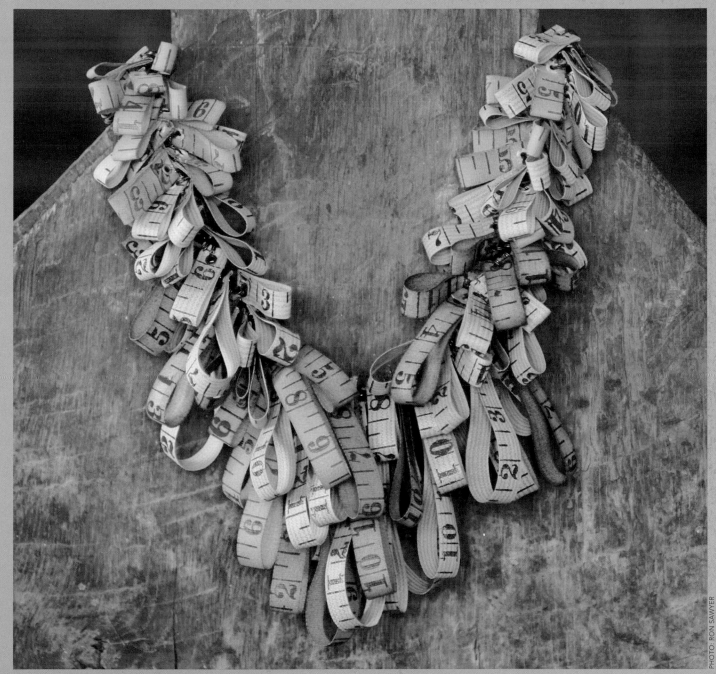

PHOTO: RON SAWYER

**029 I CHRIS GIFFIN** USA Vintage Tape Measure

**030 I BACK ALLEY CHIC** USA Reclaimed Burlap

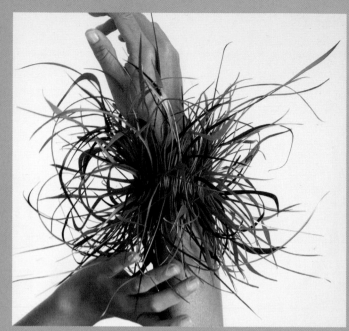

**031 I HARRIETE ESTEL BERMAN** USA
Reclaimed Shampoo Bottles & Take-Out Trays

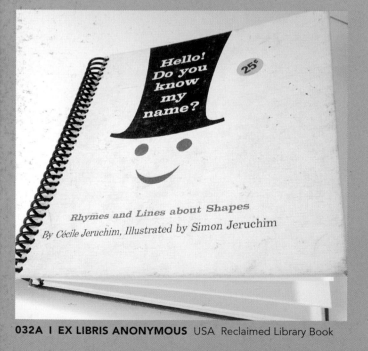

**032A I EX LIBRIS ANONYMOUS** USA Reclaimed Library Book

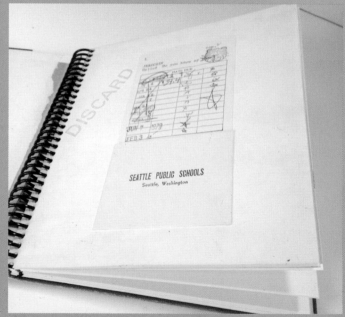

**032B I EX LIBRIS ANONYMOUS** USA Reclaimed Library Book

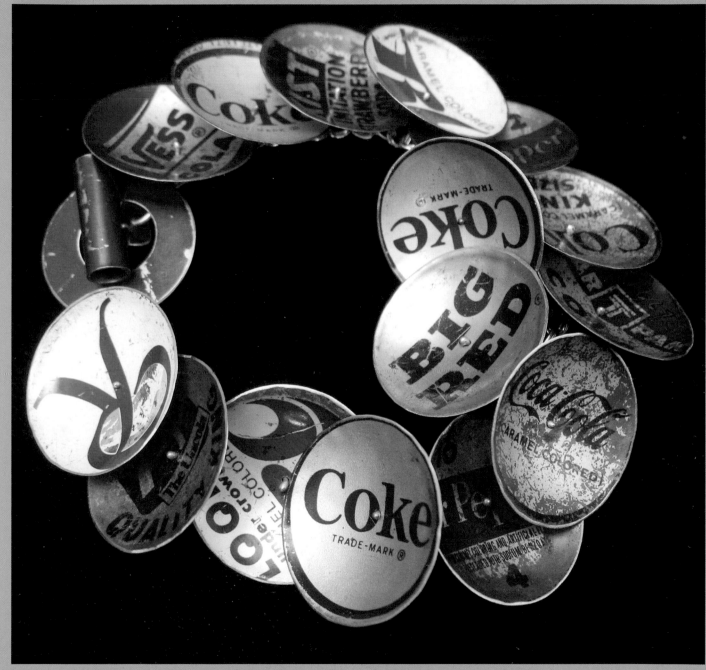

**033 I CHRISTINE TERRELL** USA Reclaimed Metal Pieces

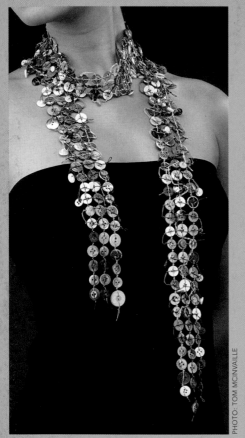

PHOTO: TOM MCINVAILLE

**034 I BLACK BUTTON STUDIO** USA
Buttons

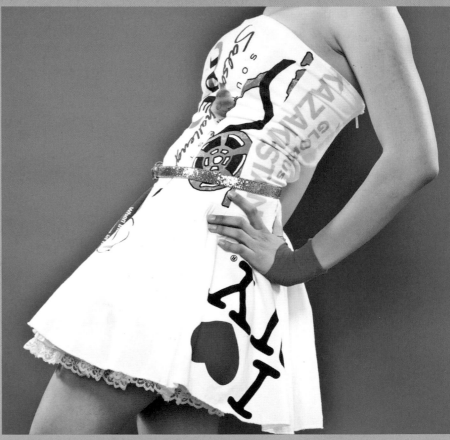

PHOTO: NICOLLE CLEMETSON

**035 I ANGELA JOHNSON** USA Assorted T-Shirts

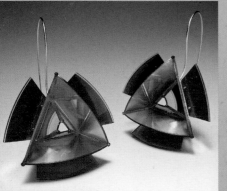

**036 I CHUN-LUNG HSIEH** TAIWAN CDs

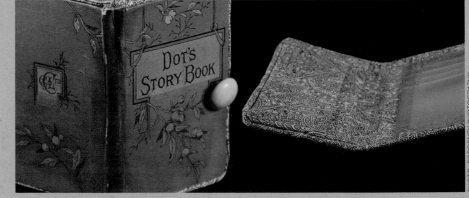

PHOTO: DDROBNEY PHOTOGRAPHY

**037 I BEEZ** USA Vintage Book

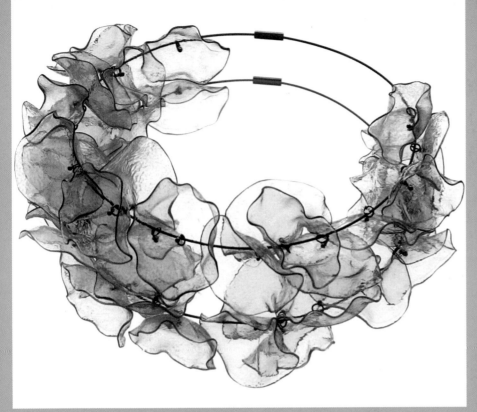

**038 I GULNUR OZDAGLAR** TURKEY Plastic Bottles

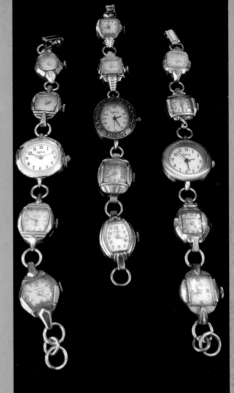

**039 I HILARY GREIF RECYCLED DESIGNS** USA Vintage Watches

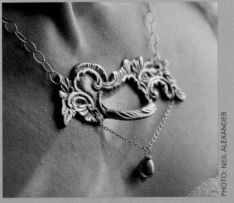

PHOTO: NEIL ALEXANDER

**040 I BRANDI COUVILLION** USA Reclaimed Drawer Pull

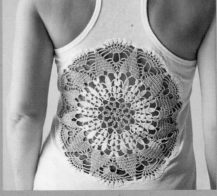

**041 I EKATERINA FEDOTOVA** ITALY Vintage Crochet Doily

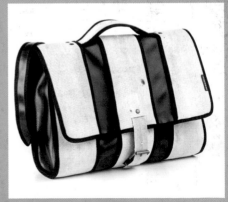

**042 I HOSEWEAR** ESTONIA Fire Hoses

PERSONAL ITEMS & ACCESSORIES    23

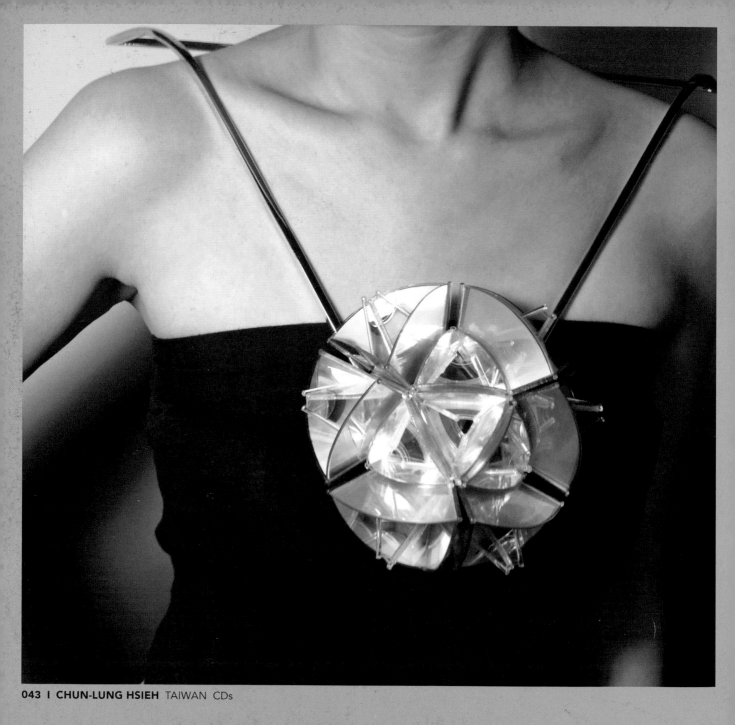

043 I **CHUN-LUNG HSIEH** TAIWAN CDs

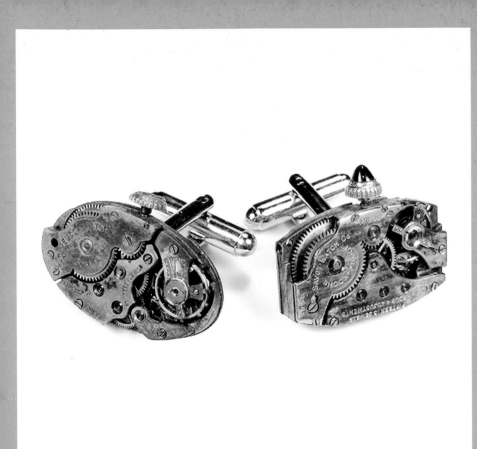

**044 I EDM DESIGNS** USA  Vintage Watch

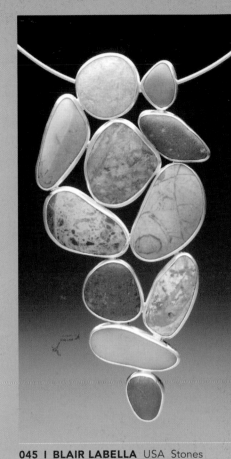

PHOTO: CHARLEY FREIBERG

**045 I BLAIR LABELLA** USA  Stones

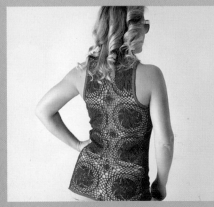

**046 I EKATERINA FEDOTOVA** ITALY
Vintage Crochet Tablecloth

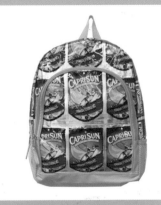

**047 I TERRACYCLE, INC.** USA
Discarded Packaging

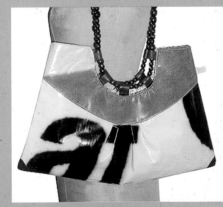

**048 I GG2G** USA  Reclaimed Billboards

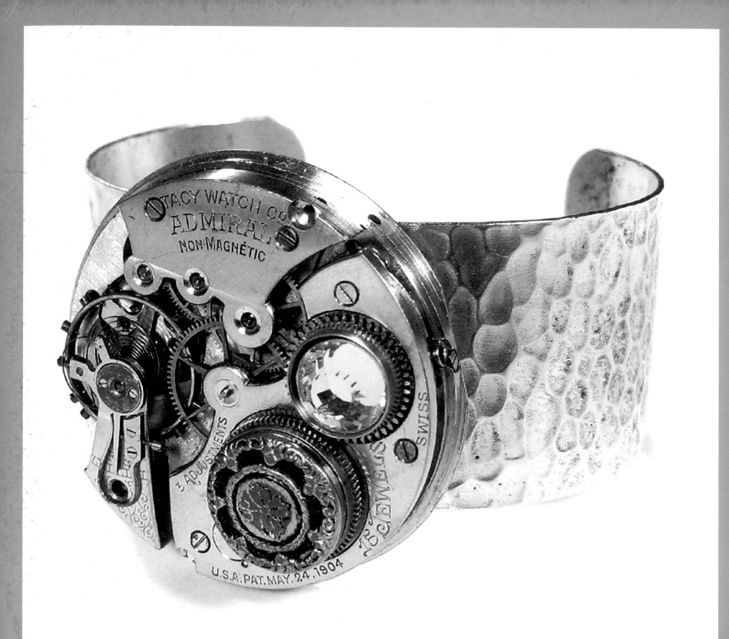

**049 I EDM DESIGNS** USA  Vintage Watch

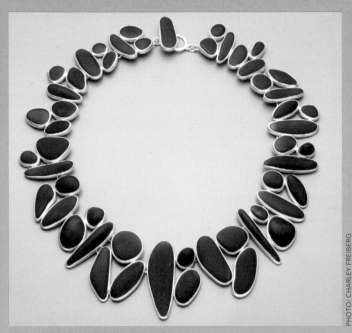

PHOTO: CHARLEY FREIBERG

**050 I BLAIR LABELLA** USA Stones

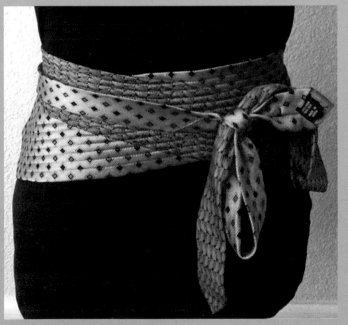

**052 I ALL TIED OUT** USA Men's Tie

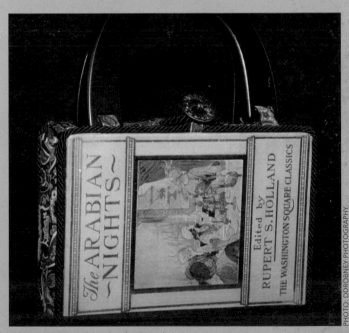

PHOTO: TOM McINVAILLE

**051 I BLACK BUTTON STUDIO** USA Buttons

PHOTO: DDROBNEY PHOTOGRAPHY

**053 I BEEZ** USA Vintage Book

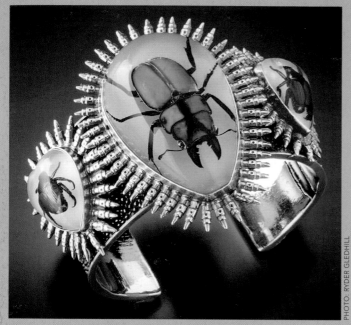

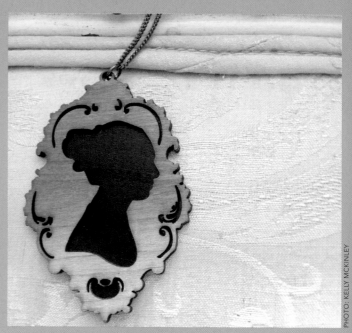

**054 I HALEY HOLEMAN** USA Reclaimed Beetles

PHOTO: RYDER GLEDHILL

**055 I WRECORDS BY MONKEY** USA Vinyl Records

PHOTO: KELLY MCKINLEY

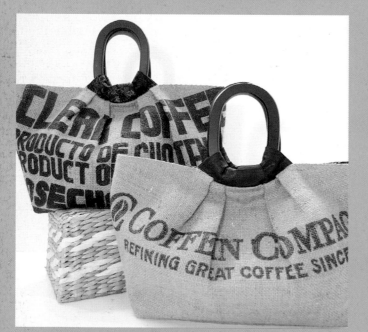

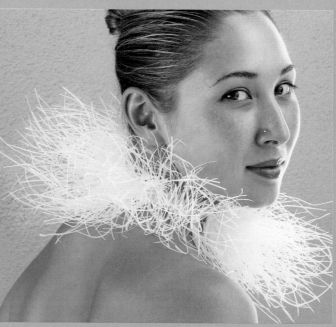

**056 I BACK ALLEY CHIC** USA Reclaimed Burlap

**057 I HARRIETE ESTEL BERMAN** USA
Reclaimed Shampoo Bottles

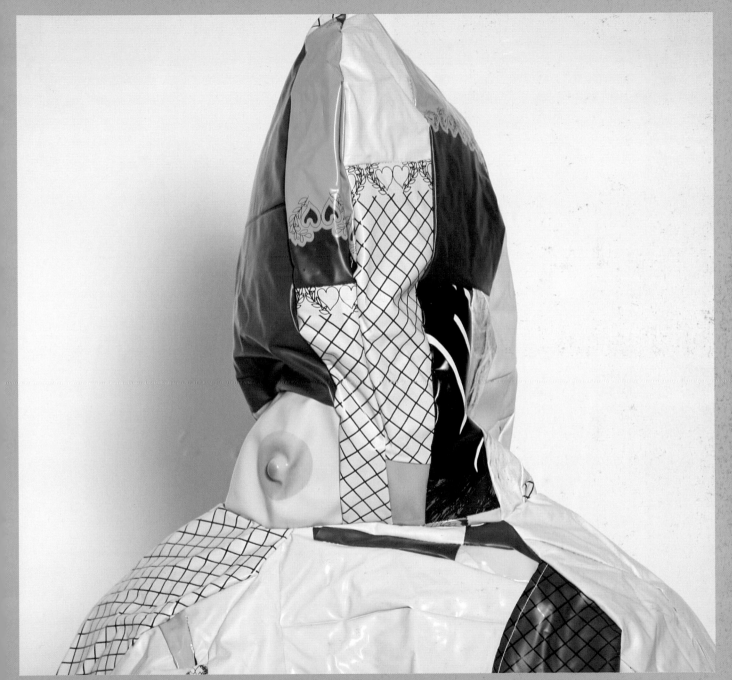

058 I **SANDER REIJGERS** NETHERLANDS  Reclaimed Blow-Up Doll

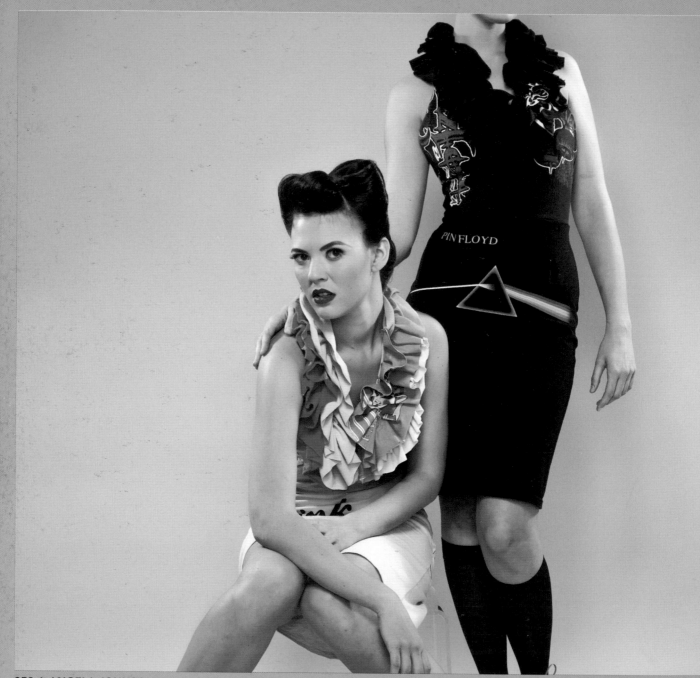

**059 I ANGELA JOHNSON** USA  Assorted T-Shirts

PHOTO: NICOLLE CLEMETSON

**060 I HILARY GREIF RECYCLED DESIGNS** USA
Reclaimed Ceramic

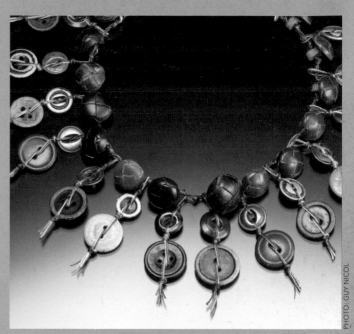

**061 I BLACK BUTTON STUDIO** USA Buttons

PHOTO: GUY NICOL

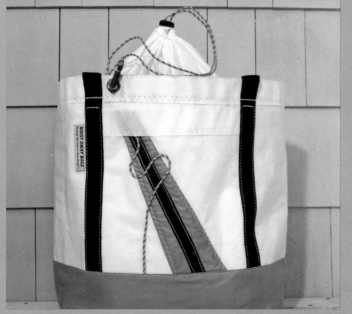

**062 I HOIST AWAY BAGS** USA Reclaimed Sails

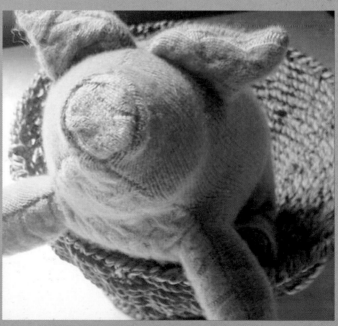

**063 I JENNIFER MEEKS** USA Reclaimed Cashmere

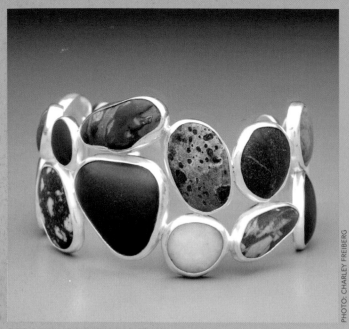

PHOTO: CHARLEY FREIBERG

**064 I BLAIR LABELLA** USA Stones

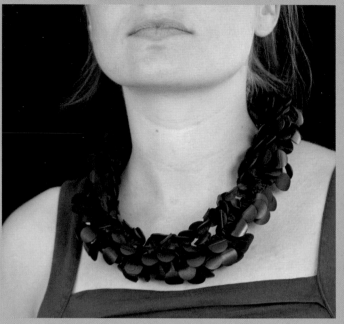

**065 I CHRISTIANE DIEHL** GERMANY Bicycle Inner Tube

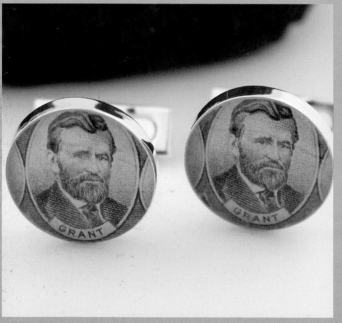

**066 I HUDSON BLUE ARTISANS** USA Reclaimed Postage Stamps

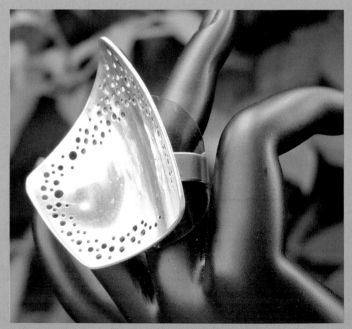

**067 I ATELIER LE DOS DE LA CUILLERE** FRANCE Spoon

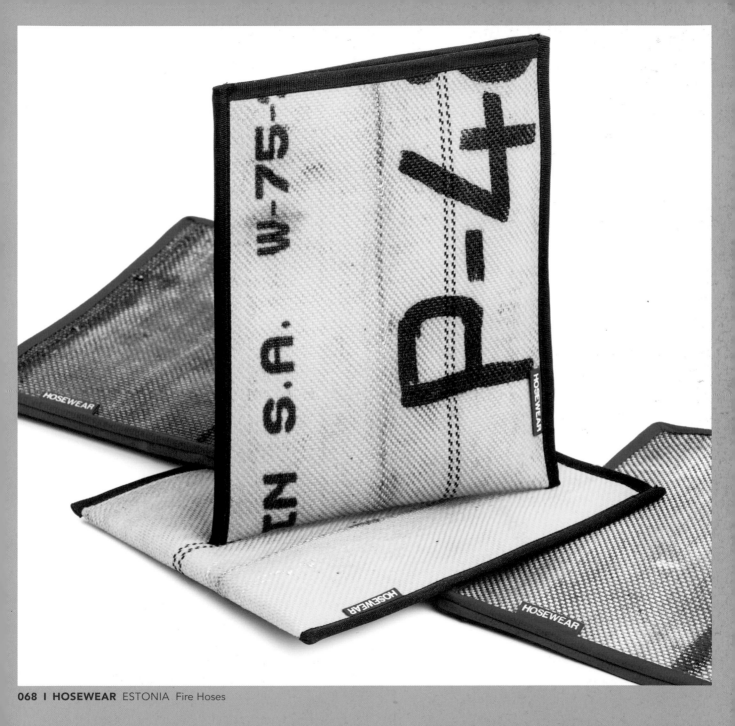

**068 I HOSEWEAR** ESTONIA Fire Hoses

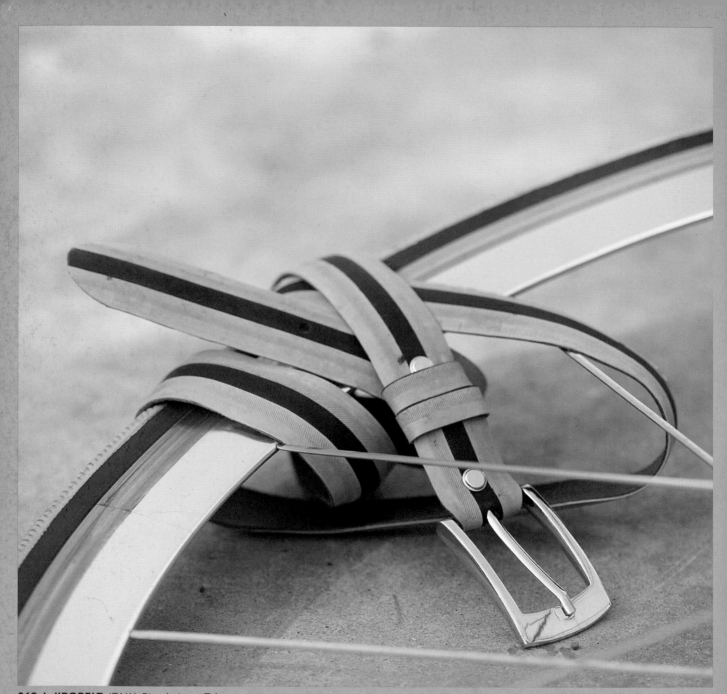

**069 I JIROBELT** ITALY  Bicycle Inner Tube

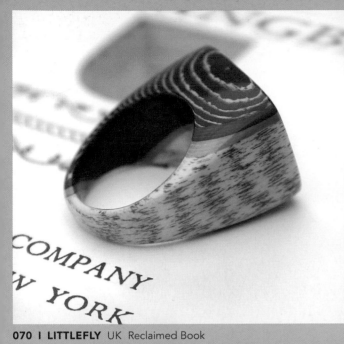

PHOTO: EVA CHLOE VAZAKA

**070 | LITTLEFLY** UK Reclaimed Book

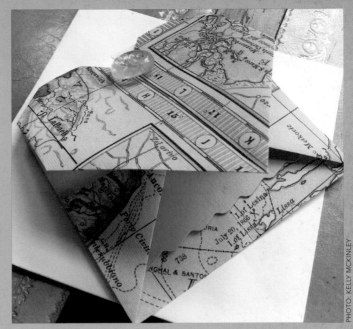

PHOTO: KELLY MCKINLEY

**071 | MADE BY ONE GIRL** USA Vintage Map & Button

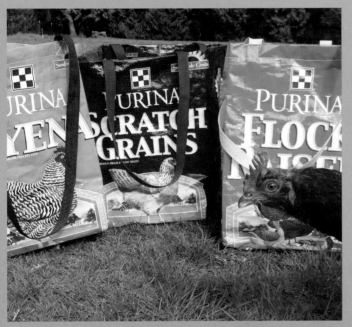

**072 | MICHELLE MORALES** USA Chicken Feed Bag

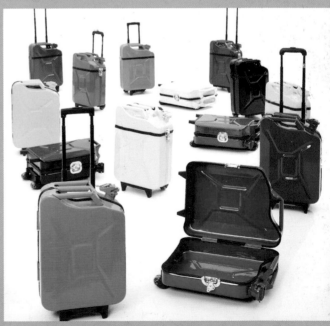

PHOTO: MARTIN OHNESORGE

**073 | IVORILLA** GERMANY Gas Can

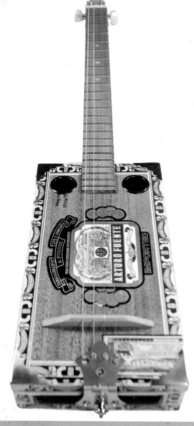

**074 I STRING TINKERS** USA Reclaimed
Cigar Boxes & Old Floorboards

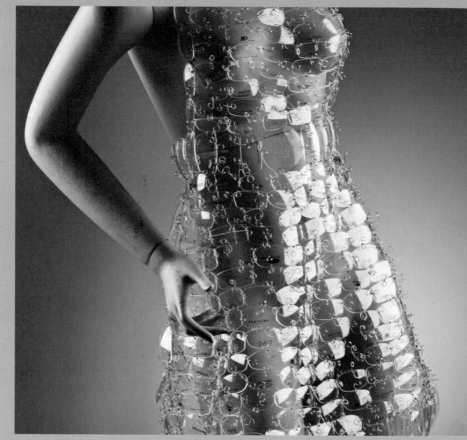

**075 I ANGELA GLEASON** USA Reclaimed Lenses

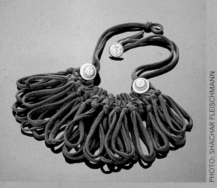

**076 I MIPOLA** ISRAEL T-Shirt,
Vintage Buttons

PHOTO: SHACHAR FLEISCHMANN

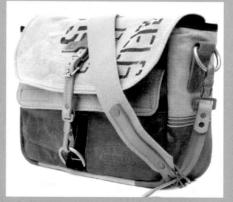

**077A I MADO©** GERMANY
Reclaimed Mailbags

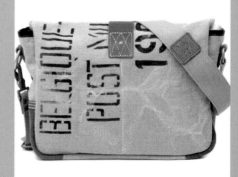

**077B I MADO©** GERMANY
Reclaimed Mailbags

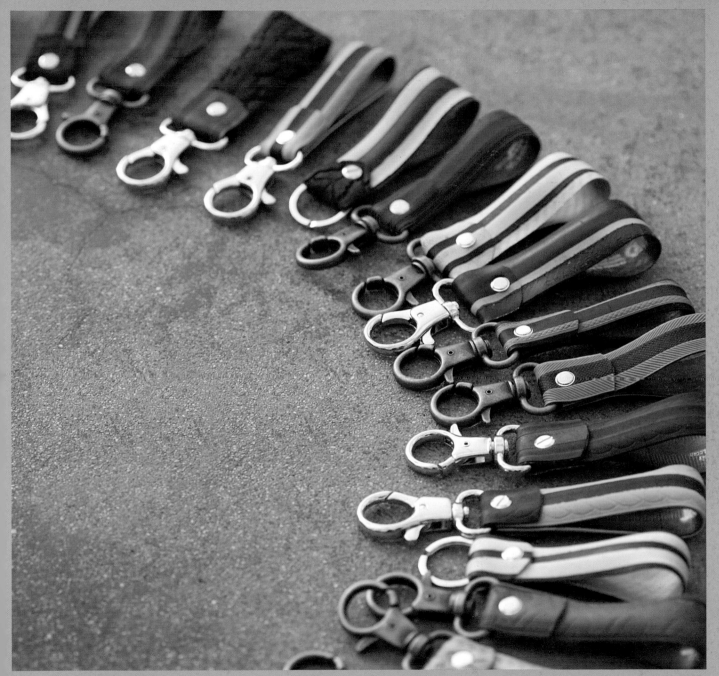

**078 I JIROBELT** ITALY  Bicycle Inner Tube

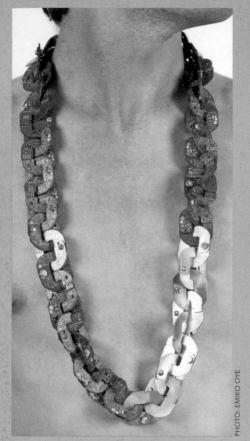

**079 I KELLY NEDDERMAN** USA
Circuit Board

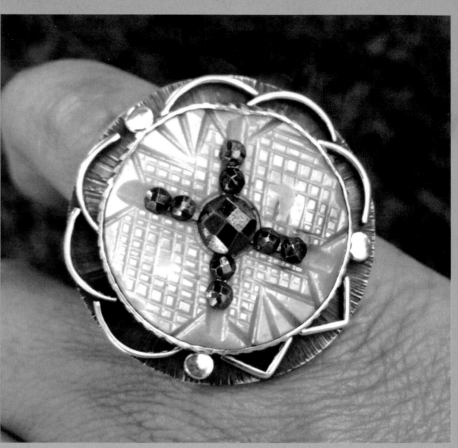

PHOTO: EMIKO OYE

**080 I TOMMY CONCH DESIGN** USA Vintage Buttons

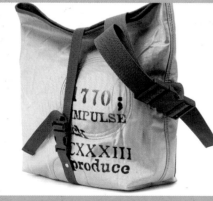

**081 I MADO©** GERMANY
Reclaimed Airbag

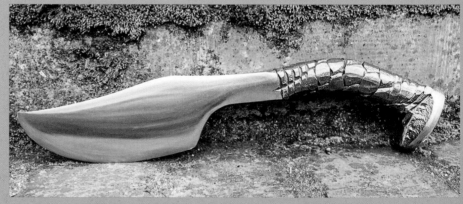

**082 I CINESCAPE STUDIOS** USA Railroad Spike

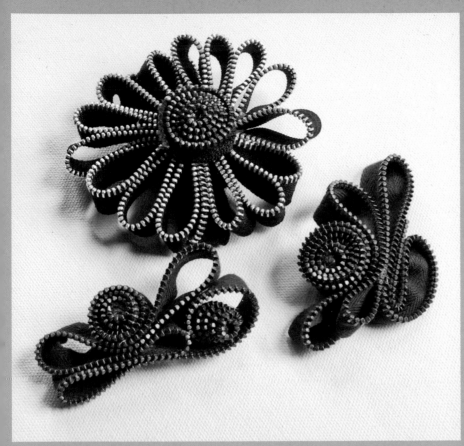

**083 I MONICA LEE** USA Zippers

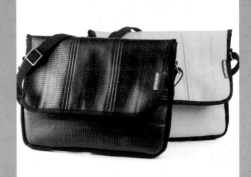

**084 I HOSEWEAR** ESTONIA Fire Hoses

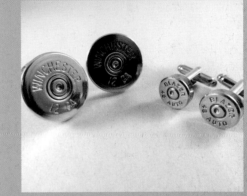

**085 I OUT OF THE ASHES** USA
Reclaimed Bullets

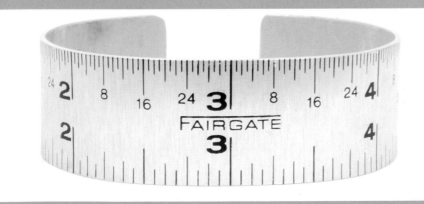

**086 I JACQ** USA Vintage Ruler

**087 I JENNIFER MEEKS** USA
Reclaimed Cashmere

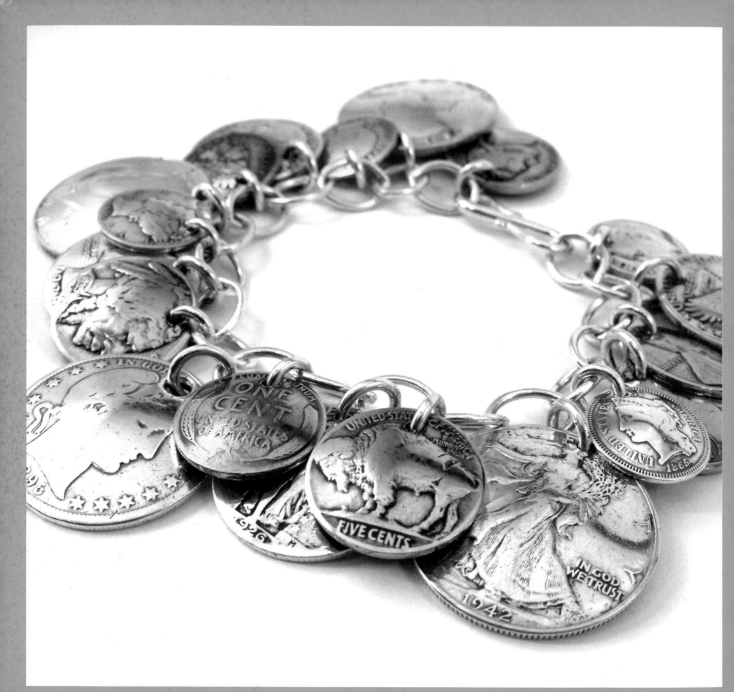

**088 I MADE FROM COINS** USA Vintage Silver & Copper Coins

**ART** WITHOUT **WASTE I** 500 UPCYCLED & EARTH-FRIENDLY DESIGNS

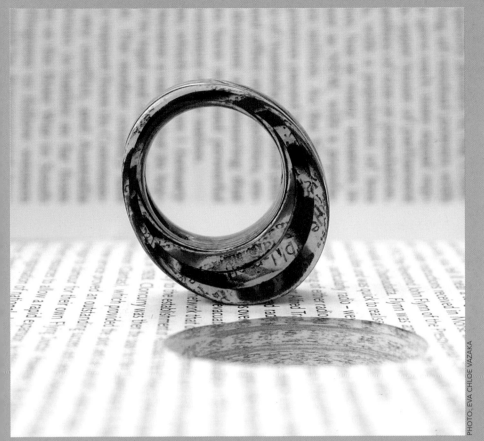

PHOTO: EVA CHLOE VAZAKA

**089 | LITTLEFLY** UK  Reclaimed Book

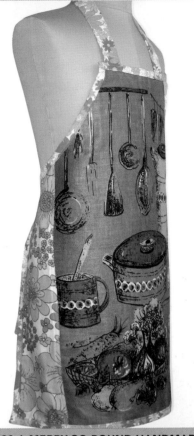

**090 | MERRY-GO-ROUND HANDMADE**
AUSTRALIA  Vintage Tea Towel

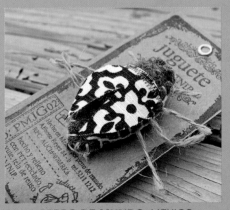

**091 | PERRO DE MUNDO** MEXICO
Assorted Found Fabrics

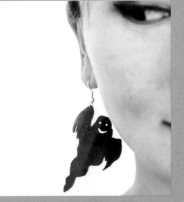

**092 | MICHELLE LUO** USA
Bike Inner Tube

PHOTO: JESSICA BOWEN

**093 | MISS MANOS** USA
Restaurant Vinyl Seating

PERSONAL ITEMS & ACCESSORIES

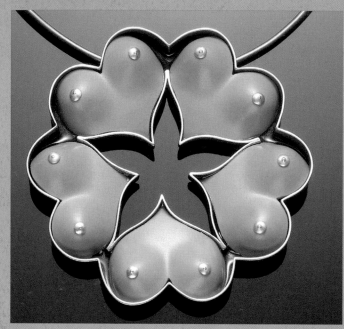

**094 I MARGAUX LANGE** USA Barbie Dolls

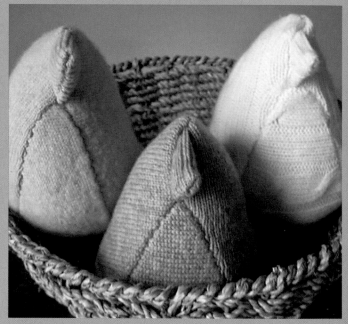

**095 I JENNIFER MEEKS** USA Reclaimed Cashmere

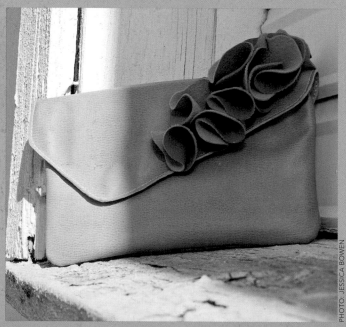

PHOTO JESSICA BOWEN

**096 I MISS MANOS** USA Restaurant Vinyl Seating

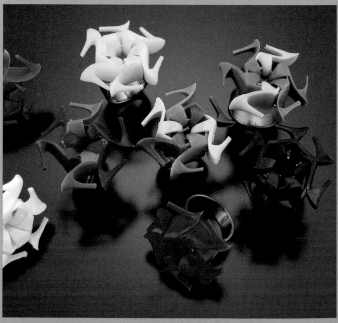

**097 I MARGAUX LANGE** USA Doll Shoes

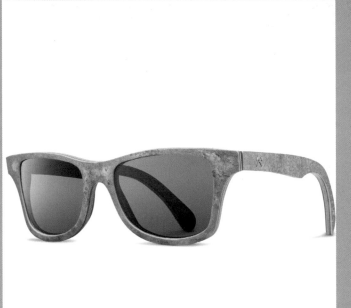

**098 I SHWOOD EYEWEAR** USA  Stone

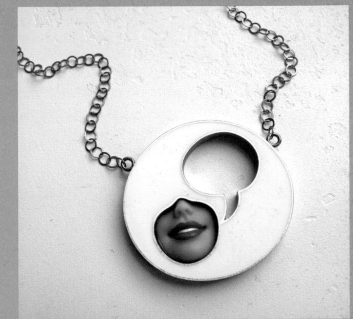

**099 I MARGAUX LANGE** USA  Barbie Dolls

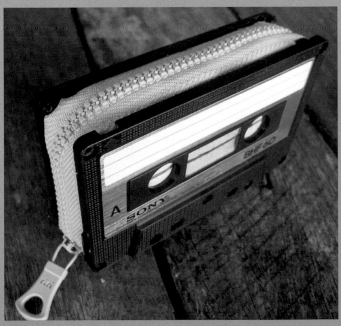

**100A I MAMA PACHA** AUSTRALIA  Cassette Tape

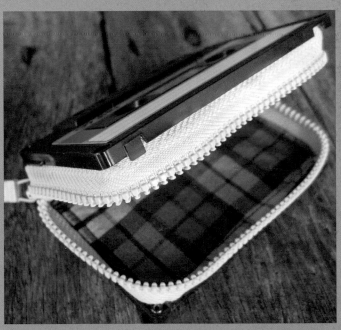

**100B I MAMA PACHA** AUSTRALIA  Cassette Tape

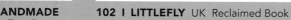

**101 I MERRY-GO-ROUND HANDMADE**
AUSTRALIA Vintage Tea Towel

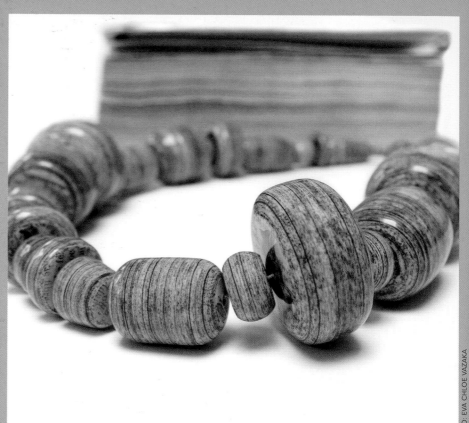

**102 I LITTLEFLY** UK Reclaimed Book

PHOTO: EVA CHLOE VAZAKA

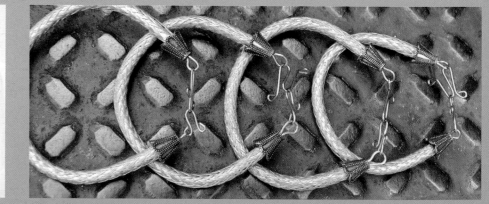

**103 I TARA LOCKLEAR** USA
Reclaimed Skateboard

**104 I MITZI BRANDON** USA Reclaimed Coaxial Cable

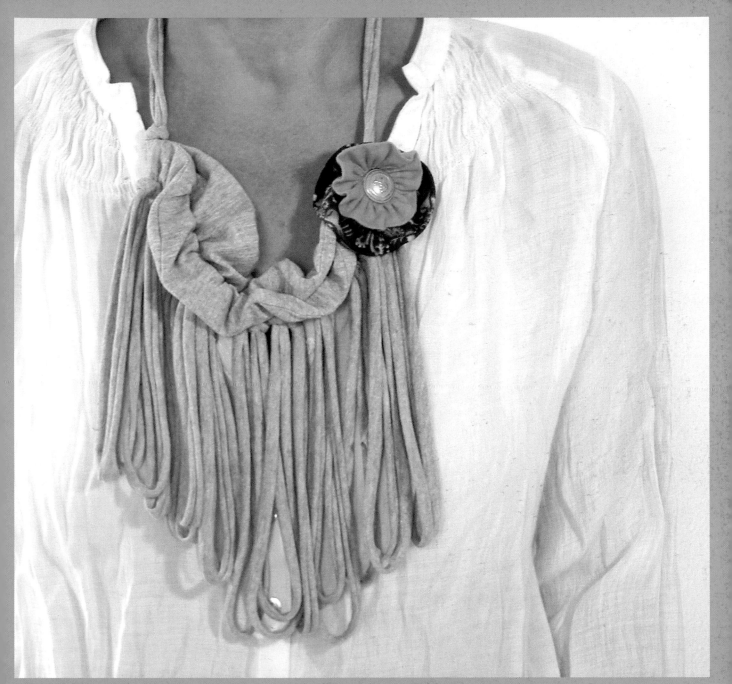

**105 | MIPOLA** ISRAEL  T-Shirt, Vintage Buttons

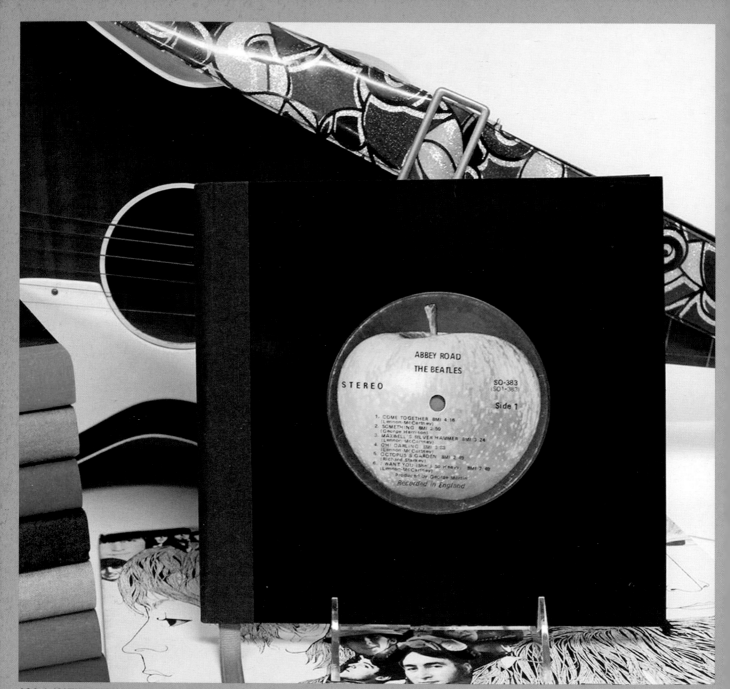

106 I KATIE PIETRAK UK Vinyl Records

**ART** WITHOUT **WASTE** I 500 UPCYCLED & EARTH-FRIENDLY DESIGNS

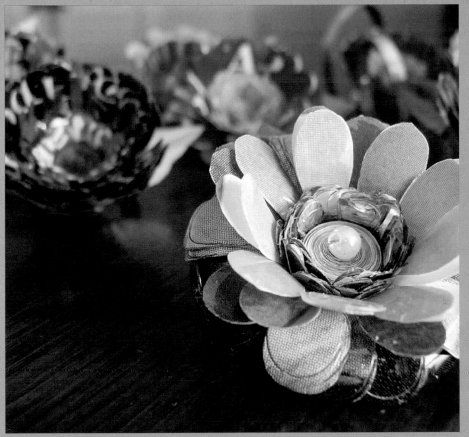

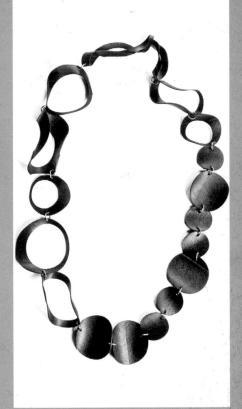

**107 I ONEMOREUSE BY CREATE MY WORLD DESIGNS** USA  Discarded Snack Bags

**108 I MONICA LEE** USA
Bicycle Inner Tube

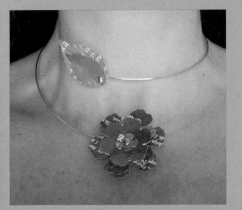

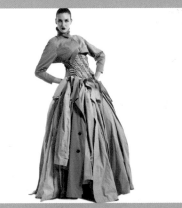

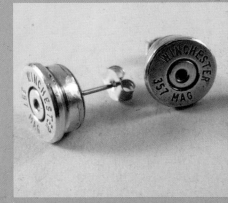

PHOTO: ROBERT DECELIS

**109 I ONEMOREUSE BY CREATE MY
WORLD DESIGNS** USA
Discarded Snack Bags

**110 I GARY HARVEY CREATIVE** UK
Trench Coats

**111 I OUT OF THE ASHES** USA
Reclaimed Bullets

PERSONAL ITEMS & ACCESSORIES     47

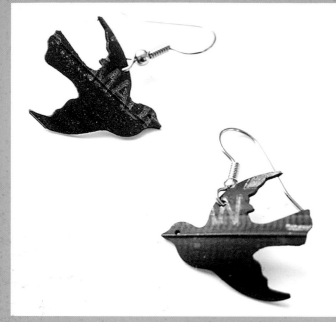

**112 I MICHELLE LUO** USA Bike Inner Tube

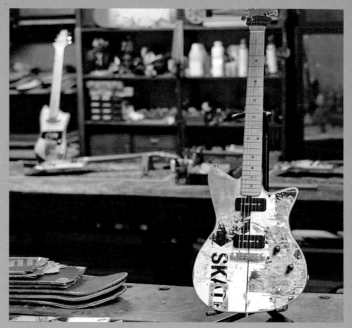

**113 I SKATE GUITAR** ARGENTINA Reclaimed Skateboard

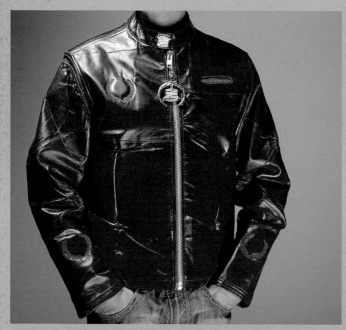

**114A I PLATINUM DIRT** USA Reclaimed Leather Car Seat

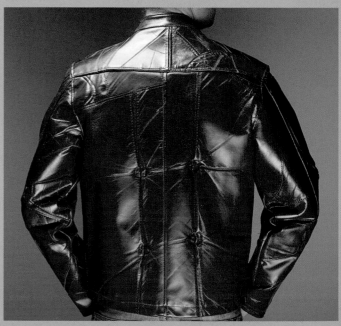

**114B I PLATINUM DIRT** USA Reclaimed Leather Car Seat

48    **ART** WITHOUT **WASTE I** 500 UPCYCLED & EARTH-FRIENDLY DESIGNS

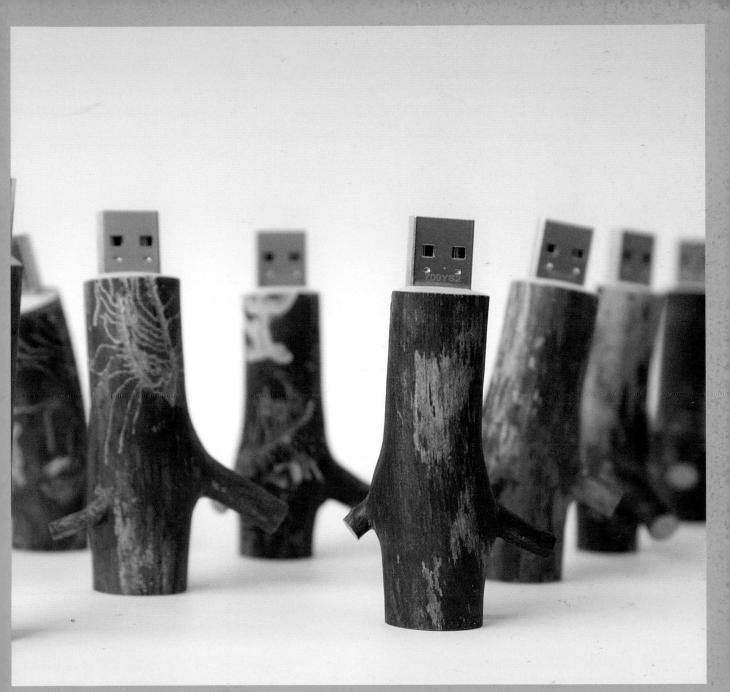

**115 I OOOMS** NETHERLANDS  Assorted Woods

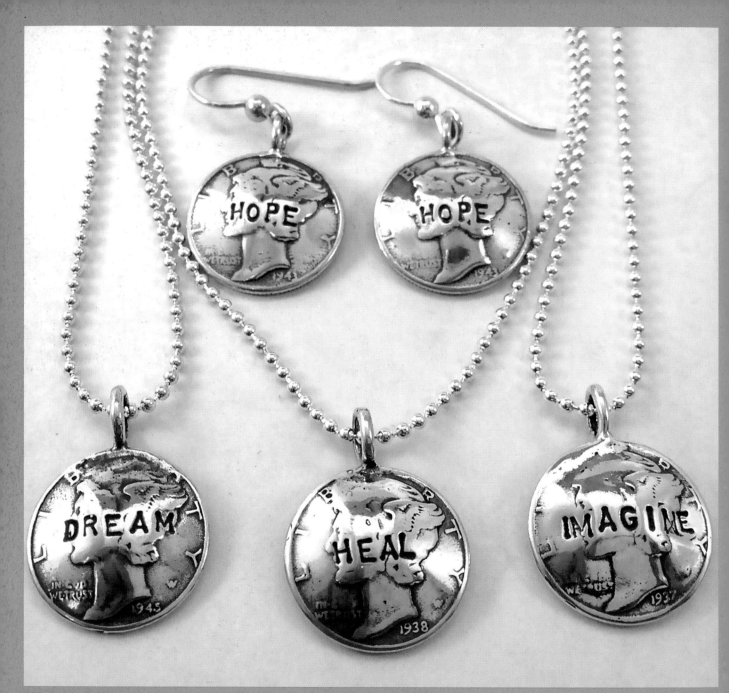

**116 I MADE FROM COINS** USA  Vintage Silver Coins

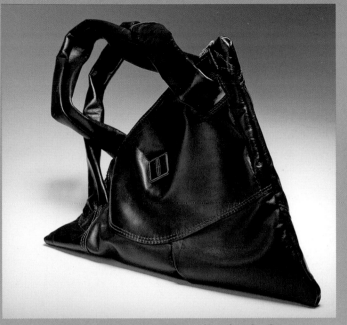

**117 I PLATINUM DIRT** USA Reclaimed Leather Car Seat

**118 I PERFECT TIN** USA Reclaimed Tin Box

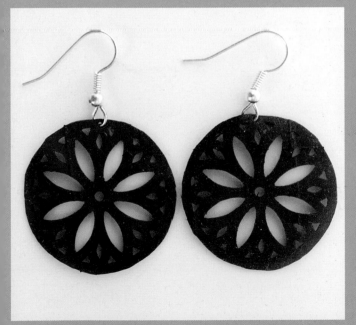

**119 I MICHELLE LUO** USA Bike Inner Tube

**120 I JACQ** USA Vintage Ruler

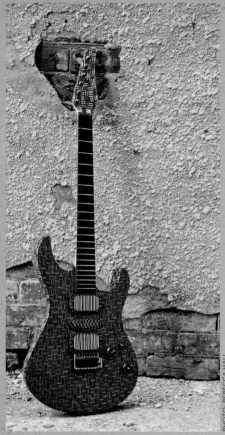

**121 I SECOND SHOT** CANADA
Skateboards

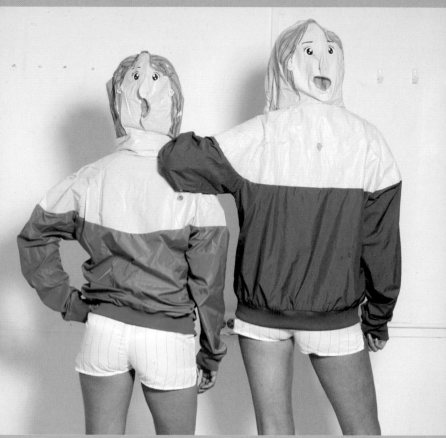

**122 I SANDER REIJGERS** NETHERLANDS Reclaimed Blow-Up Doll

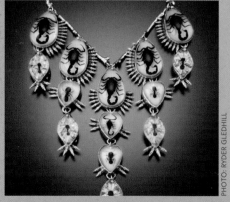

**123 I HALEY HOLEMAN** USA
Reclaimed Scorpions

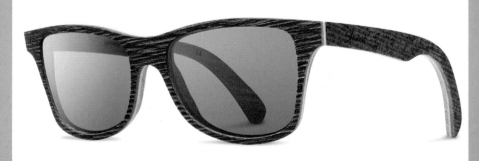

**124 I SHWOOD EYEWEAR** USA Salvaged Wood from Barn

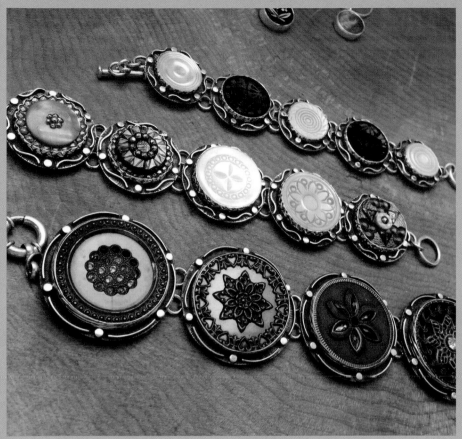

**125 I TOMMY CONCH DESIGN** USA Vintage Buttons

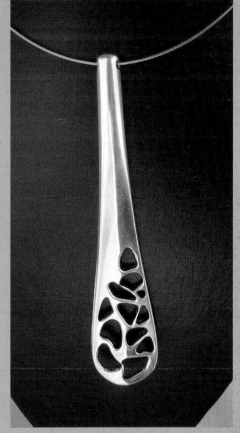

**126 I ATELIER LE DOS DE LA CUILLERE**
FRANCE Spoon

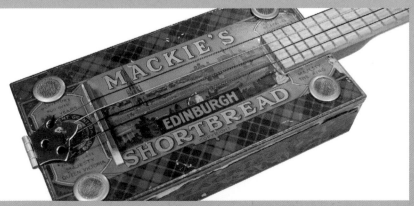

**127 I STRING TINKERS** USA Reclaimed Packaging & Old Floorboards

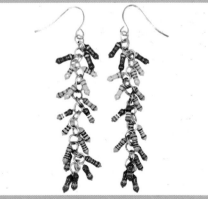

**128 I TECHCYCLED** USA
Reclaimed Transistors

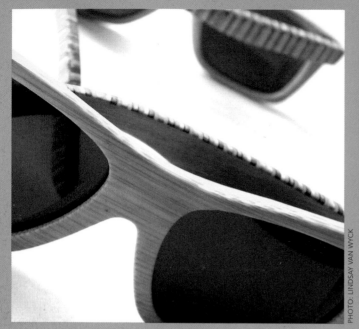

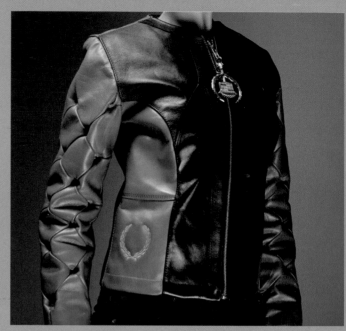

PHOTO: LINDSAY VAN WYCK

**129 I SECOND SHOT** CANADA  Skateboards

**130 I PLATINUM DIRT** USA  Reclaimed Leather Car Seat

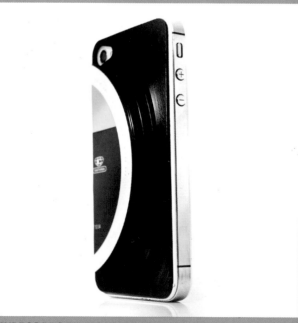

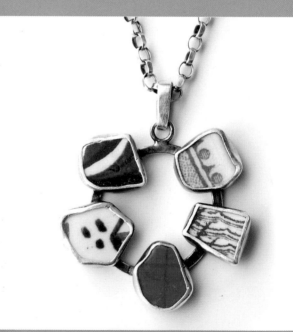

**131 I WRECORDS BY MONKEY** USA  Vinyl Record

**132 I TANIA COVO** UK  Reclaimed Ceramic

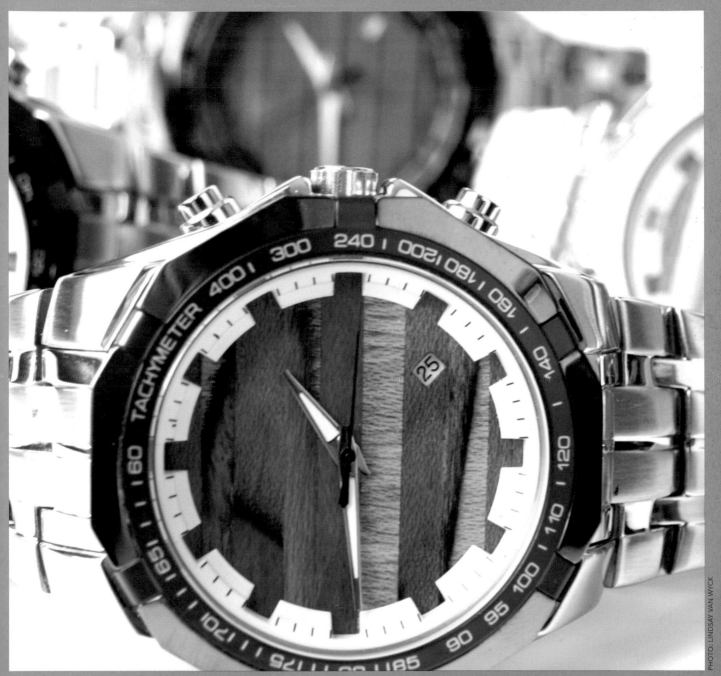

**133 | SECOND SHOT** CANADA  Skateboards

PHOTO: LINDSAY VAN WYCK

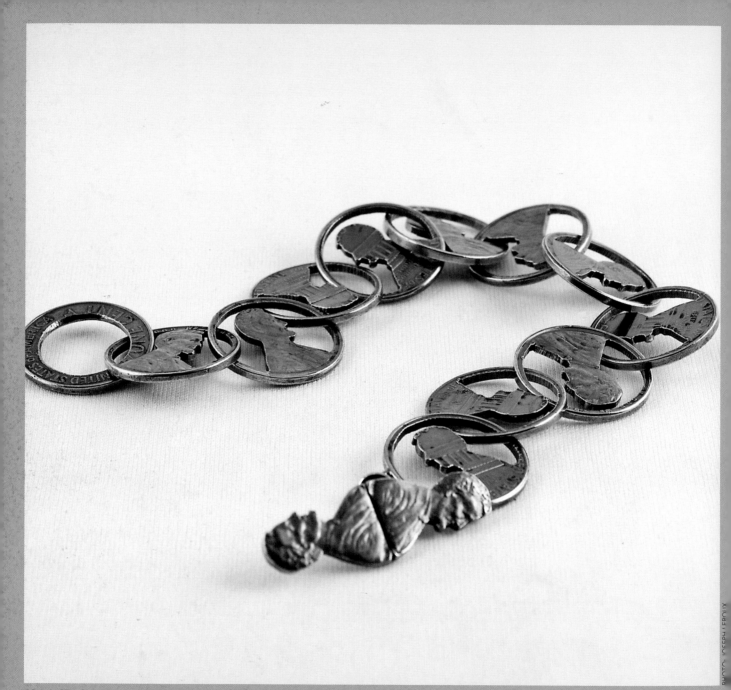

PHOTO: JOSEPH GAGNE

**134 I STACY LEE WEBBER** USA Reclaimed Coins

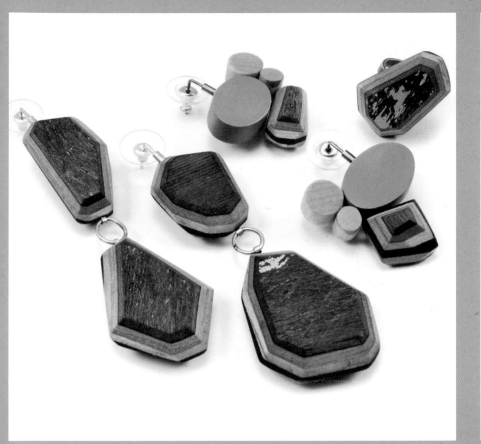

**135 I TARA LOCKLEAR** USA Reclaimed Skateboard

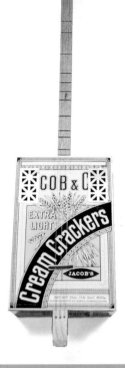

**136 I STRING TINKERS** USA Reclaimed Packaging & Old Floorboards

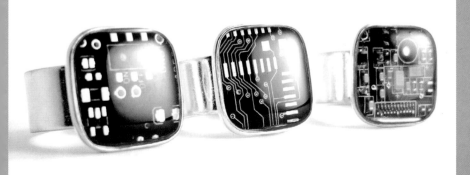

**137 I TECHCYCLED** USA Reclaimed Circuit Board

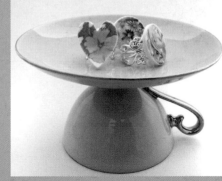

**138 I TWICELOVED CHINA** AUSTRALIA Vintage China

PERSONAL ITEMS & ACCESSORIES 57

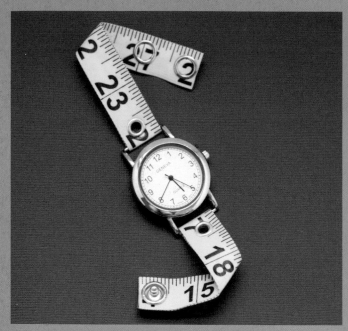

**139 I UNDONE CLOTHING** USA Vintage Tape Measure

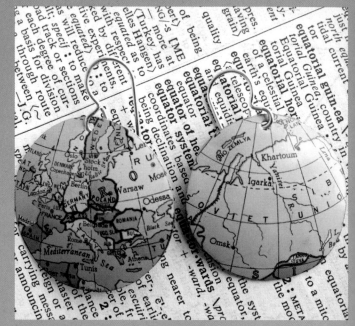

**140 I PERFECT TIN** USA Tin Globe

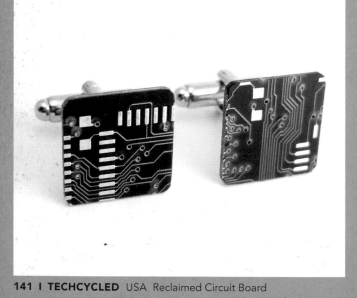

**141 I TECHCYCLED** USA Reclaimed Circuit Board

**142 I WRECORDS BY MONKEY** USA Vinyl Records

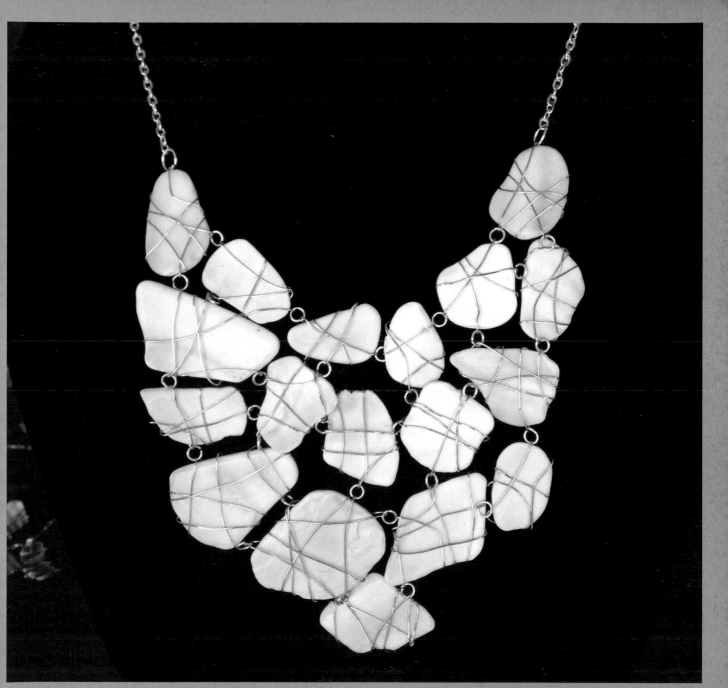

**143 I ABILITY BY ALYSSA** USA  Assorted Seashells

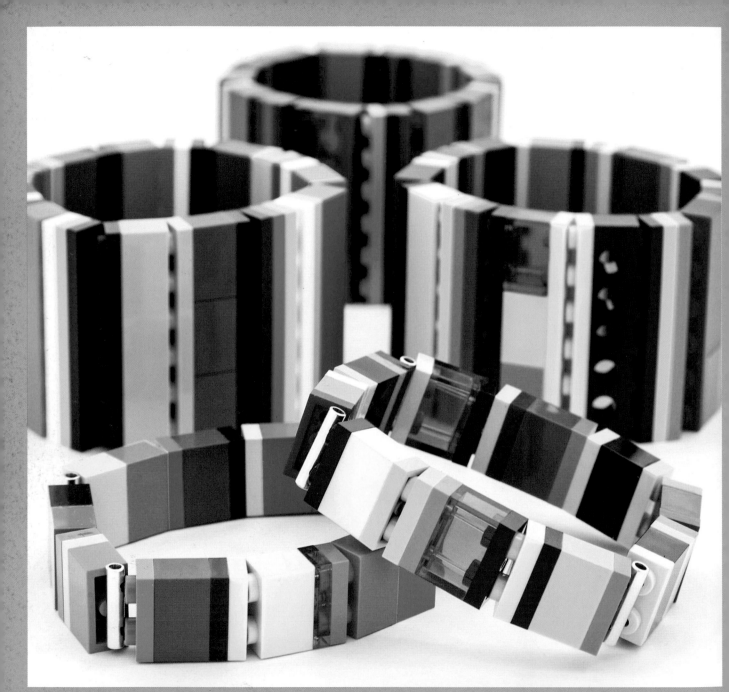

**144 I EMIKO OYE** USA LEGOs

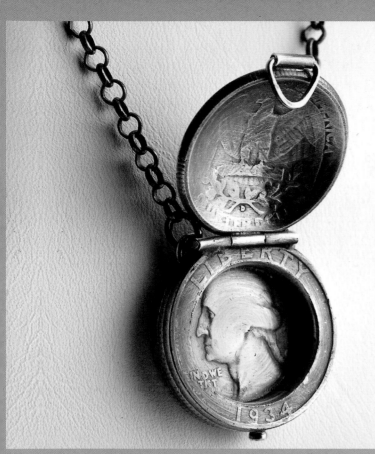

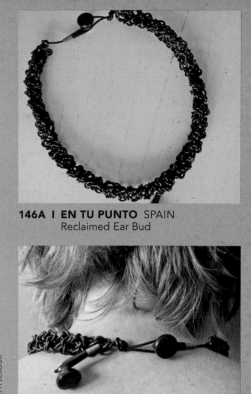

PHOTO: JOSEPH LEROUX

**146A | EN TU PUNTO** SPAIN
Reclaimed Ear Bud

**145 | STACY LEE WEBBER** USA Reclaimed Coin

**146B | EN TU PUNTO** SPAIN
Reclaimed Ear Bud

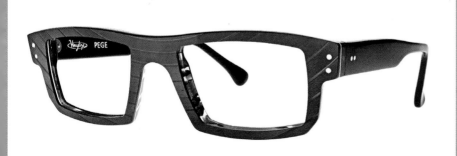

**147 | VINYLIZE** HUNGARY Vinyl Record

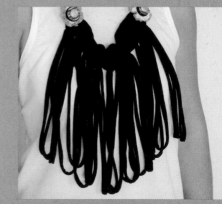

**148 | MIPOLA** ISRAEL
T-Shirt, Vintage Buttons

PERSONAL ITEMS & ACCESSORIES    61

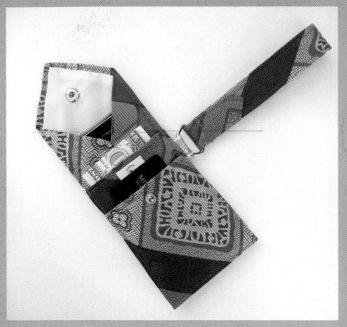

**149A | VINTAGE 180** USA Men's Tie

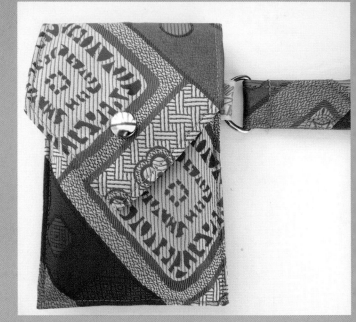

**149B | VINTAGE 180** USA Men's Tie

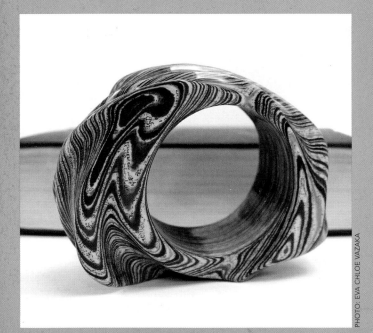

**150 | LITTLEFLY** UK Reclaimed Book

PHOTO: EVA CHLOE VAZAKA

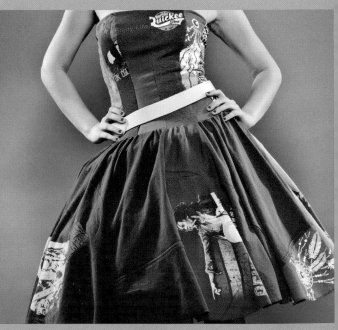

**151 | ANGELA JOHNSON** USA Vintage T-Shirts

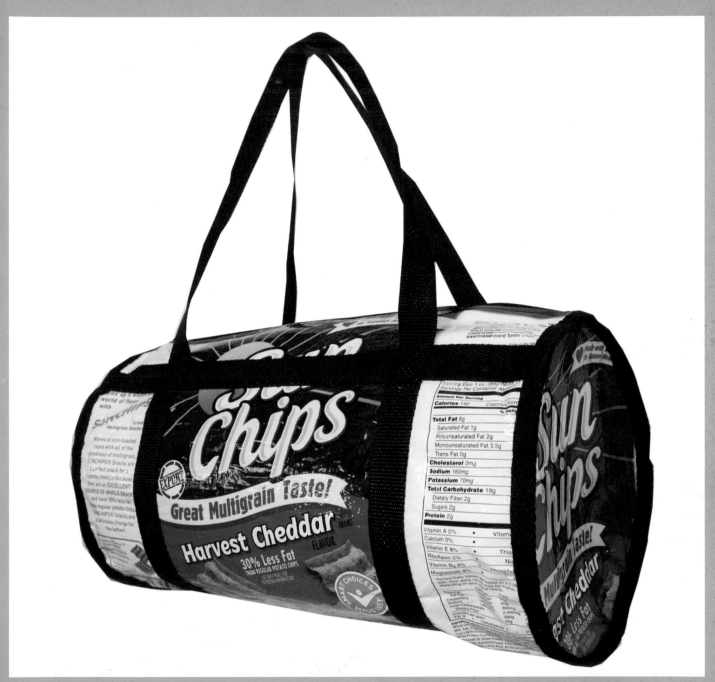

**152 I TERRACYCLE, INC.** USA  Discarded Packaging

# HOME & GARDEN

**Home & Garden** includes items that provide comfort, convenience, and style to our living environments. These unique items provide a sense of familiarity, but the use of unconventional materials creates an entirely new experience. ■

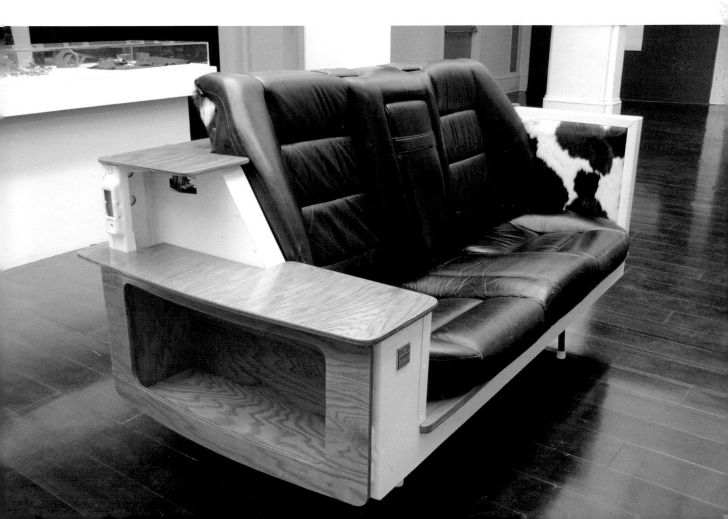

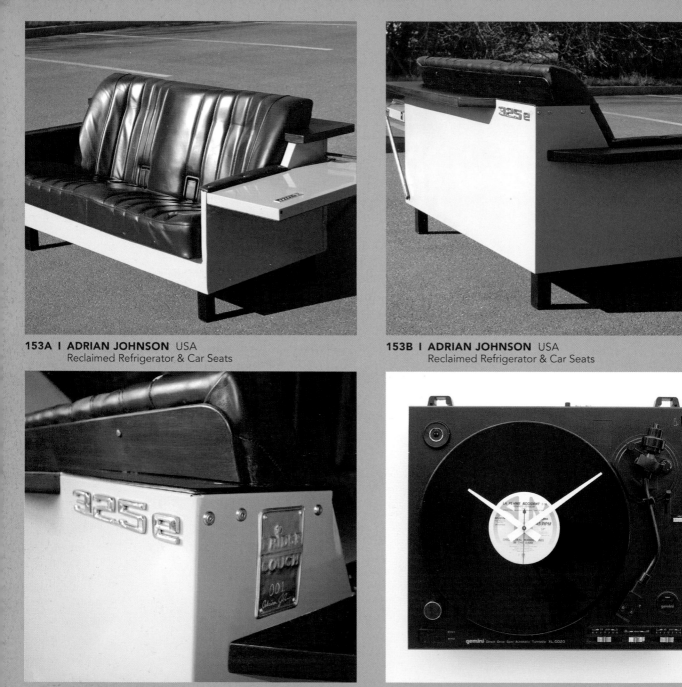

**153A I ADRIAN JOHNSON** USA
Reclaimed Refrigerator & Car Seats

**153B I ADRIAN JOHNSON** USA
Reclaimed Refrigerator & Car Seats

**153C I ADRIAN JOHNSON** USA
Reclaimed Refrigerator & Car Seats

**154 I ALLAN YOUNG** USA Vintage Turntable

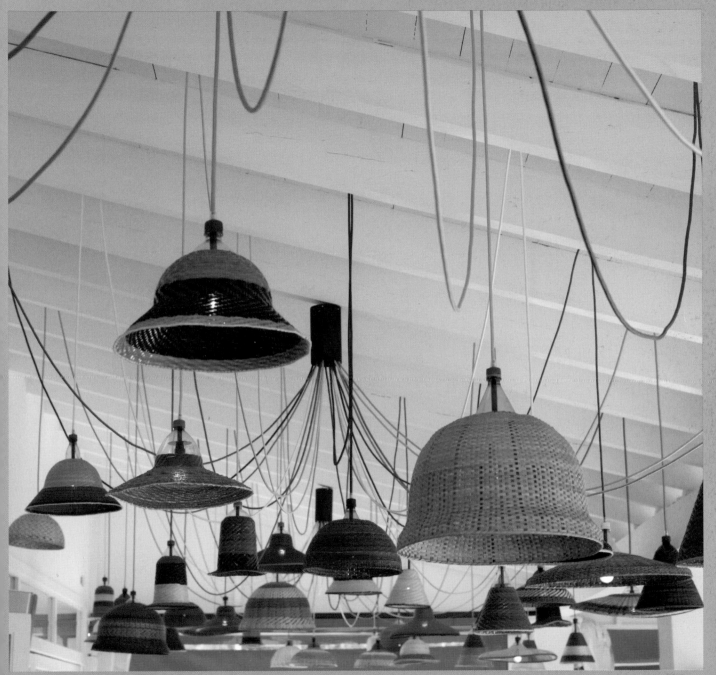

**155 I ALVARO CATALÁN DE OCÓN** SPAIN Plastic Bottles

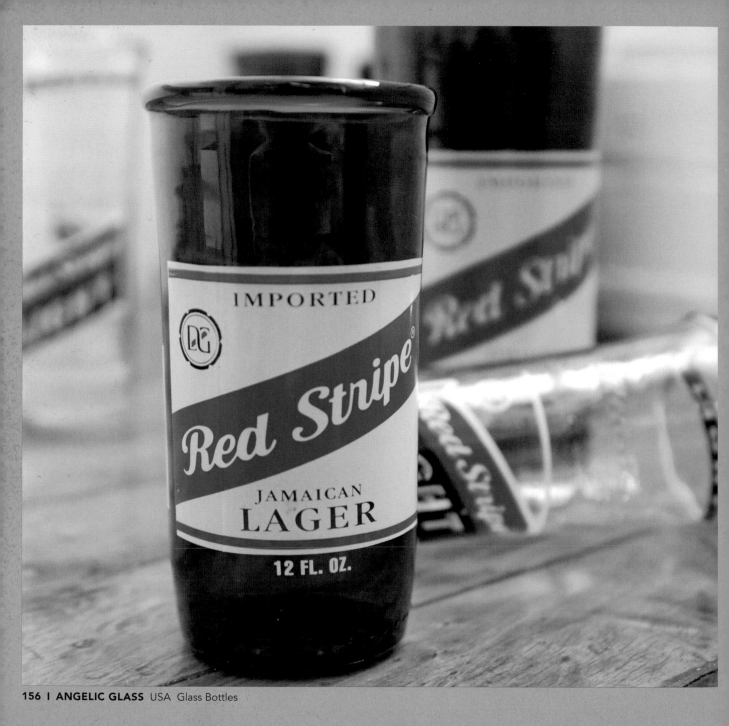

**156 | ANGELIC GLASS** USA Glass Bottles

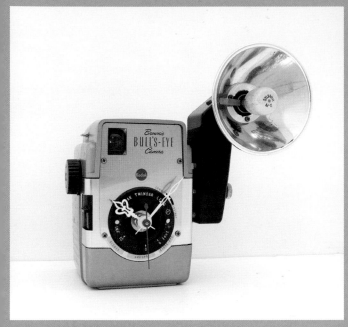

**157 I ALLAN YOUNG** USA Vintage Camera

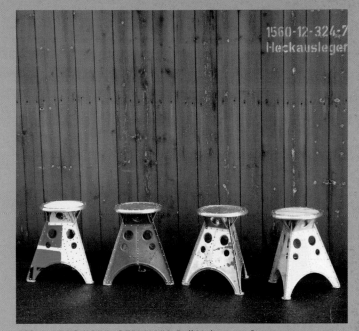

**158 I AERO-1946** GERMANY Bell Helicopter Scraps

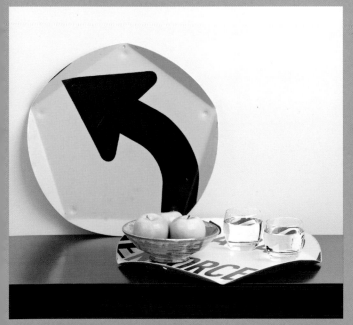

**159 I BORIS BALLY** USA Reclaimed Signs

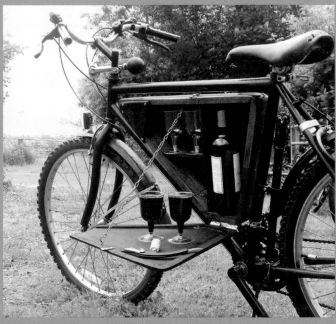

**160 I ALTERIOR DESIGN** UK Bicycle

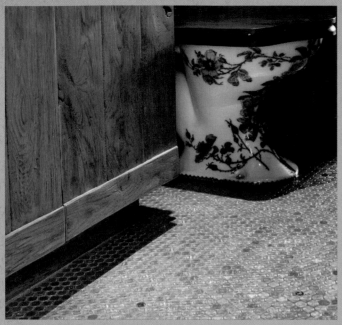

**161A I ALPENTILE** USA Coins

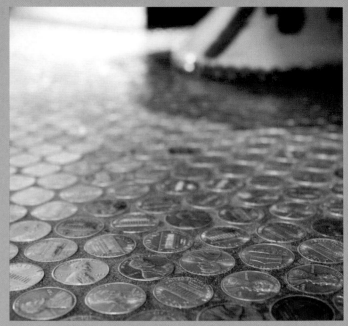

**161B I ALPENTILE** USA Coins

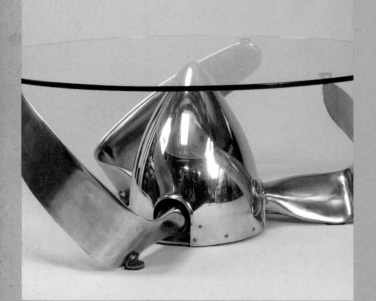

**162 I ARNT ARNTZEN** CANADA Propeller

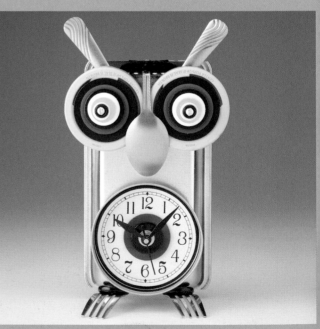

**163 I BOSS BROWN ART** USA Reclaimed Objects

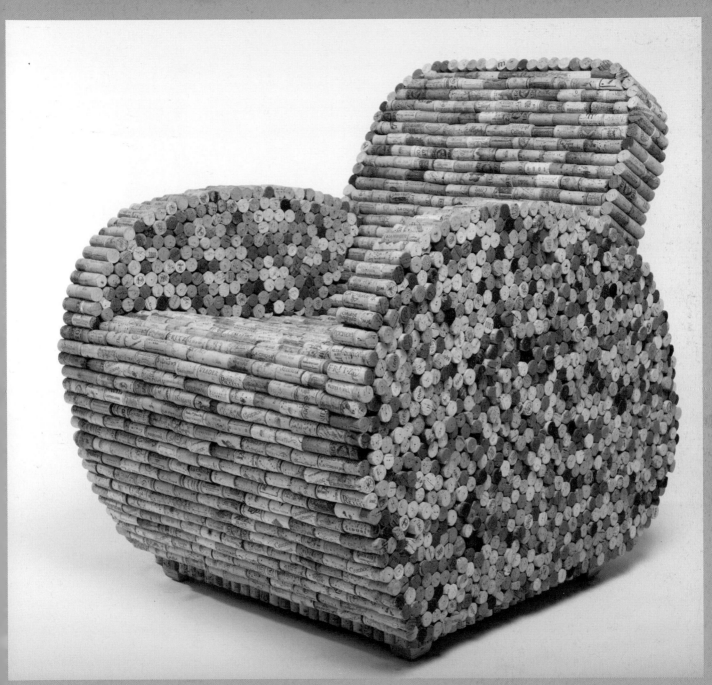

**164 I AARON KRAMER** UK Wine Corks

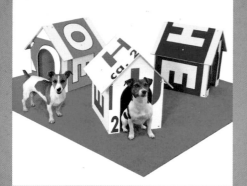

**165 I BOMDESIGN** NETHERLANDS
Reclaimed Billboards

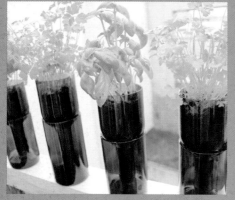

**167 I BUBBADESIGN** GERMANY
Glass Bottles

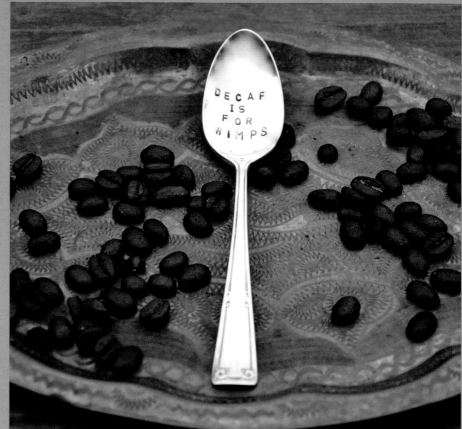

**166 I SYCAMORE HILL** USA Vintage Spoon

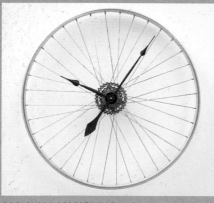

**168 I ALLAN YOUNG** USA Bicycle Rim

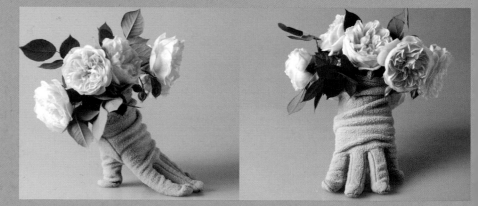

**169 I MARIYA DONSKAYA** ITALY Reclaimed Gloves

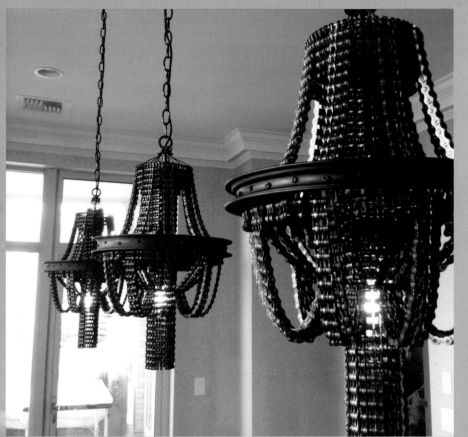

**170 I CAROLINA FONTOURA ALZAGA** USA Bike Chains

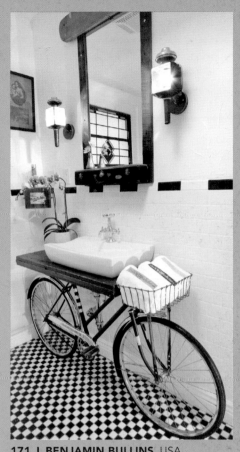

**171 I BENJAMIN BULLINS** USA
Vintage Bicycle

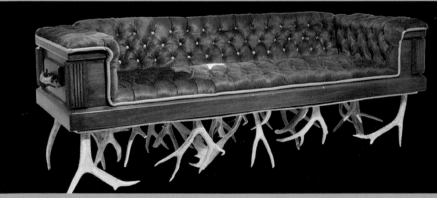

**172 I COFFIN COUCHES** USA Coffin

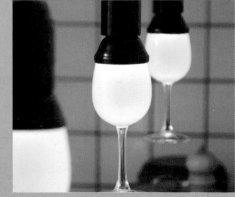

**173 I OOOMS** NETHERLANDS Stemware

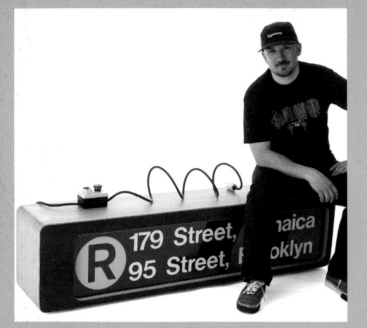

**174 I SEVEN ONE EIGHT DESIGN** USA Reclaimed Subway Sign

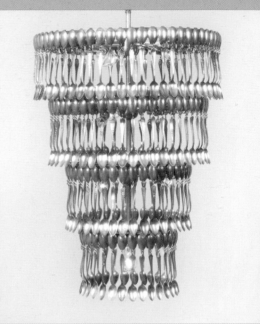

**175 I CAKE VINTAGE** USA Spoons

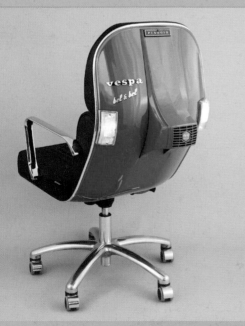

**176 I BEL&BEL** SPAIN Vespa

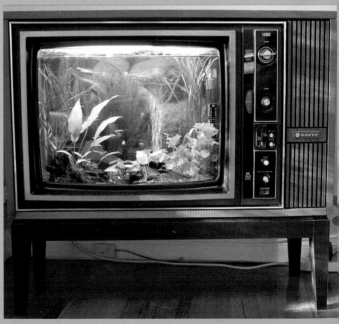

**177 I MICHAEL KHOR** AUSTRALIA Vintage Television

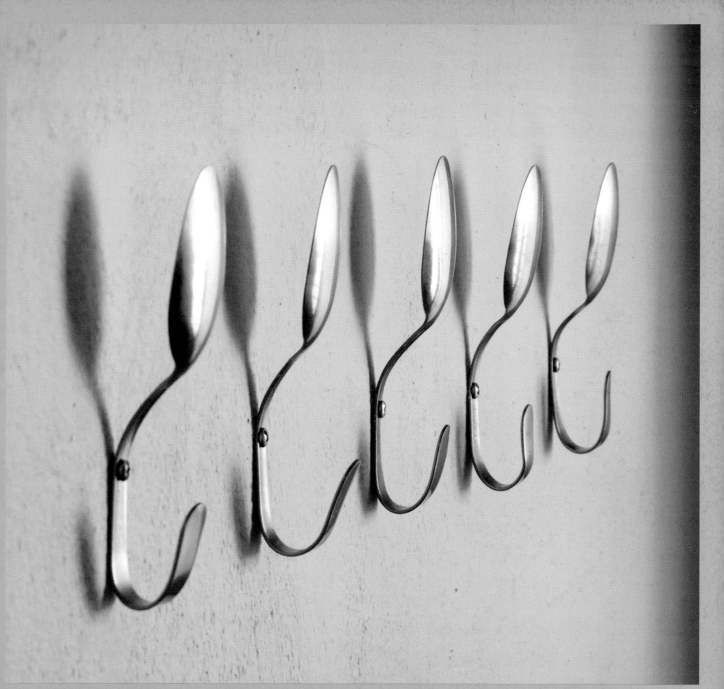

**178 I AMA RYLLIS** MEXICO  Spoons

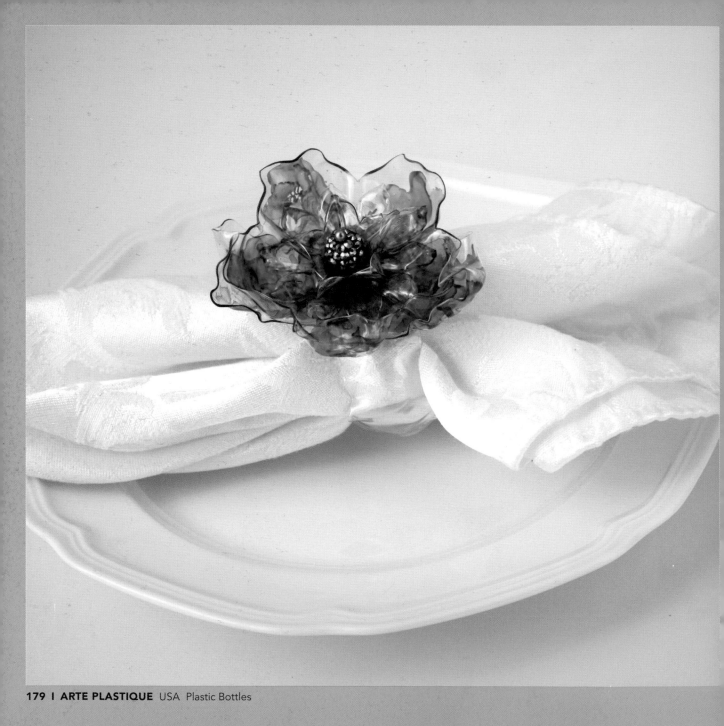

**179 I ARTE PLASTIQUE** USA  Plastic Bottles

**ART** WITHOUT **WASTE I** 500 UPCYCLED & EARTH-FRIENDLY DESIGNS

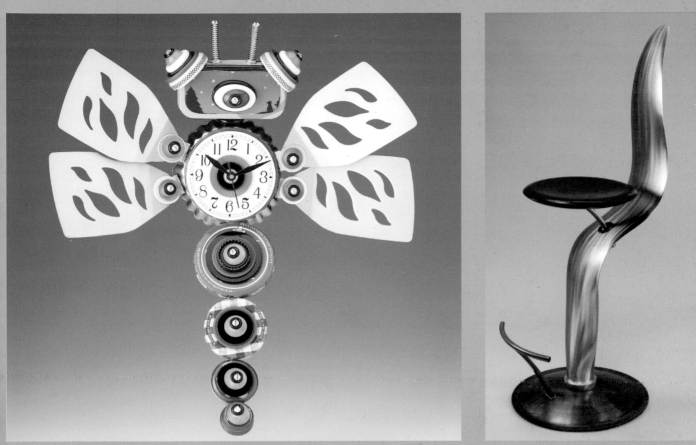

**180 I BOSS BROWN ART** USA Reclaimed Objects

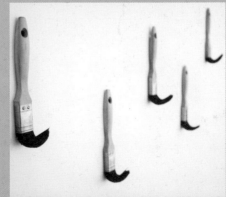

**181 I ARNT ARNTZEN** CANADA
Propeller

**182 I HUGH HAYDEN** USA
Tennis Balls

**183 I MICHAEL HANNAFORD** UK
Glass Bottles

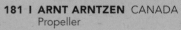

**184 I DOMINIC WILCOX** UK
Paintbrushes

**185A I BOMDESIGN** NETHERLANDS Reclaimed Book

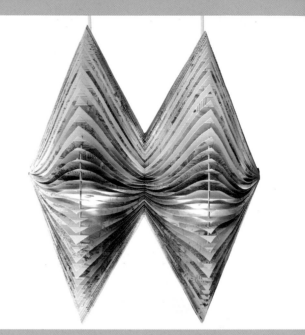

**185B I BOMDESIGN** NETHERLANDS Reclaimed Book

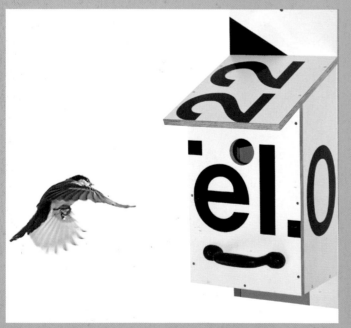

**186 I BOMDESIGN** NETHERLANDS Reclaimed Billboards

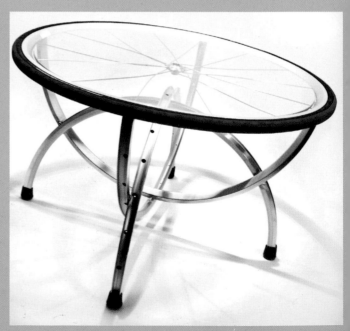

**187 I BIKE FURNITURE DESIGN** USA Bicycle Rims & Tires

**ART** WITHOUT **WASTE I** 500 UPCYCLED & EARTH-FRIENDLY DESIGNS

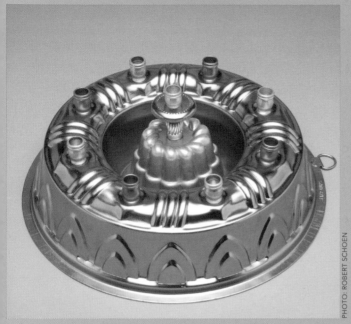

PHOTO: ROBERT SCHOEN

**188 I FRAN ADDISON** USA Copper Jello Mold

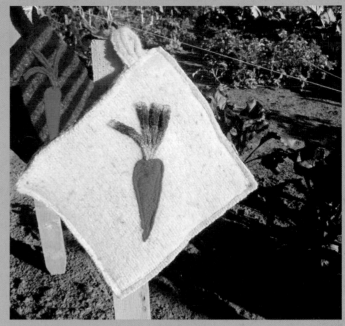

**189 I FAT TOMATO DESIGNS** USA Felted Wool

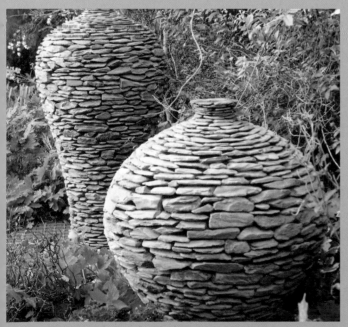

**190 I IVEL STONEWARE DESIGNS** UK Stones

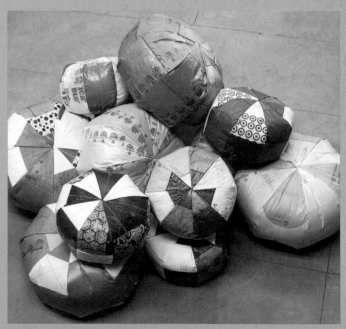

**191 I CAROL SOGARD** USA Plastic Bags

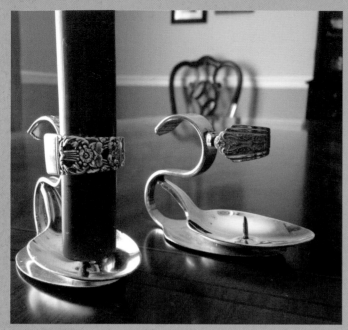

**192 I SPOONMAN CREATIONS** USA Vintage Spoon

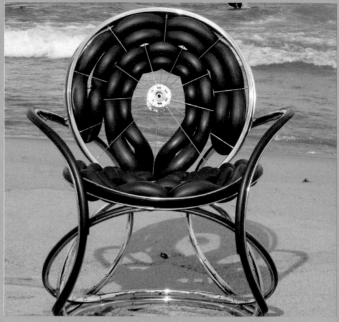

**193 I BIKE FURNITURE DESIGN** USA Bicycle Rims & Inner Tubes

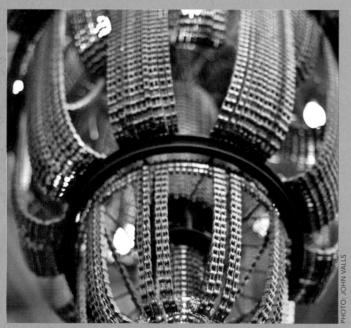

**194 I CAROLINA FONTOURA ALZAGA** USA Bike Chains

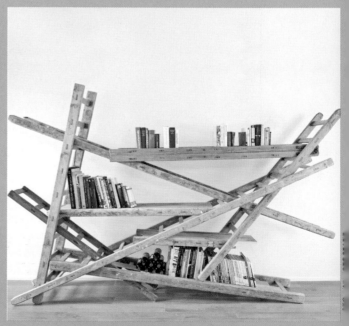

PHOTO: JOHN VALLS

**195 I CHRIS RUHE** NETHERLANDS Ladders

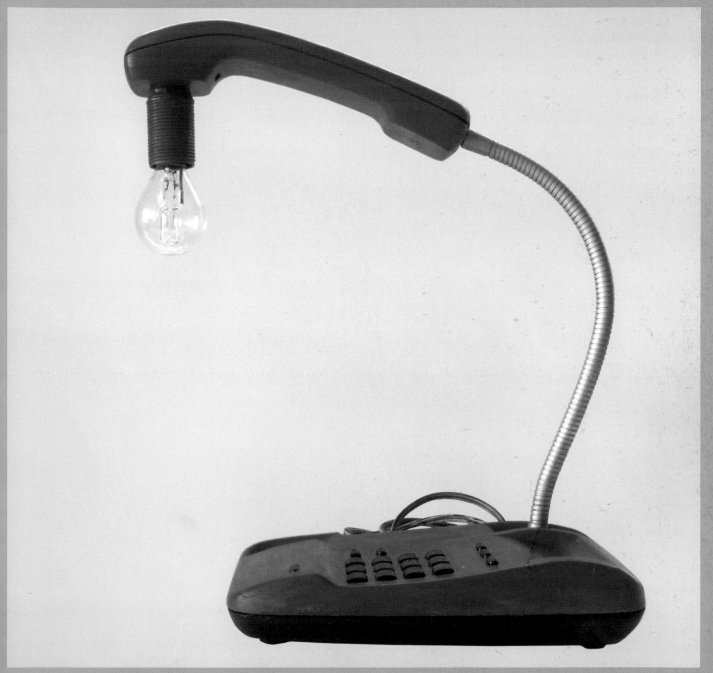

**196 I ECODESIGNEUREKA** ITALY  Vintage Telephone

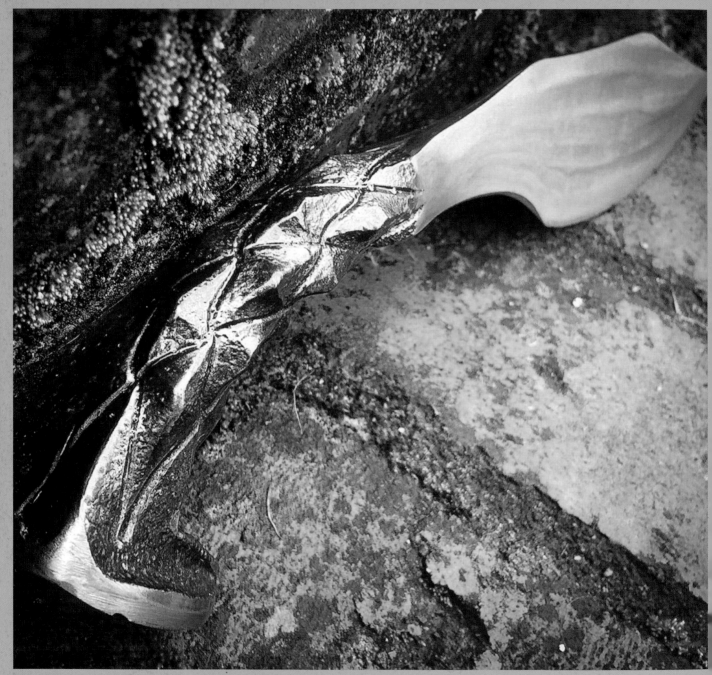

**197 I CINESCAPE STUDIOS** USA  Railroad Spike

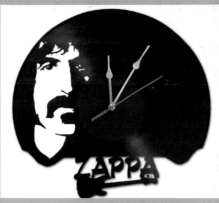

**199 I GEORGE TZAFOLIAS** GREECE
Vinyl Records

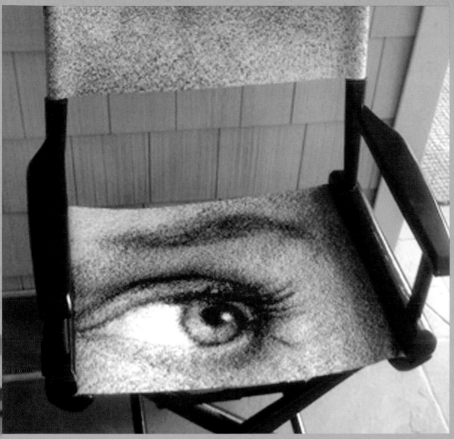

**198 I DOREEN CATENA** USA Reclaimed Billboards

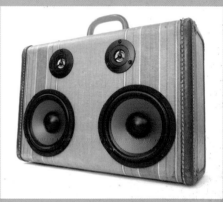

**200 I THE BOOMCASE** USA
Vintage Suitcases

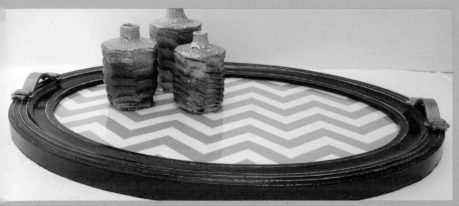

**201 I DSTRESSED** USA Frame

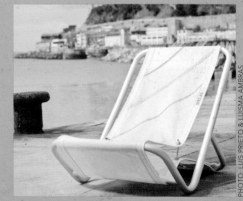

**202 I DVELAS** SPAIN Reclaimed Sails

PHOTO: LUIS PRIETO & LUISMA AMBRAS

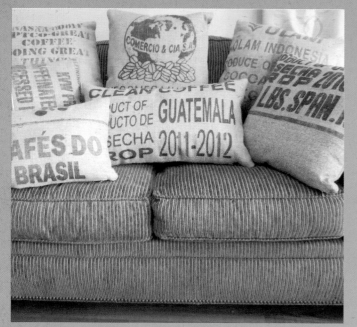

**203 I BACK ALLEY CHIC** USA Reclaimed Burlap

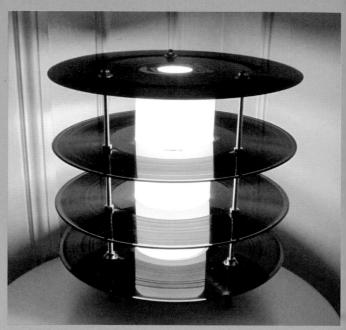

**204 I GENANVENDT** DENMARK Vinyl Records

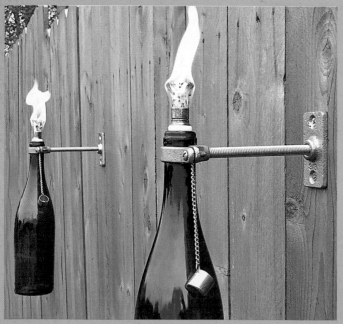

**205 I GREAT BOTTLES OF FIRE** USA Glass Bottles

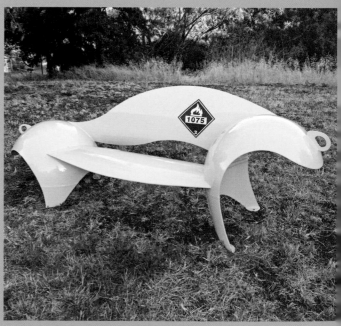

**206 I COLIN SELIG** USA Propane Tank

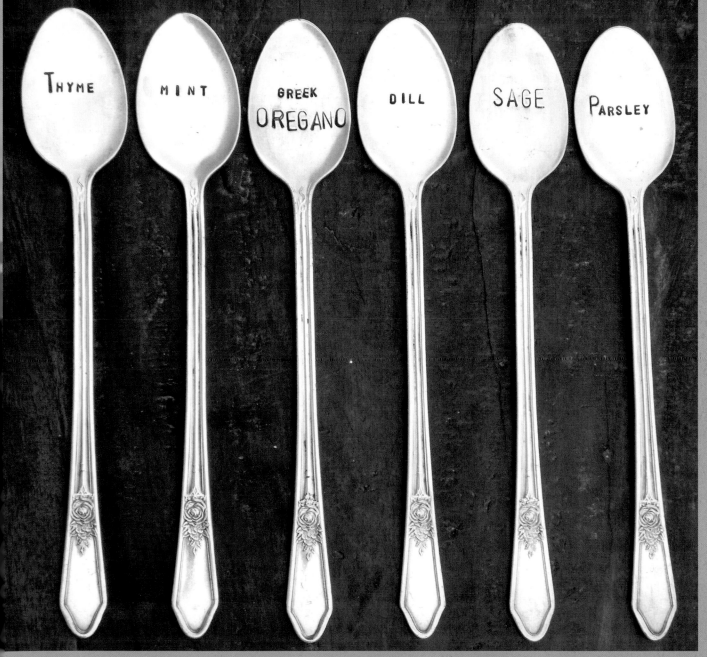

207 I **SYCAMORE HILL** USA Vintage Spoons

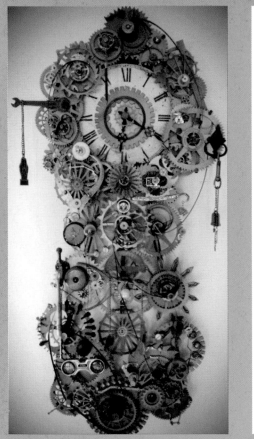

**208 I ERIN KECK** USA Reclaimed Objects

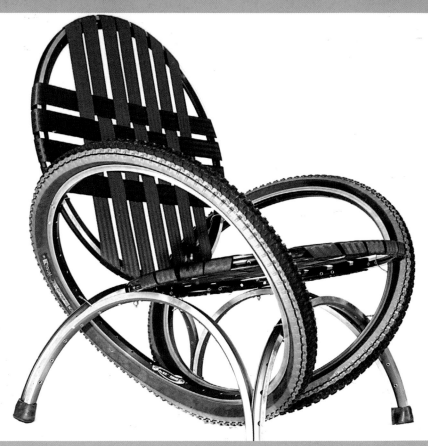

**209 I BIKE FURNITURE DESIGN** USA Bicycle Rims & Tires

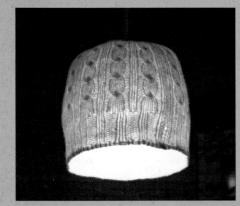

**210 I MARIYA DONSKAYA** ITALY
Reclaimed Winter Hat

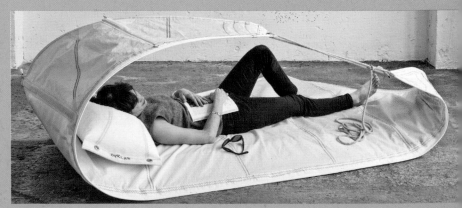

**211 I DVELAS** SPAIN Reclaimed Sails

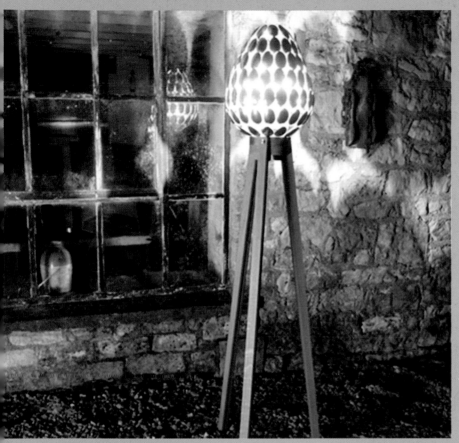

**212 I CLIVE RODDY** UK Spoons

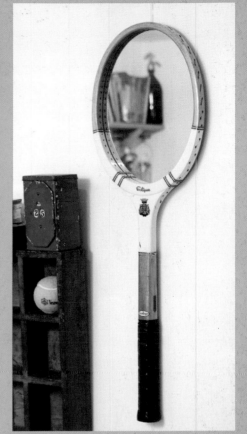

**213 I DEE PUDDY** UK
Vintage Tennis Racket

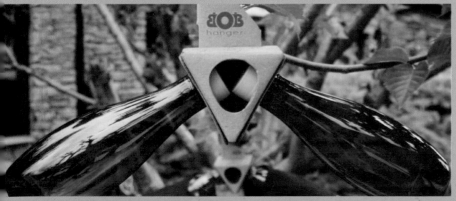

**214 I JOAN NADAL** FRANCE Bottles

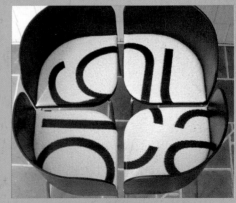

**215 I DOREEN CATENA** USA
Reclaimed Billboards

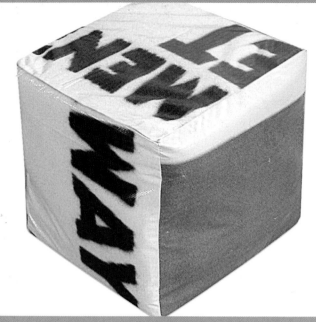

**216 I GG2G** USA Reclaimed Billboards

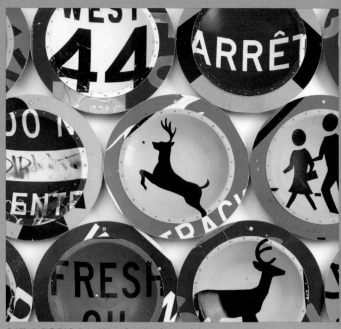

**217 I BORIS BALLY** USA Reclaimed Signs

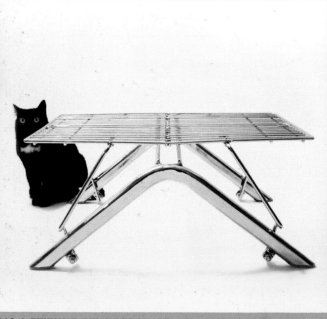

**218 I ETIENNE REIJNDERS** NETHERLANDS Shopping Cart

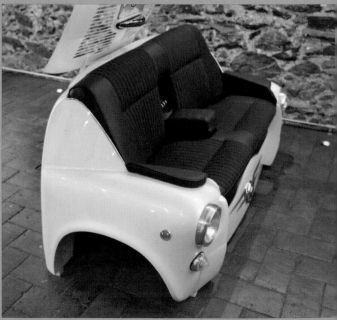

**219 I BEL&BEL** SPAIN Fiat 600 Model D

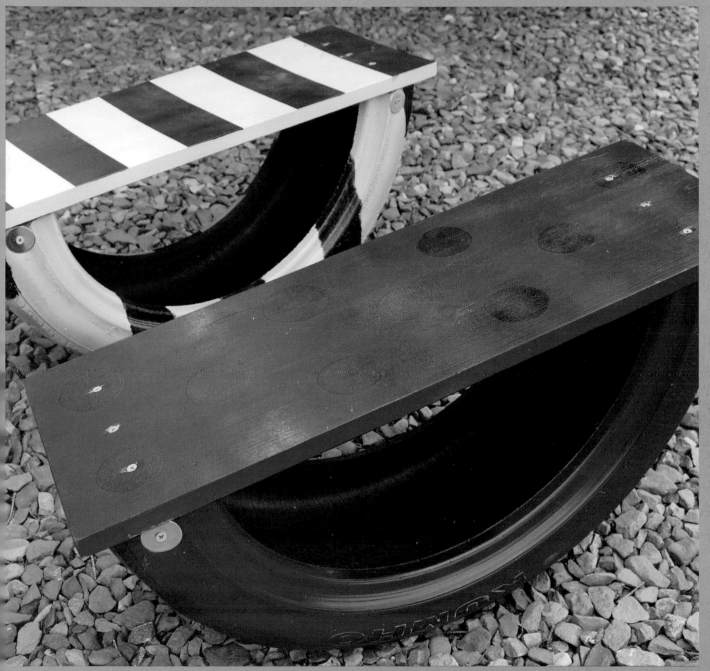

**220 I EMILY BOYLE** USA Reclaimed Car Tires & Lumber

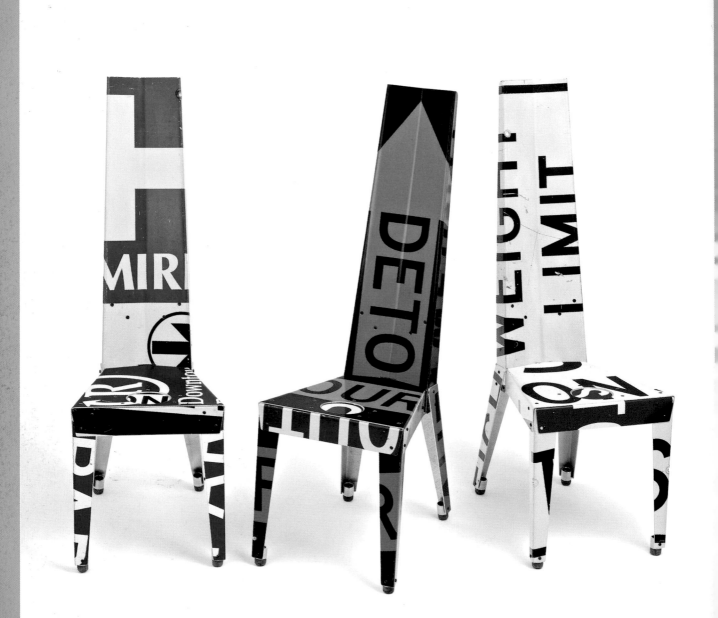

**221 I BORIS BALLY** USA Reclaimed Signs

**ART** WITHOUT **WASTE I** 500 UPCYCLED & EARTH-FRIENDLY DESIGNS

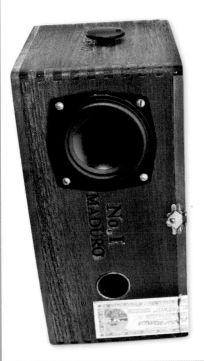
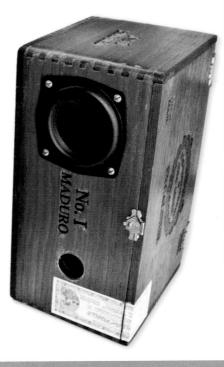

**222 I GOOD DEED AUDIO** USA Reclaimed Cigar Boxes

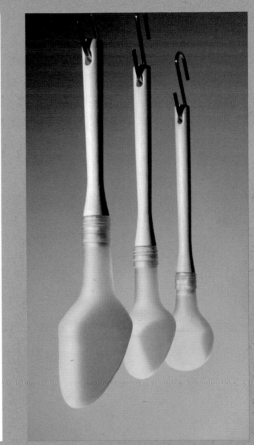

**223 I MICHAEL HANNAFORD** UK
Glass Bottles

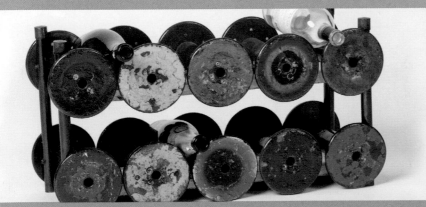

**224 I CAKE VINTAGE** USA Vintage Spools

PHOTO: JAMIE WRIGHT

**225 I DOREEN CATENA** USA
Reclaimed Billboards

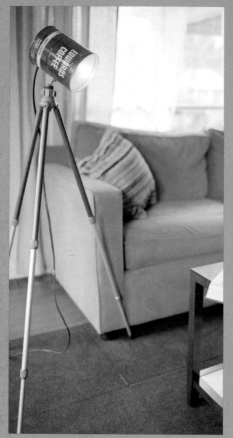

**226 I SPACEBARN** USA
Reclaimed Tin Can

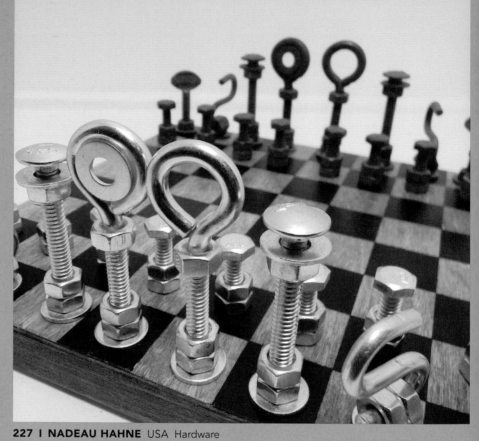

**227 I NADEAU HAHNE** USA Hardware

**228 I COFFIN COUCHES** USA Coffin

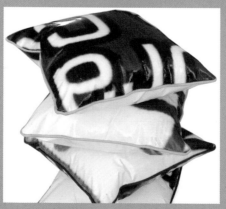

**229 I GG2G** USA Reclaimed Billboards

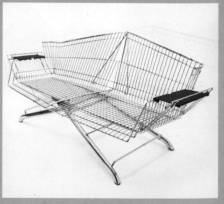

**230 I ETIENNE REIJNDERS**
NETHERLANDS Shopping Cart

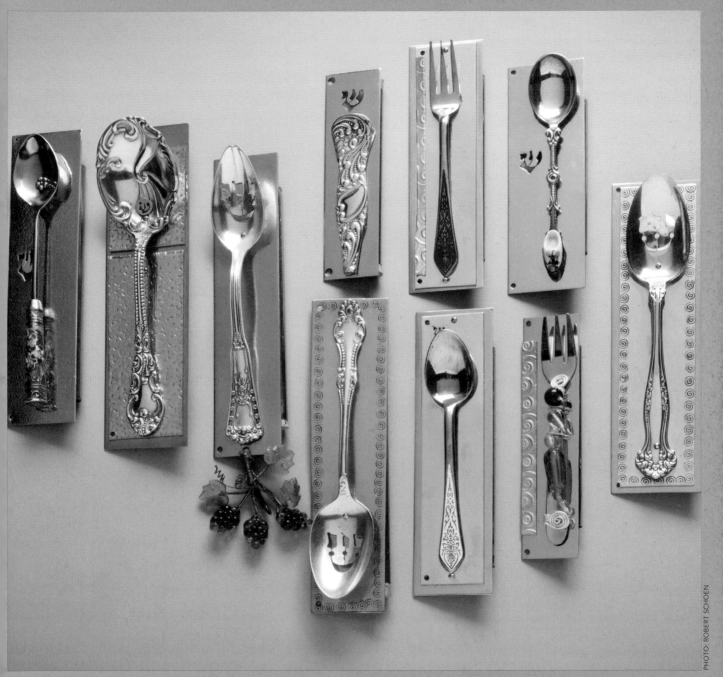

**231 I FRAN ADDISON** USA Assorted Silverware

PHOTO: ROBERT SCHOEN

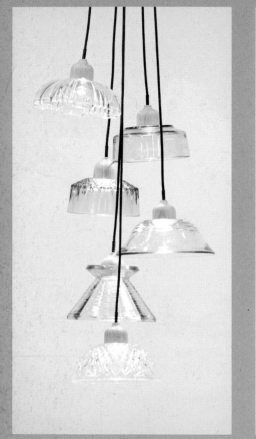

**232 I JAY WATSON DESIGN** UK
Vintage Dishes

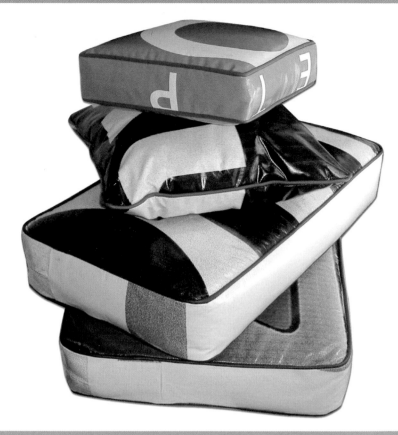

**233 I GG2G** USA Reclaimed Billboards

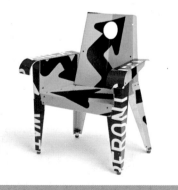

**234 I BORIS BALLY** USA Reclaimed Signs

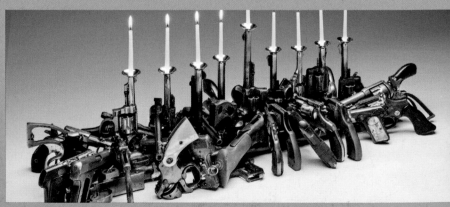

**235 I BORIS BALLY** USA Reclaimed Guns

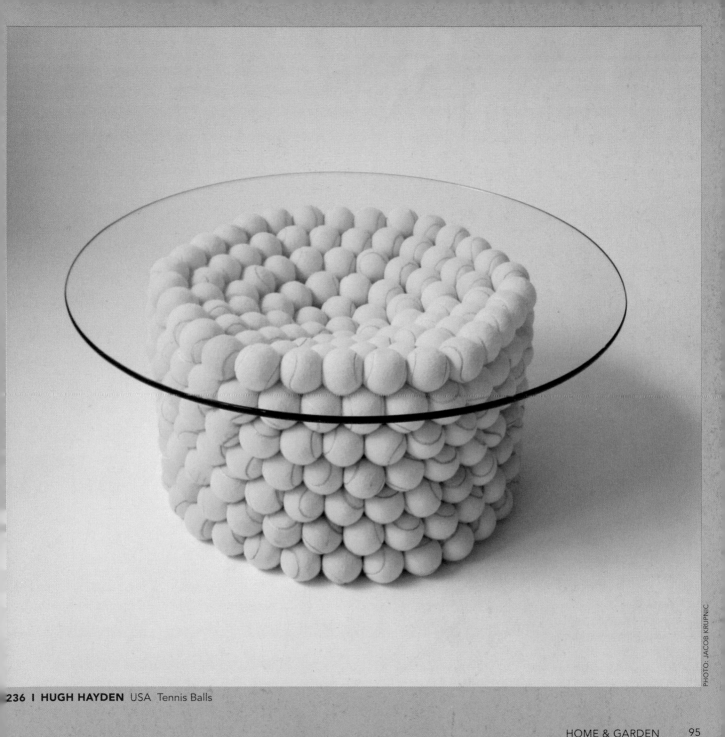

**236 I HUGH HAYDEN** USA  Tennis Balls

PHOTO: JACOB KRUPNIC

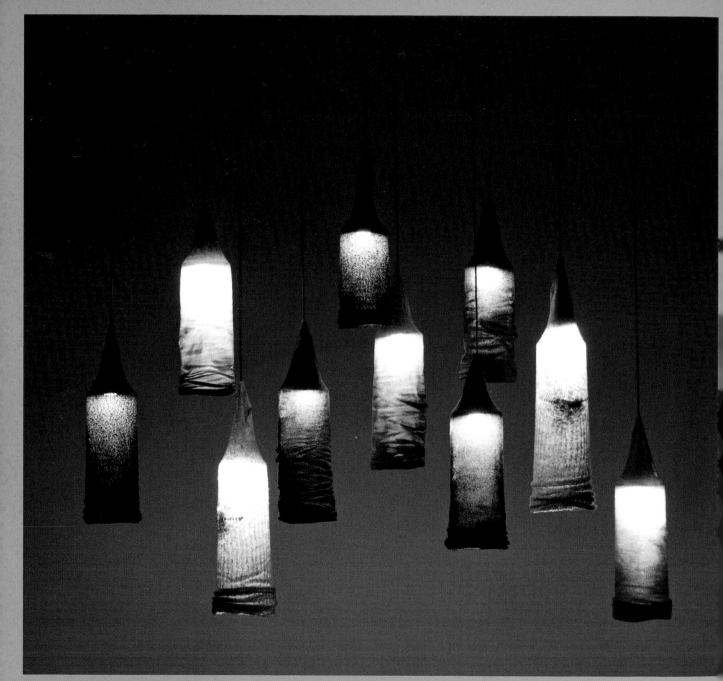

**237 I JAY WATSON DESIGN** UK  Socks

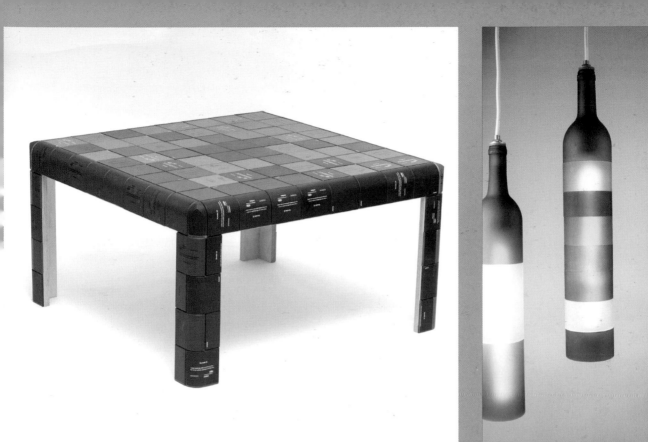

**238 I JAY WATSON DESIGN** USA  Corian Samples

**239 I JERRY KOTT** USA  Glass Bottles

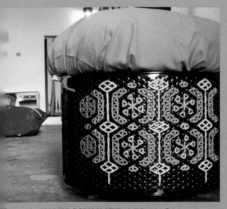

**240 I JUNK MUNKEZ** LEBANON
Reclaimed Washing Machine Drum

**241 I REIGRUCHE STUDIO** USA
Vintage Tin Boxes

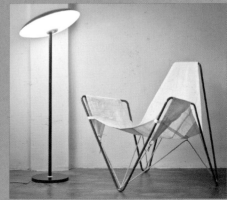

**242 I DVELAS** SPAIN  Reclaimed Sails

PHOTO: LUIS PRIETO & LUISMA AMBRAS

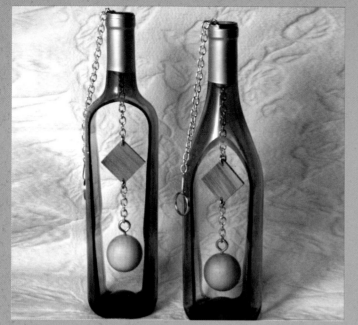

**243 I GROOVY GREEN GLASS** USA Glass Bottles

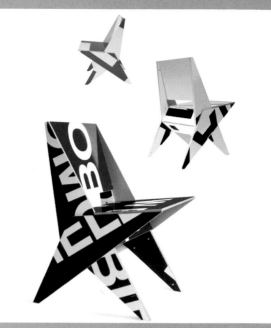

**244 I BOMDESIGN** NETHERLANDS Reclaimed Billboards

**245 I KATE FISHER** USA Bicycle Inner Tube

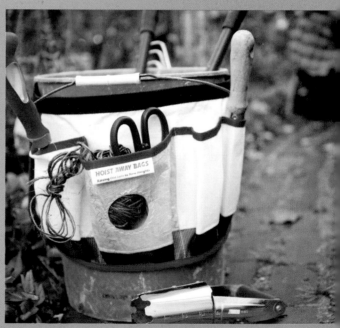

**246 I HOIST AWAY BAGS** USA Reclaimed Sails

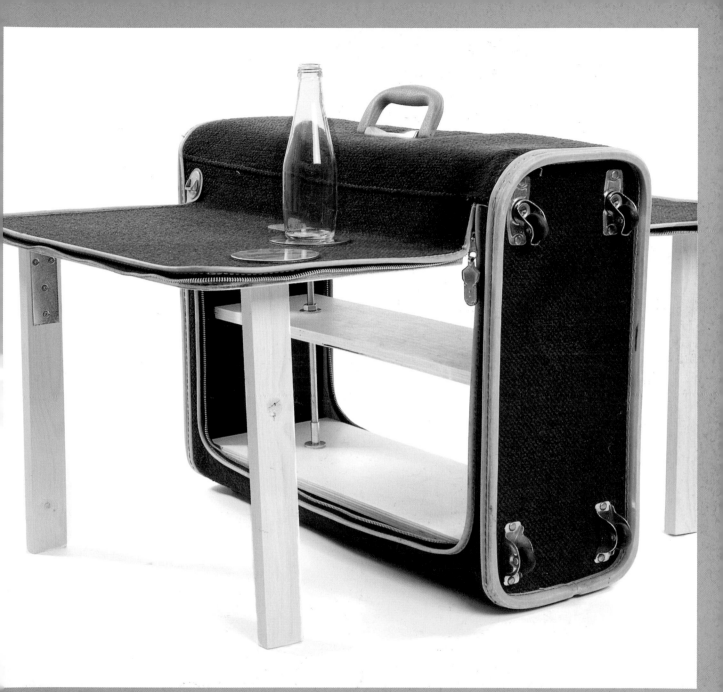

**247 I JUNKTION** ISRAEL Vintage Suitcase

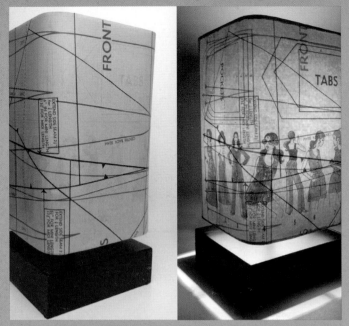

**248 I PATTURN STUDIO** AUSTRALIA Vintage Sewing Patterns

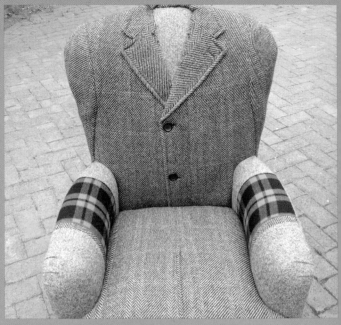

**249 I RESCUEDRETROVINTAGE** UK Club Chair

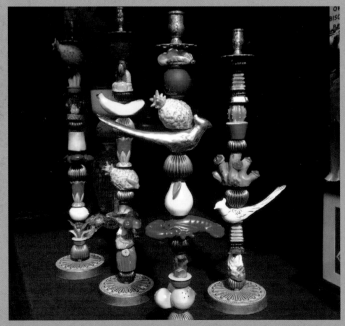

**250A I PRIMITIVE TWIG** USA Vintage Salt & Pepper Shakers

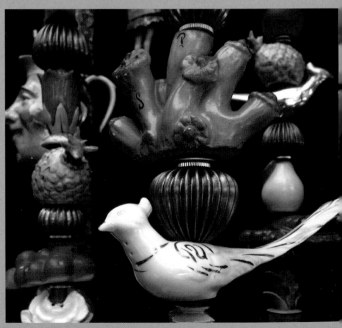

**250B I PRIMITIVE TWIG** USA Vintage Salt & Pepper Shakers

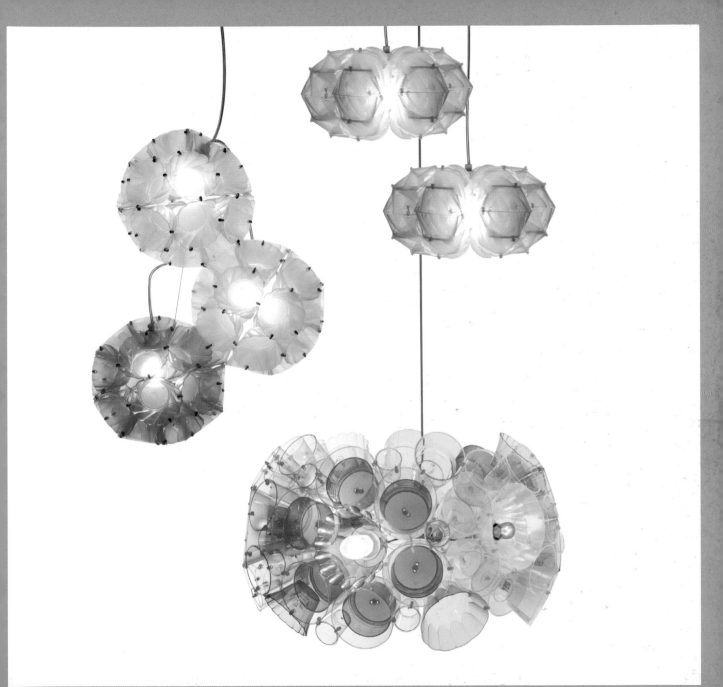

**251 I MEIKE HARDE** GERMANY Plastic Cups

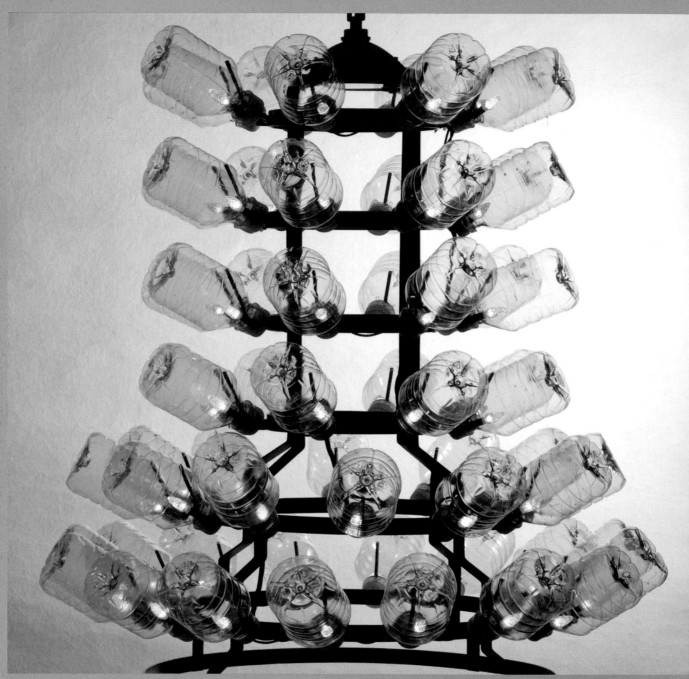

**252 | KAREN HACKENBERG** USA  Plastic Bottles

**ART** WITHOUT **WASTE I** 500 UPCYCLED & EARTH-FRIENDLY DESIGNS

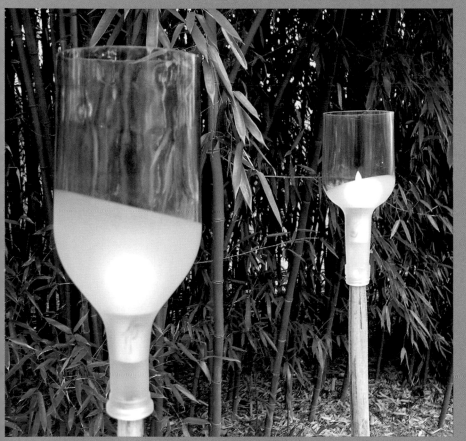

**253 I JERRY KOTT** USA Glass Bottles

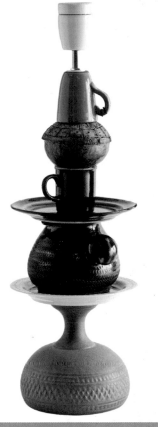

**254 I ODDBIRDS** SWEDEN
Vintage Ceramic Ware

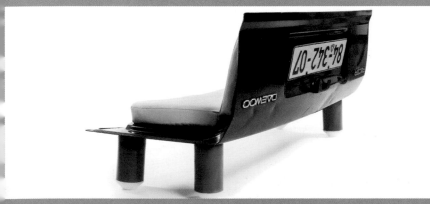

**255 I JUNKTION** ISRAEL Reclaimed Car Trunk

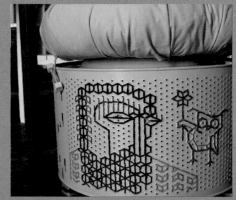

**256 I JUNK MUNKEZ** LEBANON
Reclaimed Washing Machine Drum

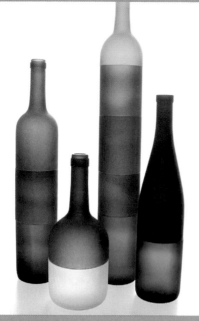

**257 I JERRY KOTT** USA Assorted Glass Bottles

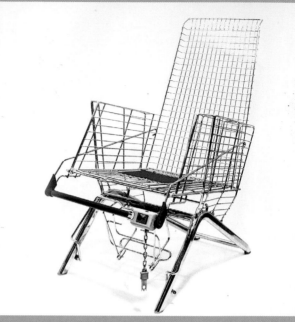

**258 I ETIENNE REIJNDERS** NETHERLANDS Shopping Cart

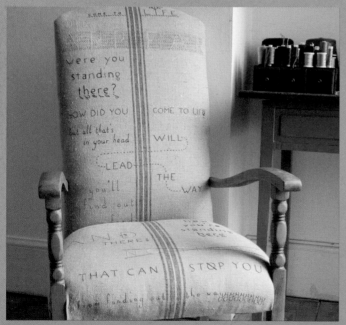

**259A I SALLY NENCINI** UK Reclaimed Chair

**259B I SALLY NENCINI** UK Reclaimed Chair

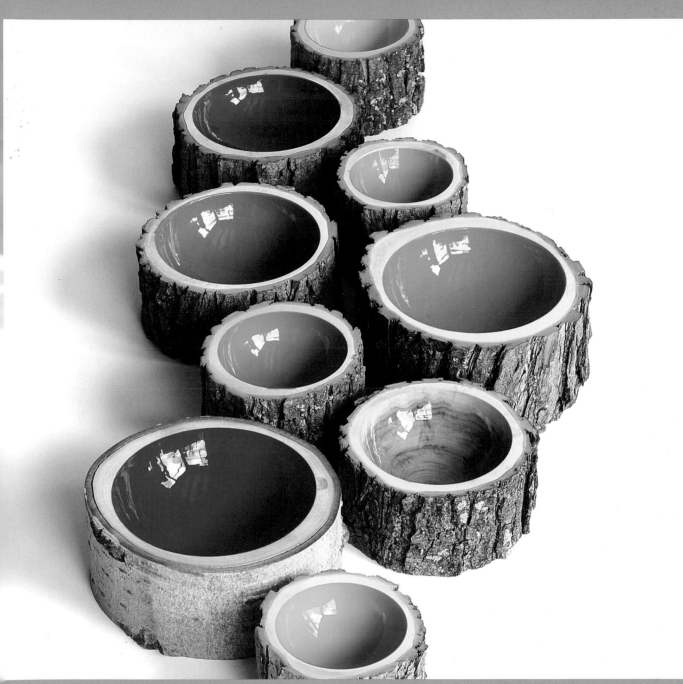

**260 | LOYAL LOOT** CANADA Reclaimed Logs

PHOTO: WEAREALLCONNECT.COM

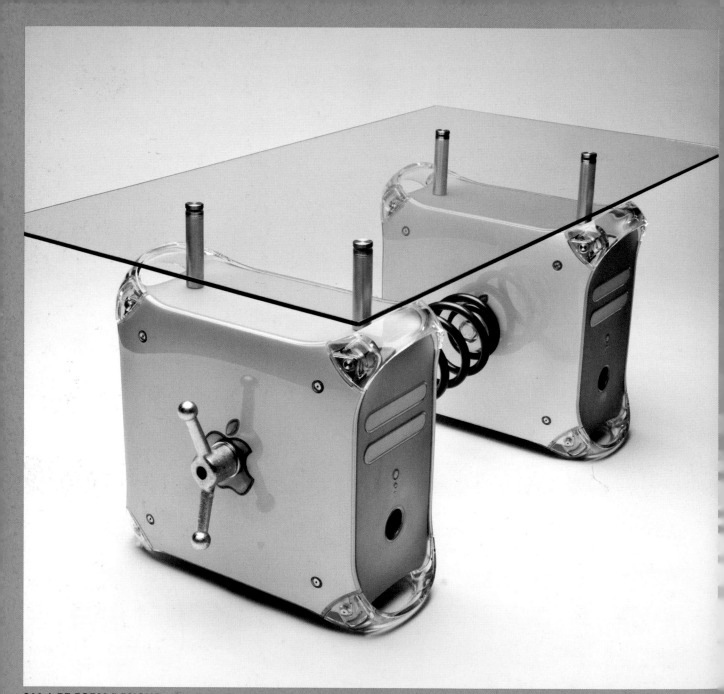

**261 I RE:FORM DESIGNS** USA Computer Desktop

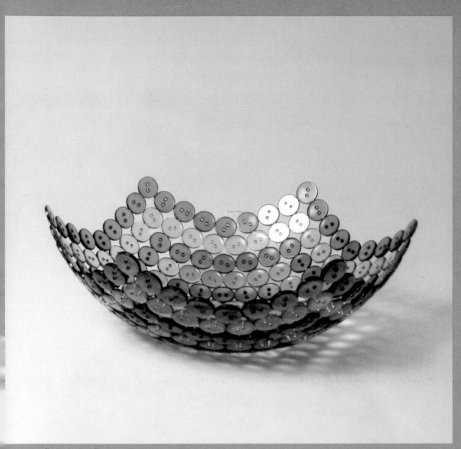

**262 I IÑIGO CAÑEDO** MEXICO Buttons

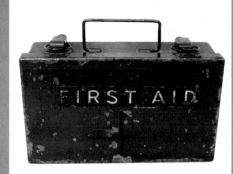

**263A I THE BOOMCASE** USA
Vintage Military First Aid Box

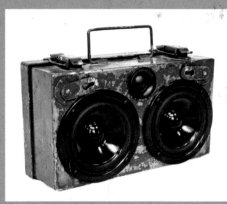

**263B I THE BOOMCASE** USA
Vintage Military First Aid Box

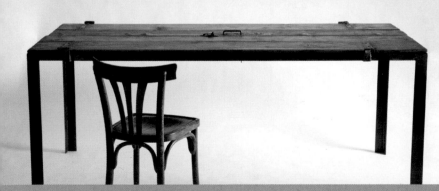

**264A I MANOTECA** ITALY Vintage Door

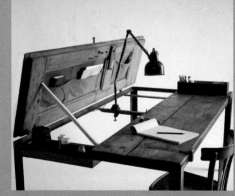

**264B I MANOTECA** ITALY Vintage Door

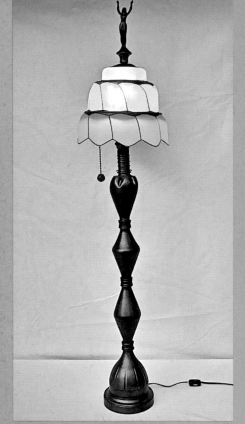

**265 I NED HOBGOOD** USA
Plastic Bottles, Jars & Bowls

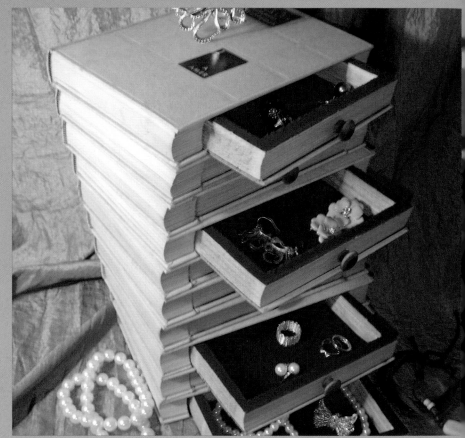

**266 I MR. FOX PRODUCTIONS** USA Reclaimed Books

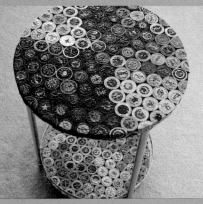

**267A I MATT LEBEAU** USA
Beer Bottle Caps

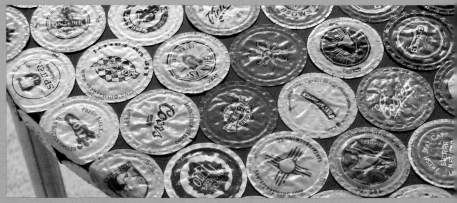

**267B I MATT LEBEAU** USA Beer Bottle Caps

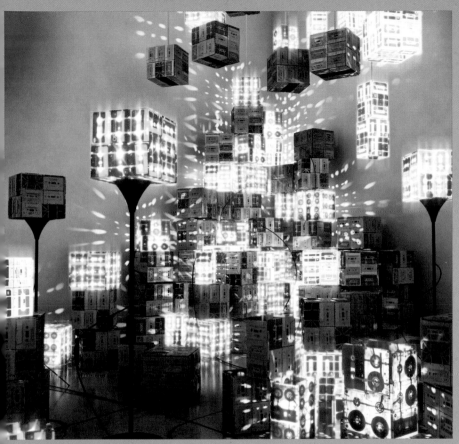

268 I OOO MY DESIGN SPAIN Cassette Tape

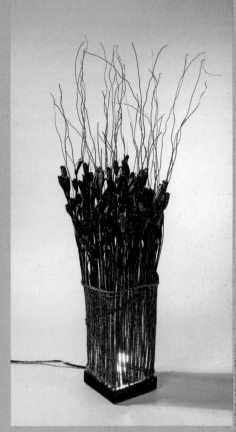

269 I MELANIE THOMPSON CANADA
Seed Pod Plant

PHOTO: GRANT KEENAN

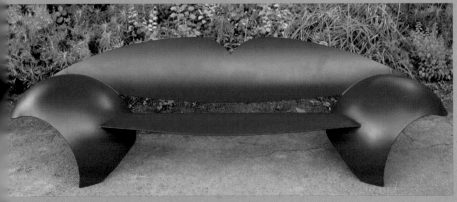

270 I COLIN SELIG USA Propane Tank

271 I LA FIRME CANADA Propane Tank

PHOTO: MARIE-ELAINE BENOIT & JEAN NICOL

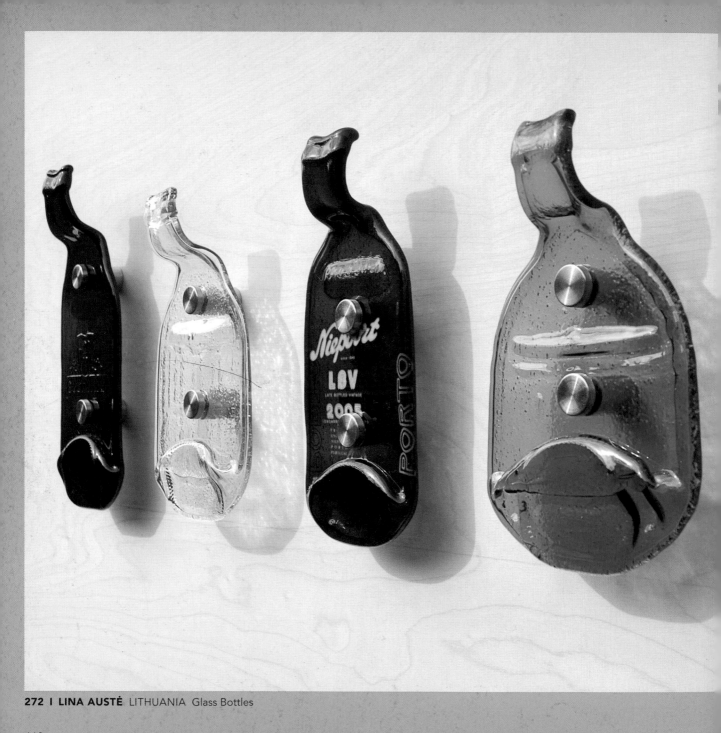

**272 I LINA AUSTÈ** LITHUANIA Glass Bottles

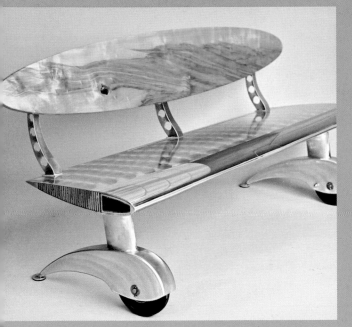

**273 | ARNT ARNTZEN** CANADA Reclaimed Airplane Wing

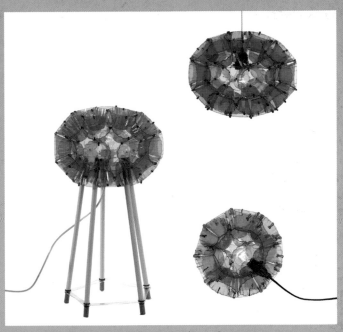

**274 | MEIKE HARDE** GERMANY Plastic Cups

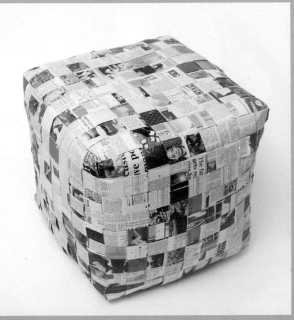

**275 | JAY WATSON DESIGN** UK Newspaper

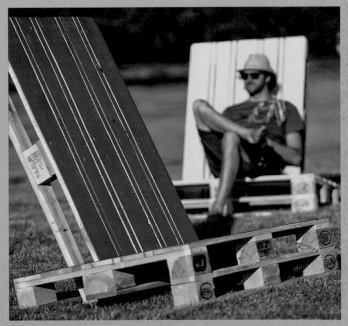

**276 | PALETTENMOEBEL** AUSTRIA Discarded Pallettes

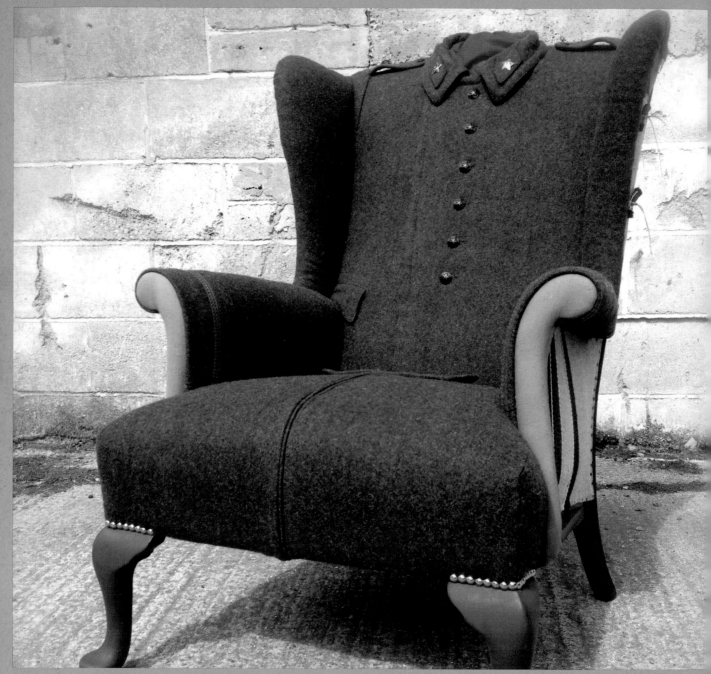

**277A I RESCUEDRETROVINTAGE** UK Club Chair

**ART** WITHOUT **WASTE I** 500 UPCYCLED & EARTH-FRIENDLY DESIGNS

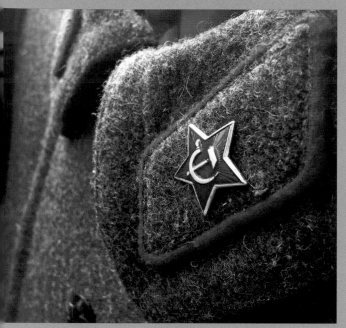

**277B I RESCUEDRETROVINTAGE** UK  Club Chair

**278 I PATTURN STUDIO** AUSTRALIA  Vintage Sewing Patterns

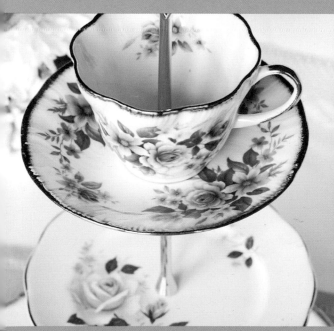

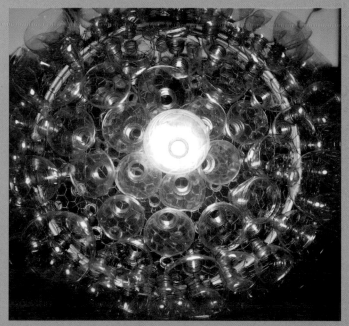

**279 I RACHEL BAKER** UK  Vintage Ceramic Plates & Cup

**280 I ORGANELLE DESIGN** USA  Plastic Bottles

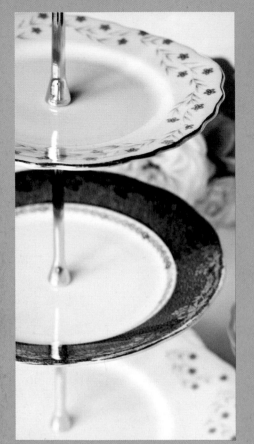

**281 I RACHEL BAKER** UK
Vintage Ceramic Plates

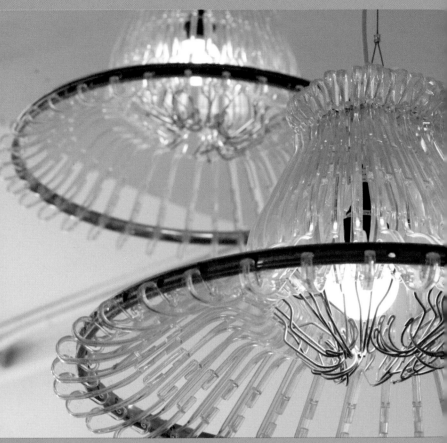

**282 I ORGANELLE DESIGN** USA Plastic Hangers, Bike Rim

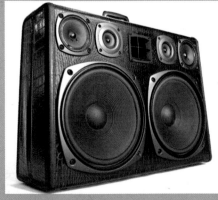

**283 I THE BOOMCASE** USA
Vintage Suitcase

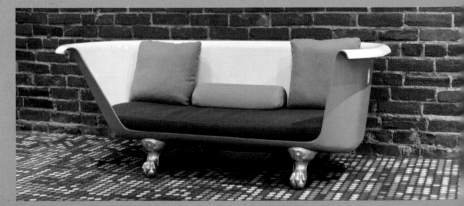

**284 I REDUX TUBS** CANADA Vintage Iron Tubs

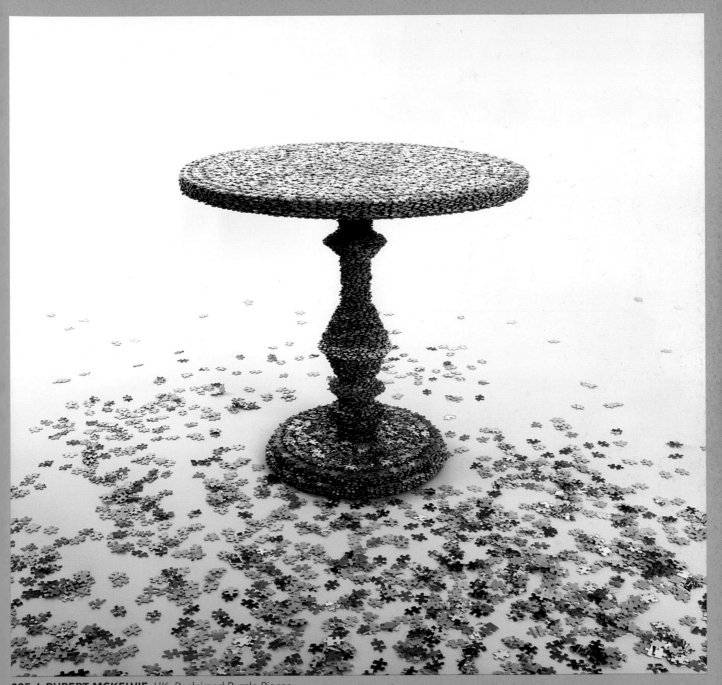

**285 I RUPERT MCKELVIE** UK Reclaimed Puzzle Pieces

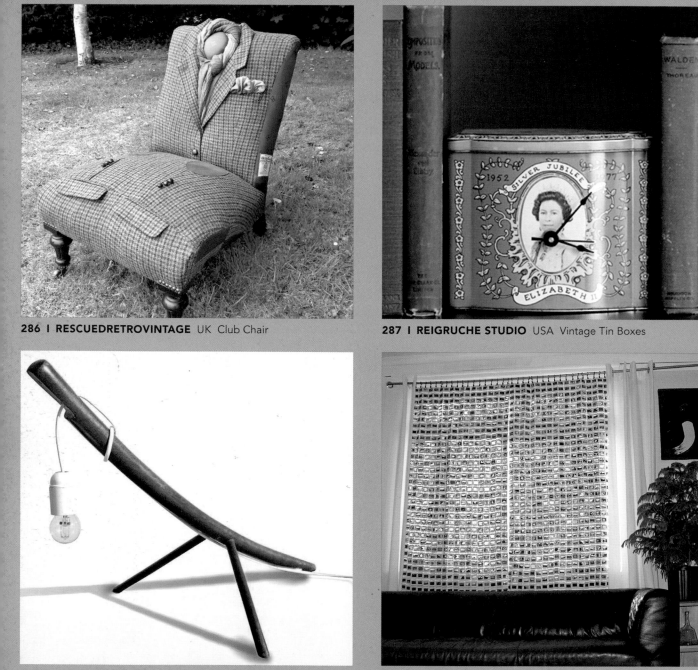

**286 I RESCUEDRETROVINTAGE** UK  Club Chair

**287 I REIGRUCHE STUDIO** USA  Vintage Tin Boxes

**288 I SILVIA RAMALLI** ITALY  Reclaimed Chair Parts

**289 I SCOTT SHERWOOD** USA  35-mm Transparencies

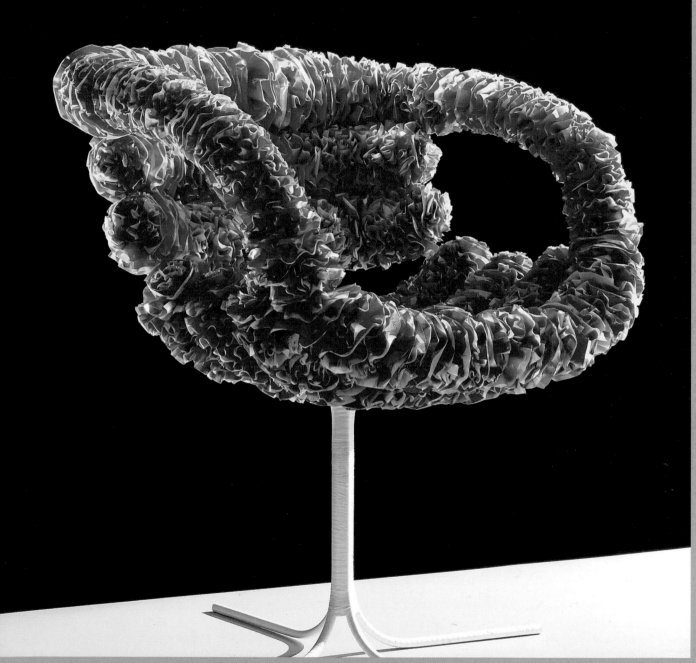

**290 I RYAN FRANK** SPAIN  Reclaimed Plastic Bags

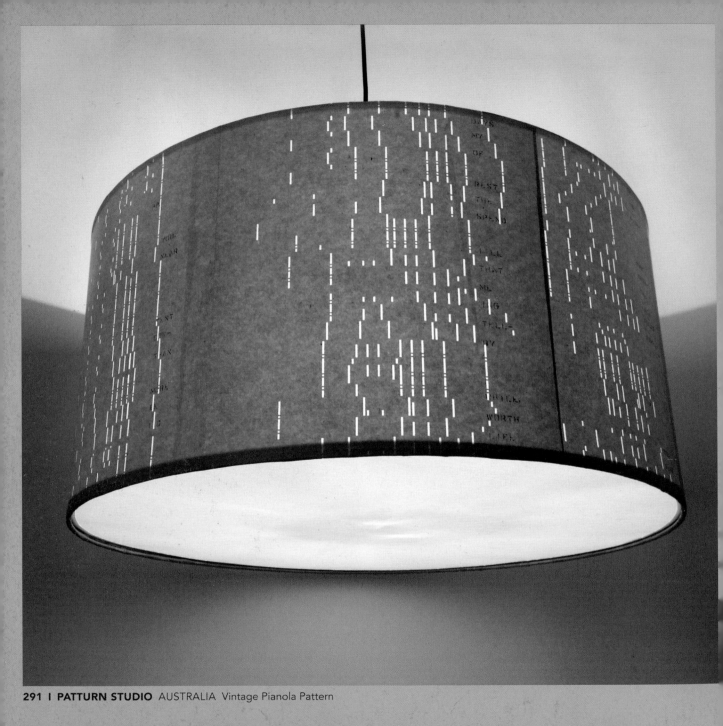

**291 I PATTURN STUDIO** AUSTRALIA Vintage Pianola Pattern

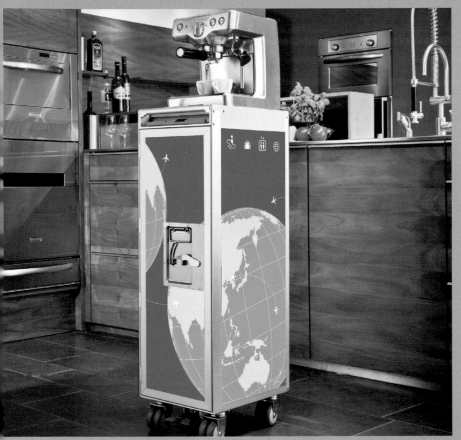

**292A I SKYPAK** DENMARK Airplane Trolly

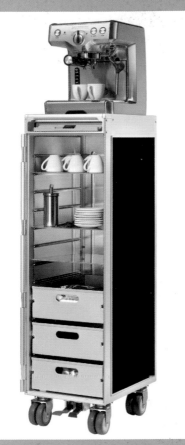

**292B I SKYPAK** DENMARK Airplane Trolly

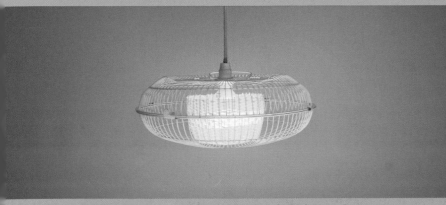

**293 I SEP VERBOOM** BELGIUM Reclaimed Fan & Industrial Waste Strips

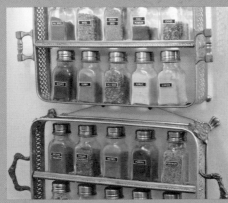

**294 I NITA STACY** USA Silver Tray

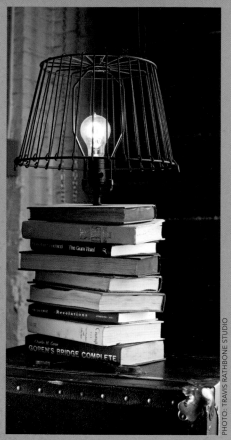

PHOTO: TRAVIS RATHBONE STUDIO

**295 I DANIEL GRADY FAIRES** USA
Reclaimed Books

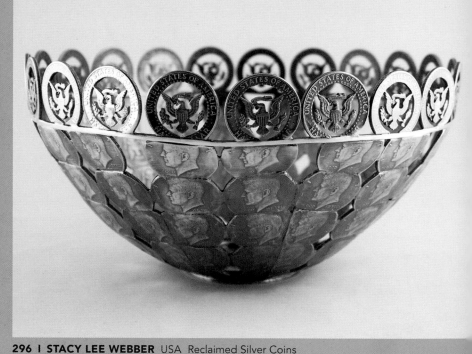

**296 I STACY LEE WEBBER** USA Reclaimed Silver Coins

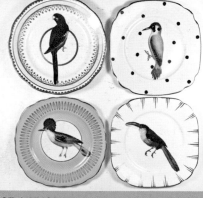

**297 I YVONNE ELLEN** UK Vintage Plates

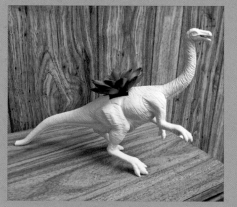

**298 I THE PDF FILES** USA
Reclaimed Toy

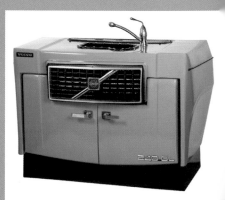

**299 I STUDIO TINMAN** ISRAEL
Reclaimed Cart Parts

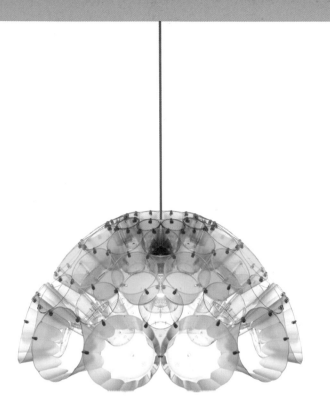

**300 | MEIKE HARDE** GERMANY Plastic Cups

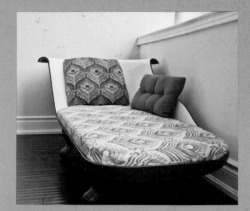

**301 | REDUX TUBS** CANADA
Vintage Iron Tubs

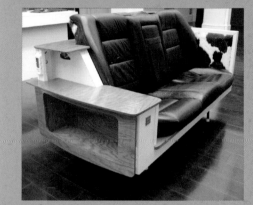

**302 | ADRIAN JOHNSON** USA
Reclaimed Refrigerator & Car Seats

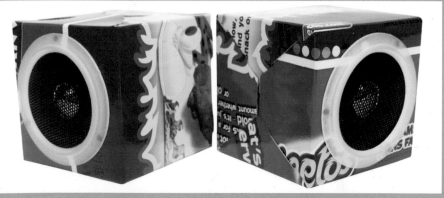

**03 | TERRACYCLE, INC.** USA Discarded Packaging

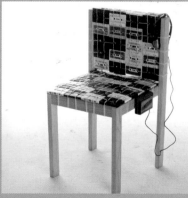

**304 | OOO MY DESIGN** SPAIN
Cassette Tape

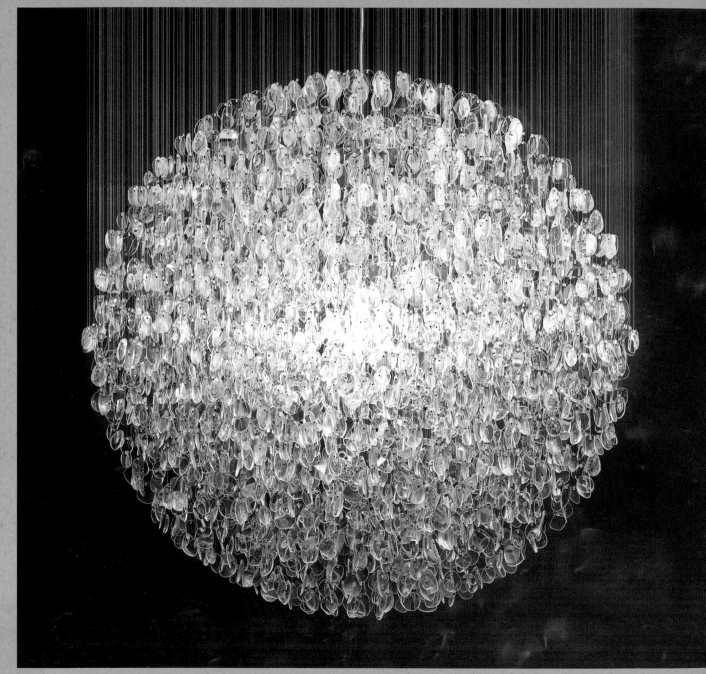

**305 I STUART HAYGARTH** UK  Reclaimed Eyeglass Lenses

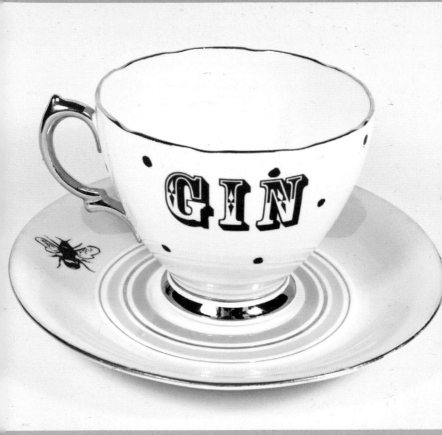

**806 I YVONNE ELLEN** UK Vintage Cup & Saucer

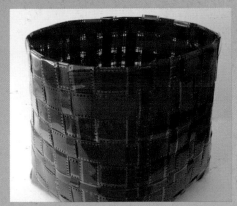

**307A I EN TU PUNTO** SPAIN
Assorted Celluloid Film

**307B I EN TU PUNTO** SPAIN
Assorted Celluloid Film

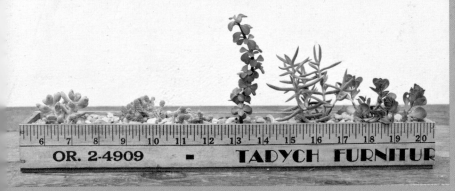

**08 I WHISKY GINGER** USA Reclaimed Yardstick

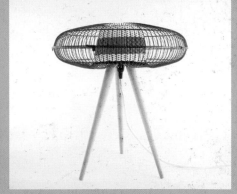

**309 I SEP VERBOOM** BELGIUM
Reclaimed Fan & Industrial Waste Strips

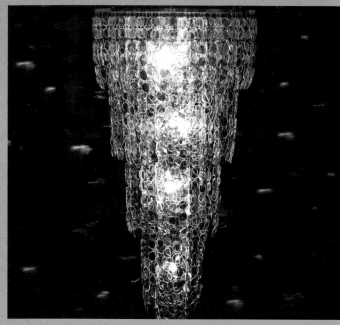

**310 | STUART HAYGARTH** UK Reclaimed Eyeglasses

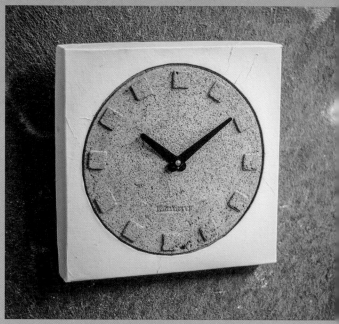

**311 | TRATTOTEMPO** ITALY Organic Material (Sand)

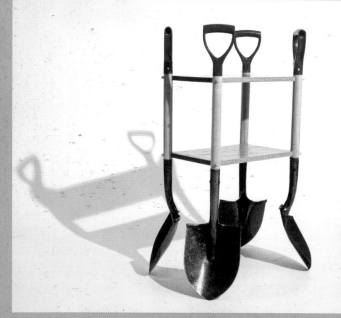

**312 | T.O.M.T.** USA Shovels

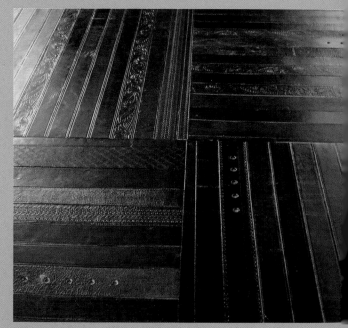

**313 | TING** UK Reclaimed Leather Belts

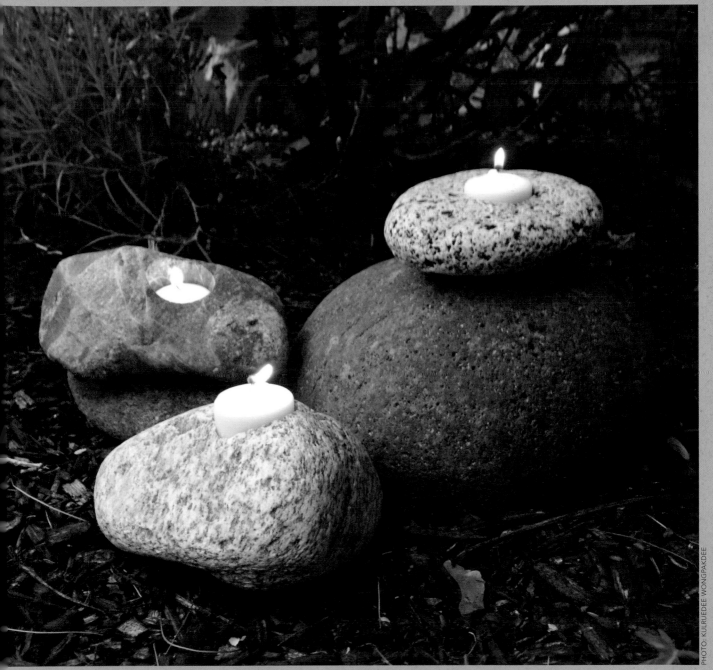

**314 I ROCK POT ORIGINALS** CANADA River Rocks

PHOTO: KULRUEDEE WONGPAKDEE

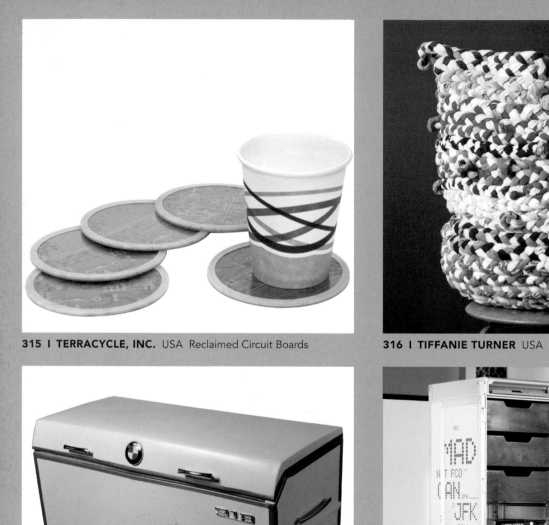

**315 I TERRACYCLE, INC.** USA Reclaimed Circuit Boards

**316 I TIFFANIE TURNER** USA T-Shirts

PHOTO: KEITH GLASMAN & ORLY WASSERMAN

**317 I STUDIO TINMAN** ISRAEL Reclaimed Car Parts

**318 I SKYPAK** DENMARK Airplane Trolly

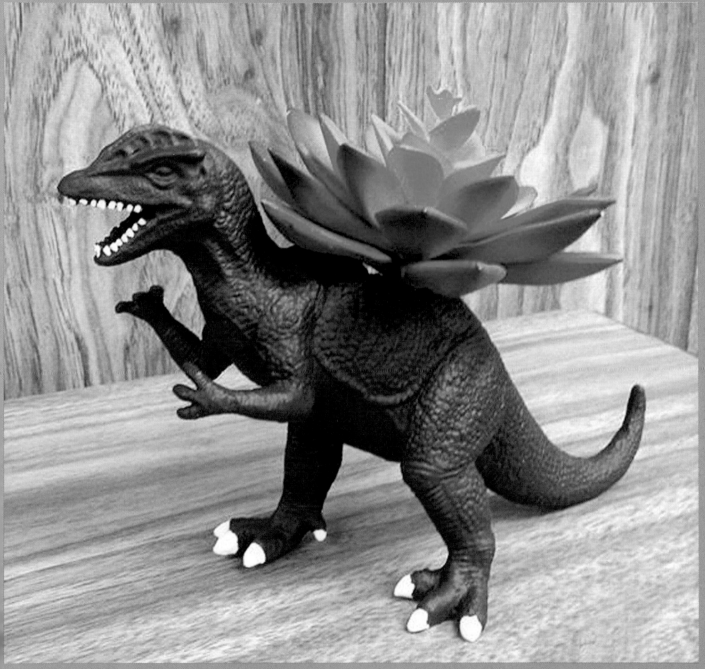

**319 I THE PDF FILES** USA Reclaimed Toy

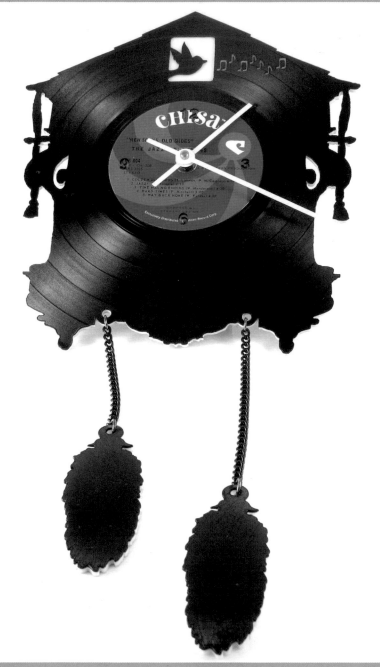

**320 I WRECORDS BY MONKEY** USA  Vinyl Records

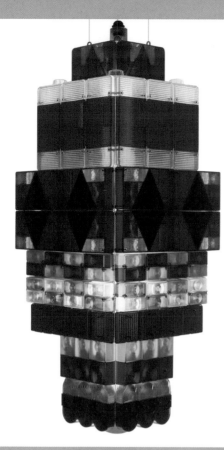

**321 | STUART HAYGARTH** UK Reclaimed Car Taillights

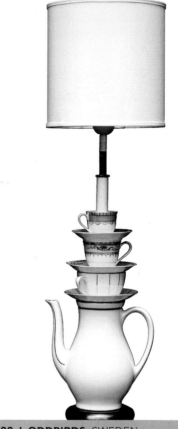

**322 | ODDBIRDS** SWEDEN
Vintage Ceramic Ware

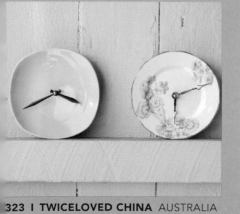

**323 | TWICELOVED CHINA** AUSTRALIA
Vintage China

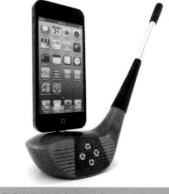

**324 | DOCK ARTISAN** USA
Vintage Golf Club

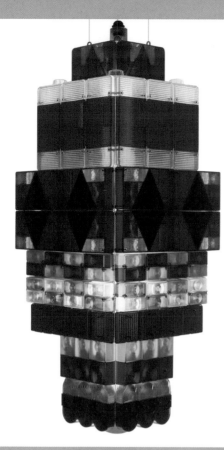

**325 | THIS INTO THAT** USA
Reclaimed Books

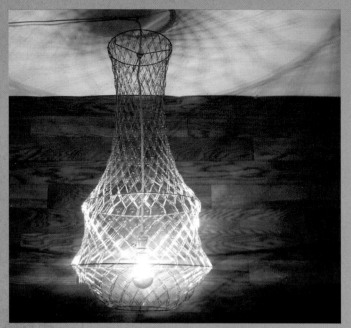

**326 I THE FLYING FOX ART AND DESIGN** CANADA
Paper Clips

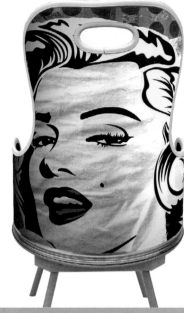

**327 I TRENDY-TUB** FRANCE Industrial Drum

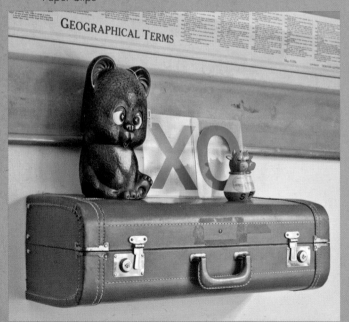

**328 I WHISKY GINGER** USA Vintage Suitcase

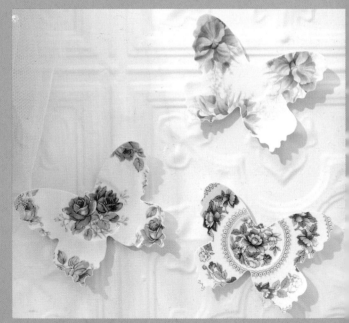

**329 I TWICELOVED CHINA** AUSTRALIA Vintage China

**330 | ANGELIC GLASS** USA Glass Bottles

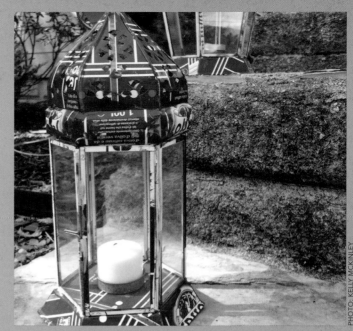

**331 | AUTHOR PURCHASE** USA Reclaimed Tin

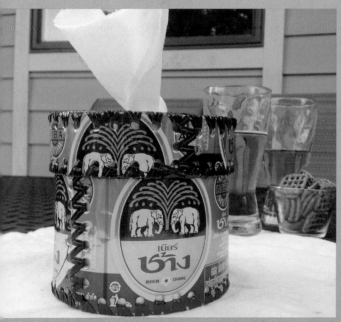

**332 | STREET VENDOR** THAILAND Reclaimed Beer Cans

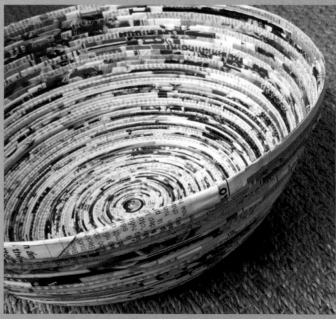

**333 | AUTHOR PURCHASE** USA Reclaimed Magazines

PHOTO: KELLY MCKINLEY

PHOTO: KELLY MCKINLEY

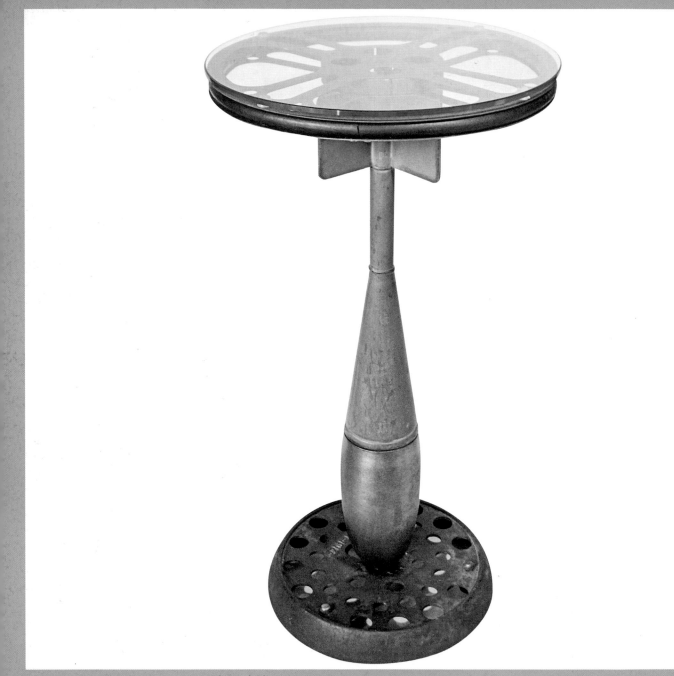

**334 | GRAHAM SCHODDA** USA Reclaimed Objects

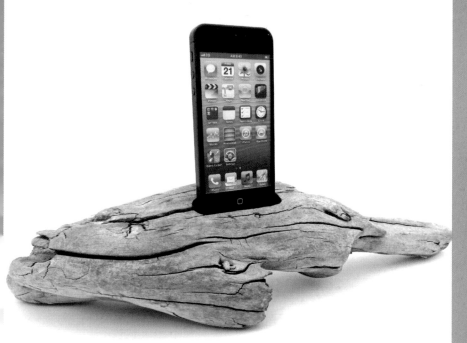

**335 | DOCK ARTISAN** USA Driftwood

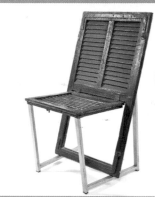

**336 | JUNKTION** ISRAEL
Reclaimed Window Shutter

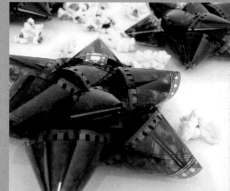

**337 | UNDONE CLOTHING** USA
Reclaimed Celluloid Film

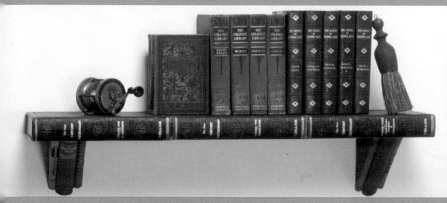

**338 | THIS INTO THAT** USA Reclaimed Books

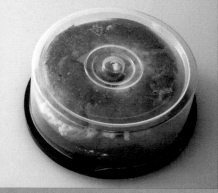

**339 | RODRIGO PIWONKA A.** CHILE
CD Packaging

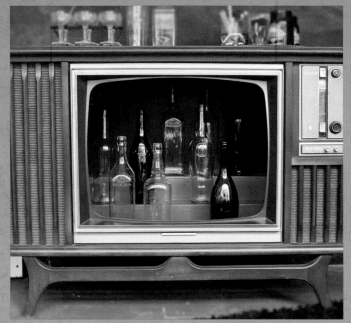

**340 I WHISKY GINGER** USA Vintage Television

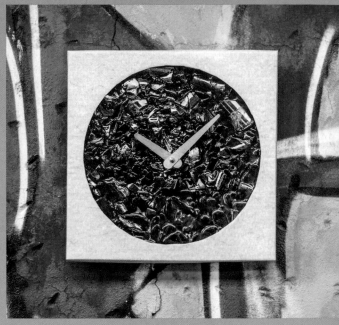

**341 I TRATTOTEMPO** ITALY Glass Bottles

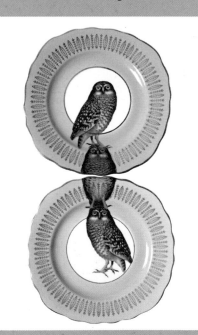

**342 I YVONNE ELLEN** UK Vintage Plates

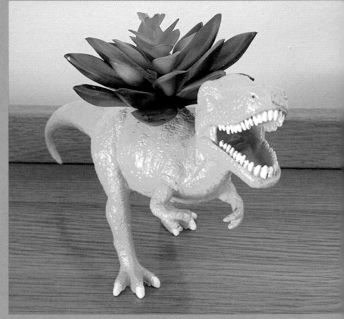

**343 I THE PDF FILES** USA Reclaimed Toy

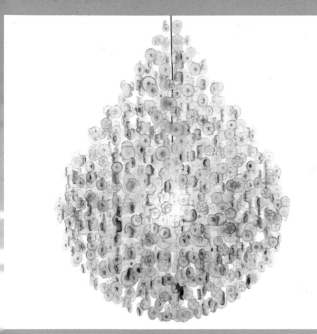

**344 | STUART HAYGARTH** UK Plastic Bottles

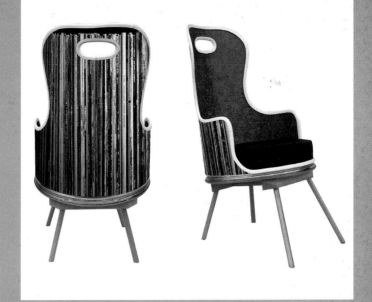

**345 | TRENDY-TUB** FRANCE Industrial Drum

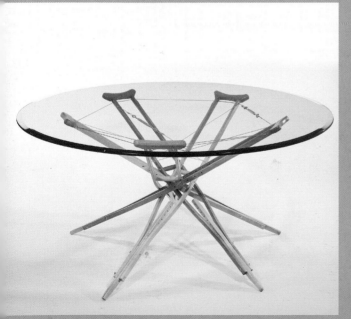

**346 | T.O.M.T.** USA Reclaimed Crutches

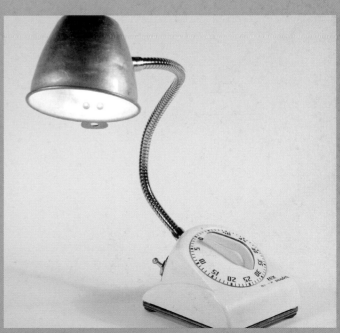

**347 | T.O.M.T.** USA Reclaimed Objects

# INTERIOR & OUTDOOR SPACES

**Interior & Outdoor Spaces** includes items of upcycled and recycled art and design that unexpectedly inhabit these open canvases. Whatever the location—be it a public library, the outside of a building, or a rice field—unconventionality is a powerful communication tool when conveying Earth-friendly designs and messages. ∎

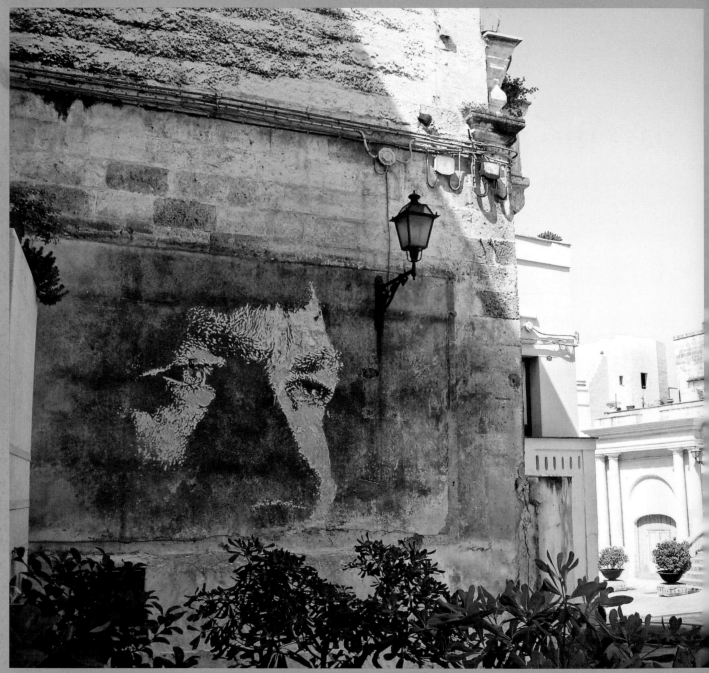

**348 | ALEXANDER FARTO** PORTUGAL Brick Façade

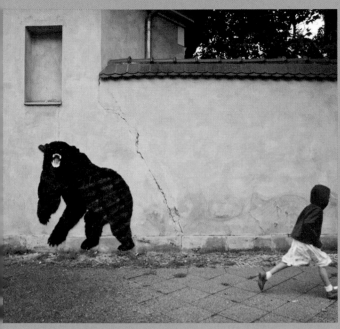

**349 I NEOZOON** GERMANY/FRANCE Discarded Fur Coats

**350 I BRUKETA & ZINIC OM** CROATIA Satellite Dishes

PHOTO: DOMAGOJ BLAZEVIC & DOMAGOJ KUNIC

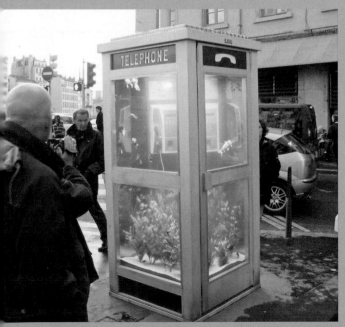

**351A I BENEDETTO BUFALINO & BENOIT DESEILLE** FRANCE
Phone Booth

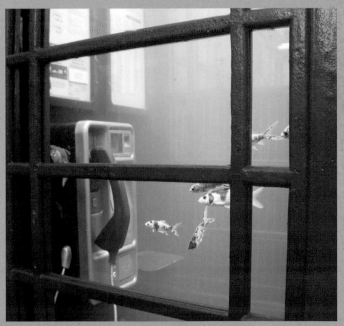

**351B I BENEDETTO BUFALINO & BENOIT DESEILLE** FRANCE
Phone Booth

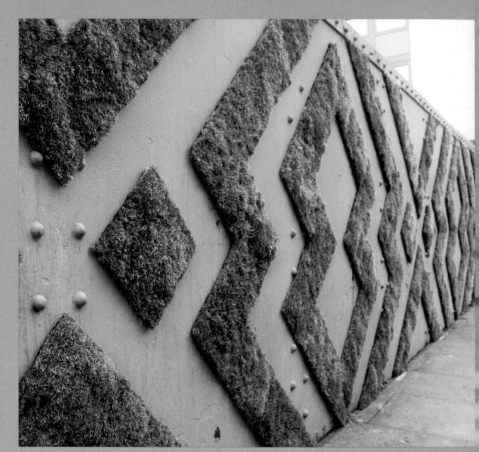

**352 I ANNA GARFORTH** UK
Reclaimed Milk Jug

**353 I ANNA GARFORTH** UK  Organic Material

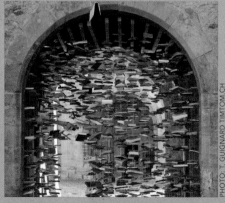

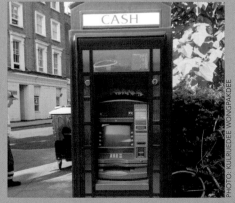

PHOTO: T. GUIGNARD TIMTOM.CH

PHOTO: KULRUEDEE WONGPAKDEE

**354 I JAN REYMOND** FRANCE
Reclaimed Books

**355 I LONDON PHONE BOOTH** UK
Phone Booth

**356 I MOSSTIKA** USA  Organic Material

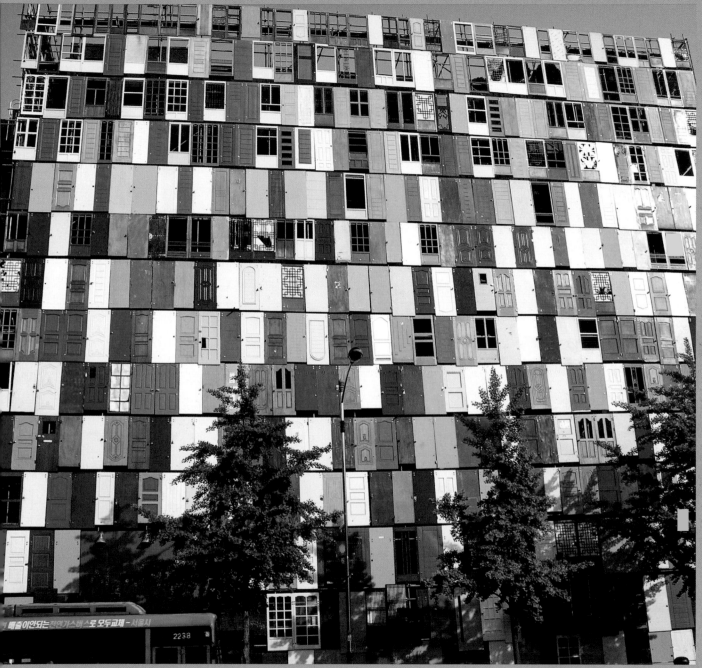

357 I **CHOI JEONG HWA** KOREA Reclaimed Doors

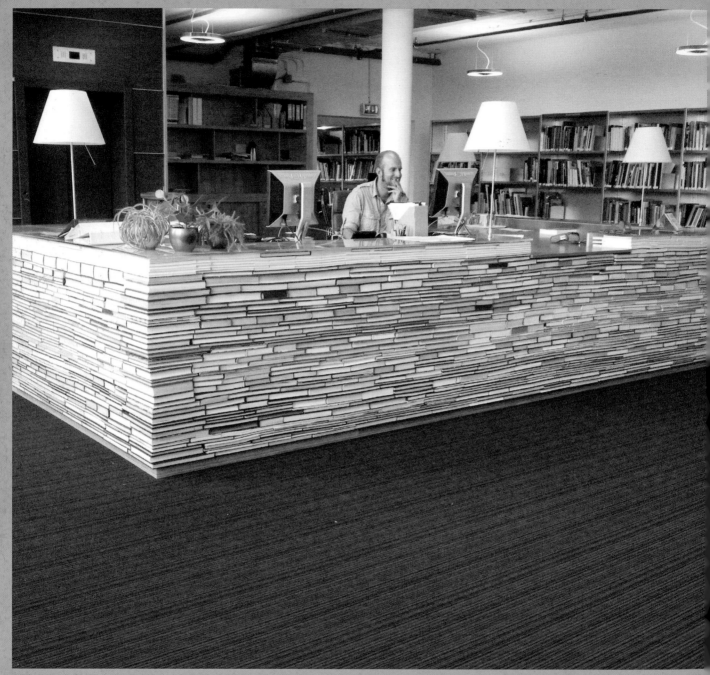

**358 I TU DELFT ARCHITECTURE BIBLIOTHEEK** NETHERLANDS Reclaimed Books

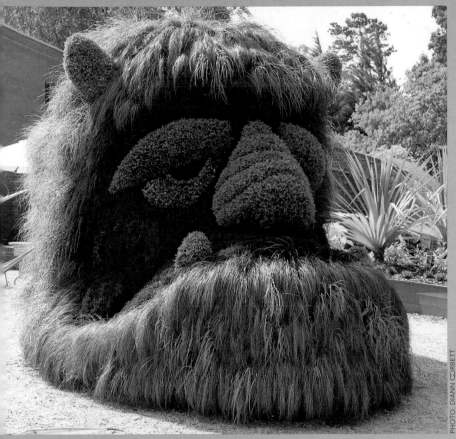

**359 I ATLANTA BOTANICAL GARDEN** USA Organic Material

PHOTO: DIANN CORBETT

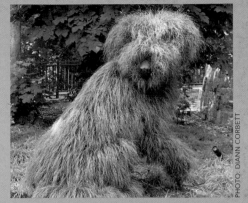

**360 I ATLANTA BOTANICAL GARDEN**
USA Organic Material

PHOTO: DIANN CORBETT

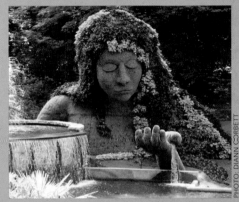

**361 I ATLANTA BOTANICAL GARDEN**
USA Organic Material

PHOTO: DIANN CORBETT

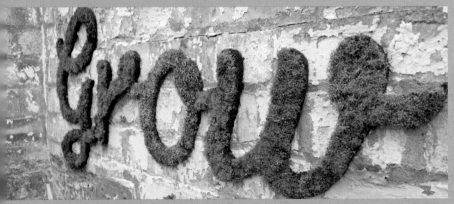

**362 I ANNA GARFORTH** UK Organic Material

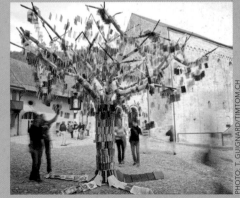

**363 I JAN REYMOND** FRANCE
Reclaimed Books

PHOTO: T. GUIGNARD/TIMTOM.CH

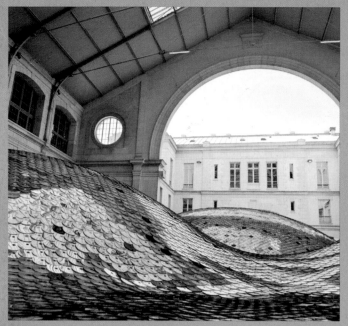

**364A | ELISE MORIN** FRANCE CDs

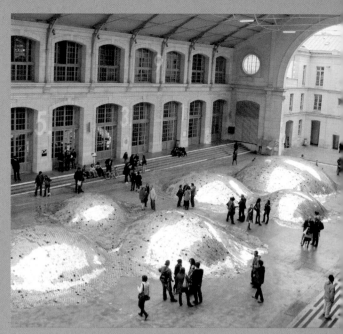

**364B | ELISE MORIN** FRANCE CDs

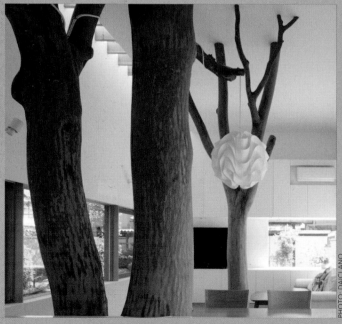

PHOTO: DAICI ANO

**365A | HIRONAKA OGAWA AND ASSOCIATES** JAPAN Wood

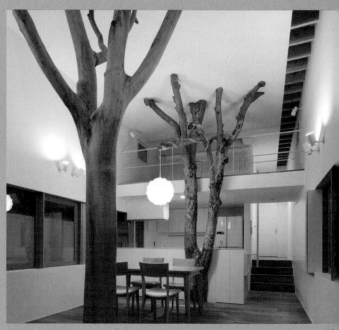

**365B | HIRONAKA OGAWA AND ASSOCIATES** JAPAN Wood

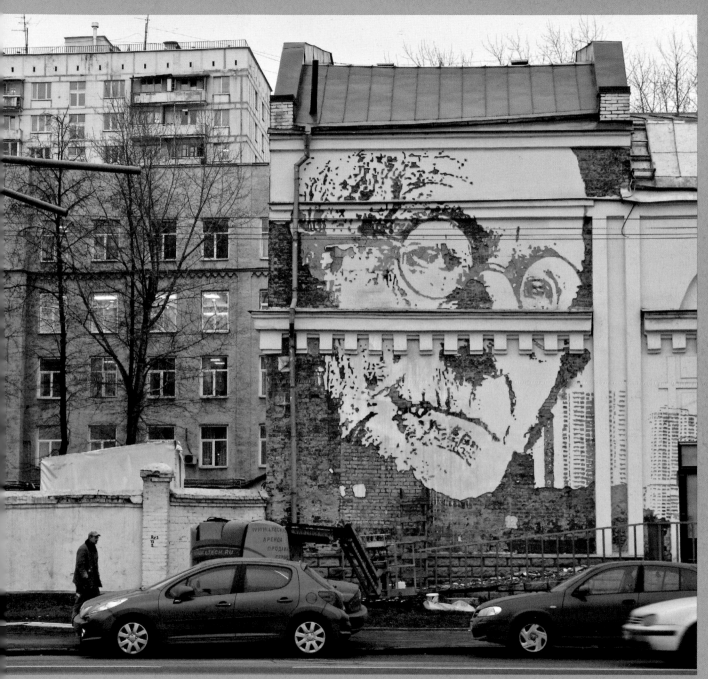

166 | **ALEXANDER FARTO** PORTUGAL Brick Façade

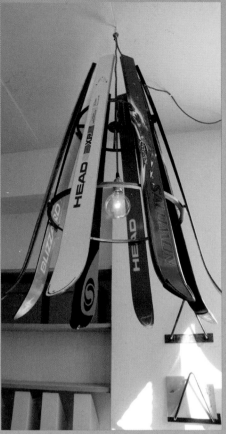

**367 I WILLEM HEEFFER** FINLAND
Reclaimed Skis

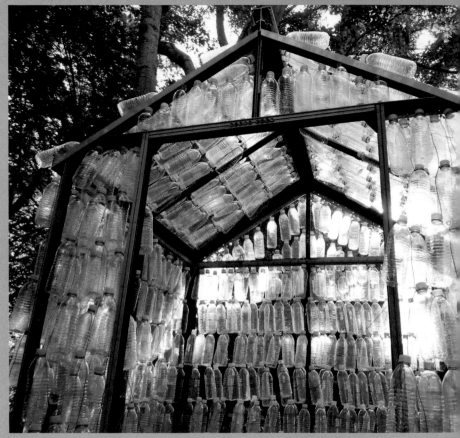

**368 I KAREN HACKENBERG** USA Plastic Bottles

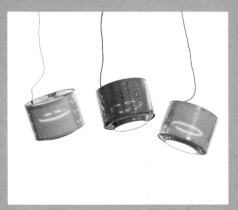

**369 I WILLEM HEEFFER** FINLAND
Reclaimed Washing Machine Drums

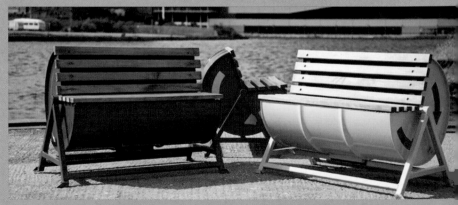

**370 I ROBERT JOHNSON & JOHNSON FURNITURE** UK Industrial Drums

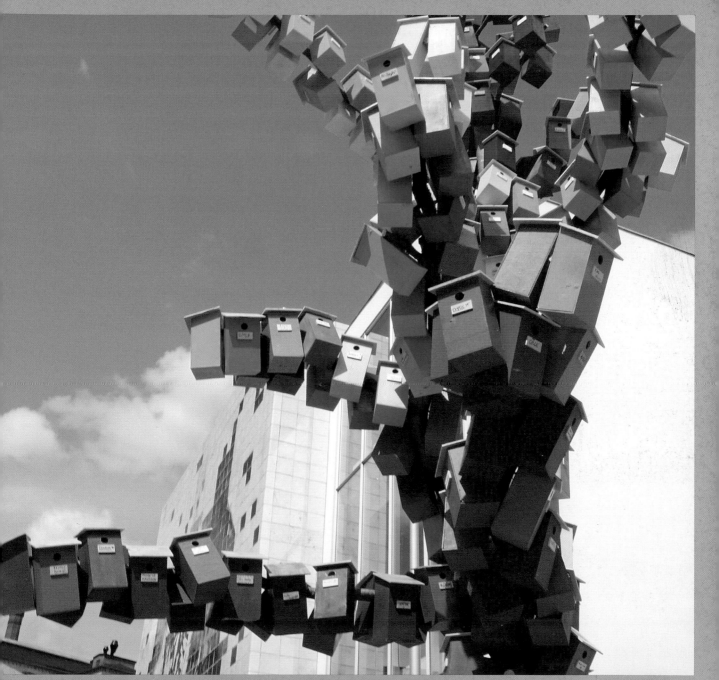

871 | **THOMAS DAMBO** DENMARK  Reclaimed Wood

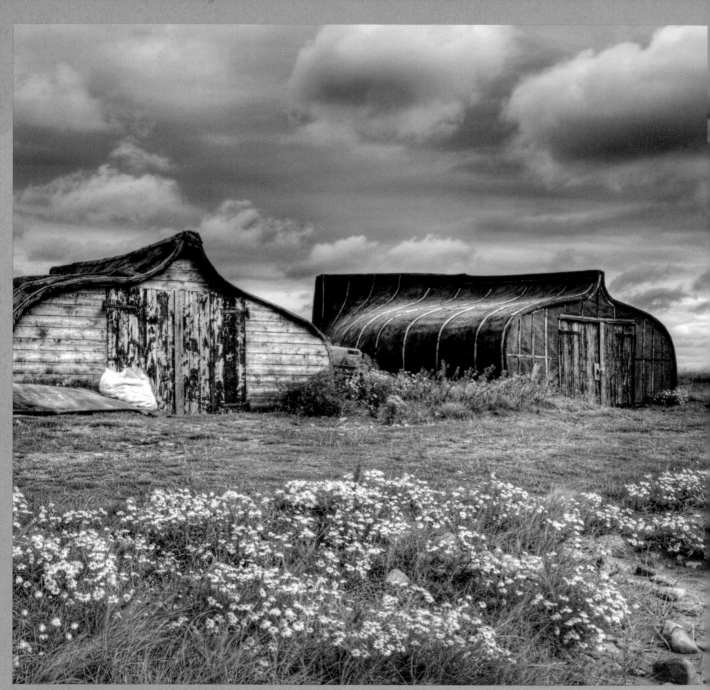

**372 I HOLY ISLAND OF LINDISFARNE** UK Reclaimed Fishing Boats

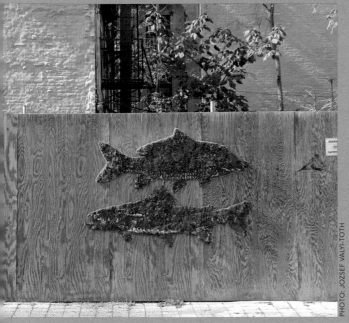

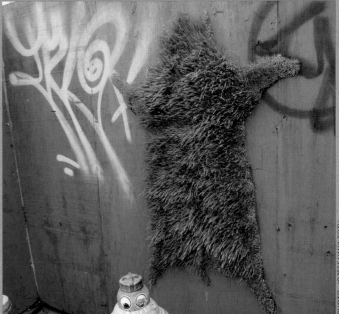

**373 I MOSSTIKA** USA Organic Material

PHOTO: JOZSEF VALYI-TOTH

**374 I MOSSTIKA** USA Organic Material

PHOTO: JOZSEF VALYI-TOTH

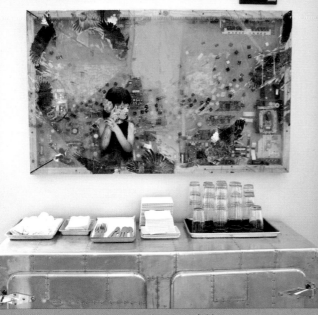

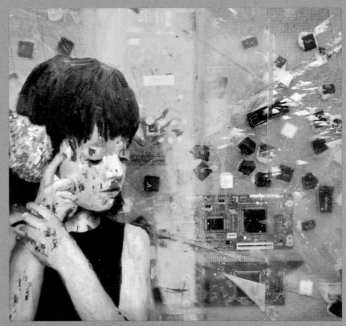

**375A I JENNIFER HANSEN** USA Found Objects

**375B I JENNIFER HANSEN** USA Found Objects

**376 I NEOZOON** GERMANY/FRANCE Discarded Fur Coats

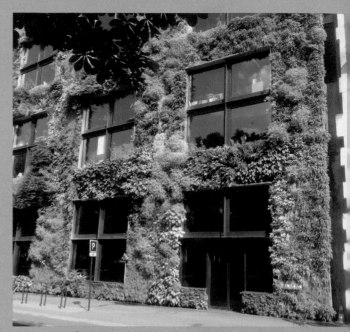

**377 I MUSÉE DU QUAI BRANLY** FRANCE Organic Material

**378 I WILLEM HEEFFER** FINLAND Reclaimed Tin Cans

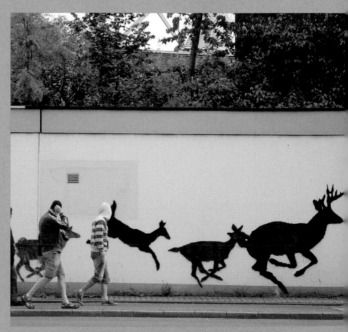

**379 I NEOZOON** GERMANY/FRANCE Discarded Fur Coats

**380A I NEOZOON** GERMANY/FRANCE Discarded Fur Coats

**380B I NEOZOON** GERMANY/FRANCE Discarded Fur Coats

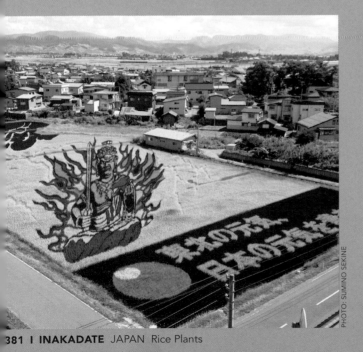

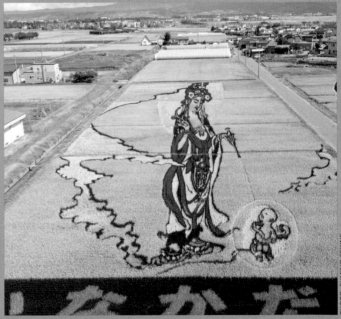

PHOTO: SUMINO SEKINE

PHOTO: SUMINO SEKINE

**381 I INAKADATE** JAPAN Rice Plants

**382 I INAKADATE** JAPAN Rice Plants

**383 I THOMAS DAMBO** DENMARK  Reclaimed Wood

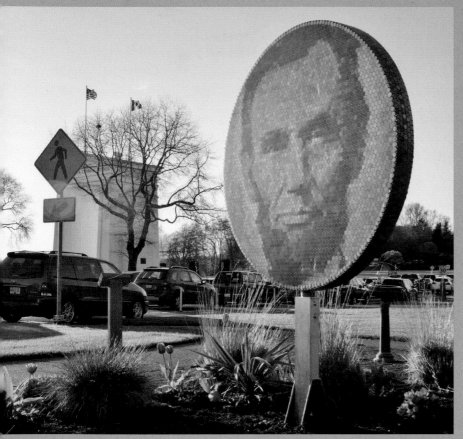

**384 | WILLIAM FRYMIRE** CANADA Pennies

**385 | THOMAS DAMBO** DENMARK
Reclaimed Wood

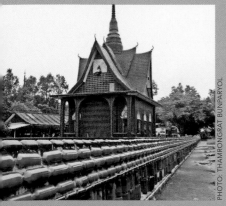

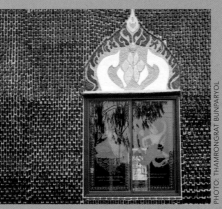

PHOTO: THAMRONGRAT BUNPARYOL

PHOTO: THAMRONGRAT BUNPARYOL

**386A | WAT PA MAHA CHEDI KAEW**
THAILAND Assorted Glass Bottles

**386B | WAT PA MAHA CHEDI KAEW**
THAILAND Assorted Glass Bottles

**387 | WILLEM HEEFFER** FINLAND
Reclaimed Tin Can

# ART & DESIGN

**Art & Design** contains pieces inspired by each artist's culture and experience. It showcases new and unexpected uses for ordinary items and places them in unique settings. Sustainability is the common thread that has begun to command the world's attention. ■

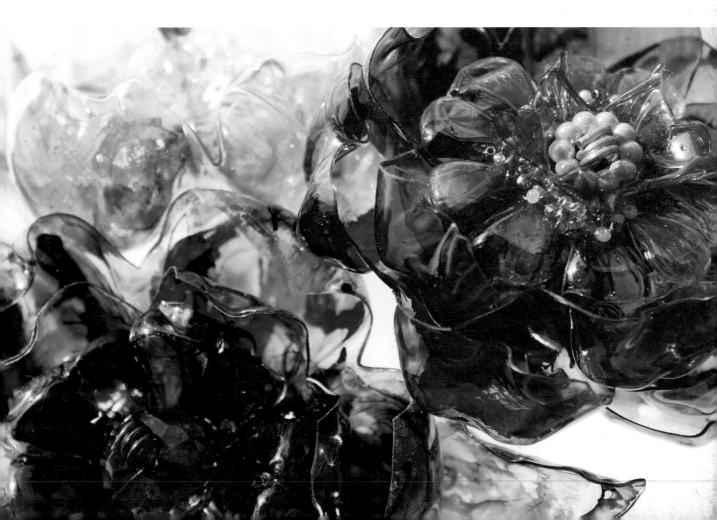

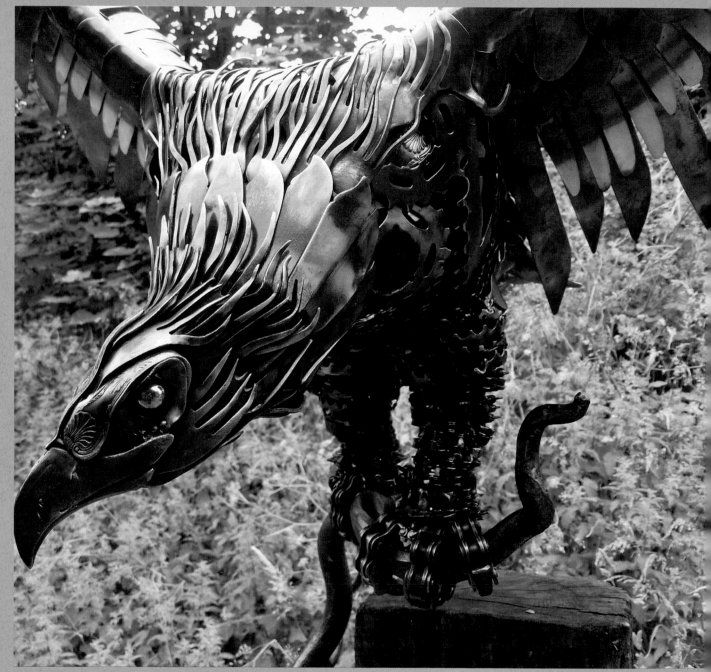

**388 I ALAN WILLIAMS** UK Assorted Metal Objects

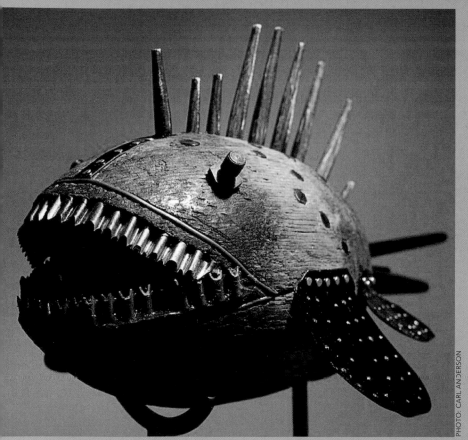

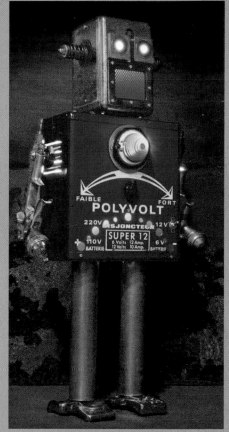

**389 I LAUNI LUCAS** CANADA  Reclaimed Cedar Fish Net Floats & Objects

PHOTO: CARL ANDERSON

**390 I +BAUER** FRANCE
Reclaimed Objects

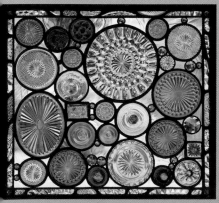

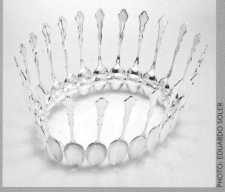

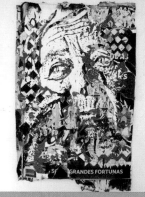

PHOTO: EDUARDO SOLER

**391 I DANIEL MAHER** USA
Assorted Glass Bottles & Plates

**392 I DAVE MEEKER** USA  Spoons

**393 I ALEXANDER FARTO** PORTUGAL
Reclaimed Billboards

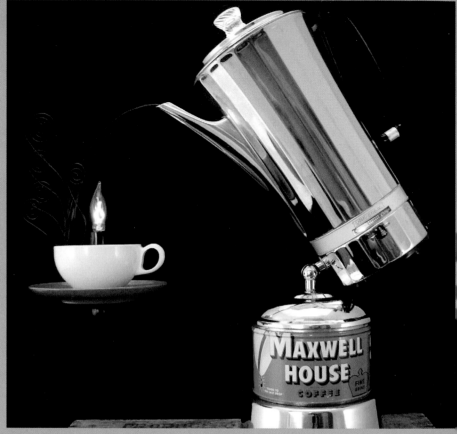

**394 I CLEO MUSSI** UK
Assorted Ceramic Pieces

**395 I BENCLIF DESIGNS** USA Reclaimed Objects

**396 I ELISABETH LECOURT** UK
Vintage Maps

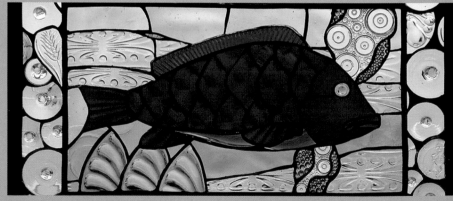

**397 I DANIEL MAHER** USA Assorted Glass Bottles & Plates

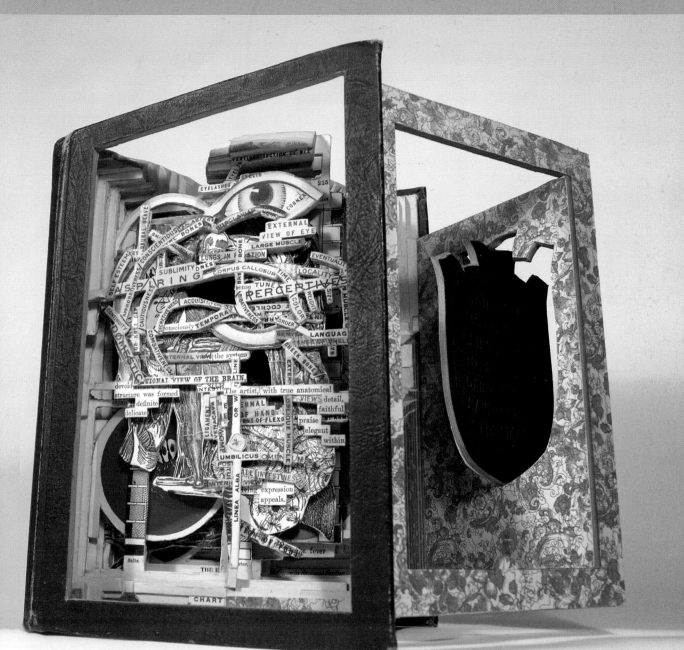

**398 I BRIAN DETTMER** USA Reclaimed Book

COURTESY OF THE ARTIST AND SALTWORKS

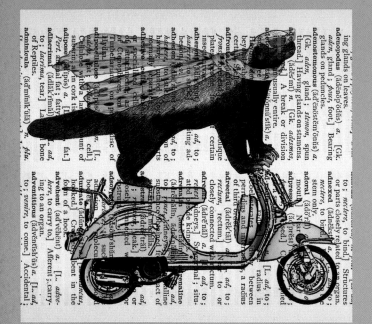

**399 I ECOCYCLED** USA Vintage Book Page

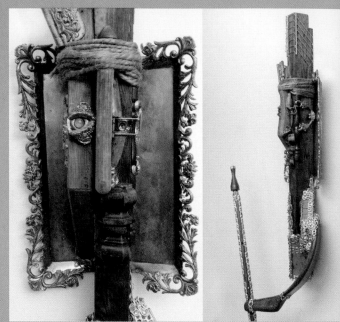

**400 I JAMES GAYNOR** USA Found Objects

**401 I HARRIETE ESTEL BERMAN** USA Handmade Paper

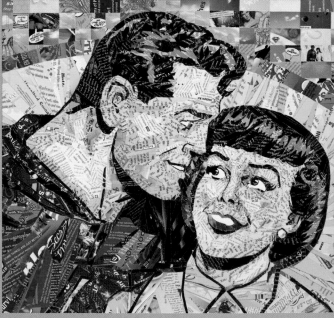

**402 I JEFFREY BALLARD** USA Reclaimed Packaging, Junk Mail

**ART** WITHOUT **WASTE** I 500 UPCYCLED & EARTH-FRIENDLY DESIGNS

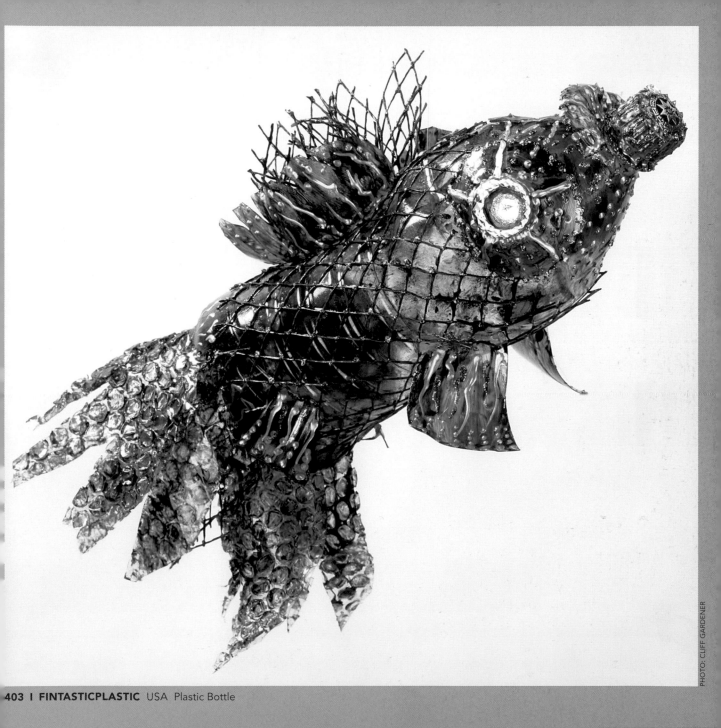

**403 I FINTASTICPLASTIC** USA  Plastic Bottle

PHOTO: CLIFF GARDENER

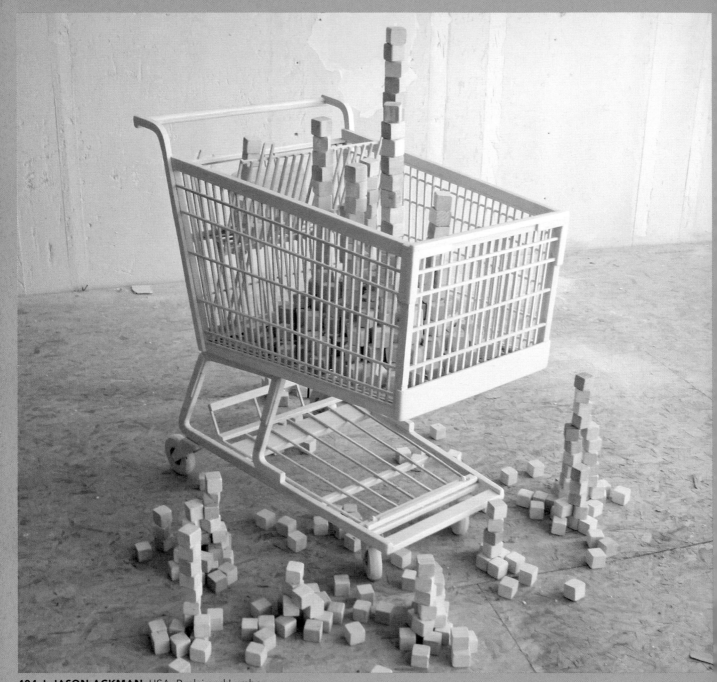

**404 | JASON ACKMAN** USA  Reclaimed Lumber

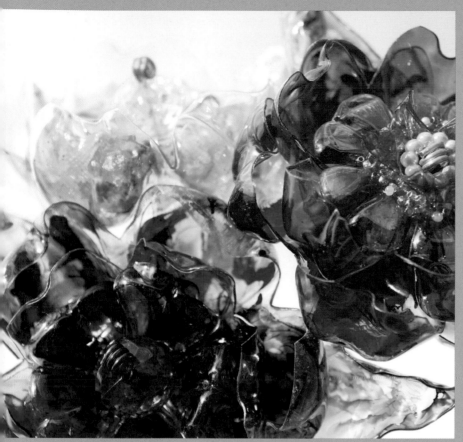

405 | **ARTE PLASTIQUE** USA Plastic Bottle

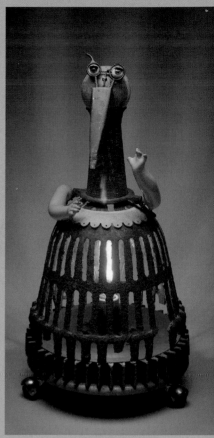

406 | **CHRIS GIFFIN** USA
Reclaimed Objects

PHOTO: RON SAWYER

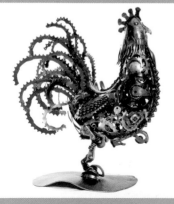

07 | **ALAN WILLIAMS** UK
Assorted Metal Objects

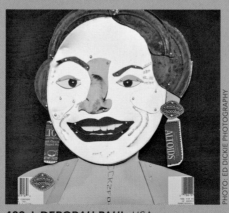

408 | **DEBORAH PAUL** USA
Reclaimed Metal Pieces

PHOTO: ED DICKIE PHOTOGRAPHY

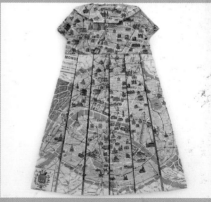

409 | **ELISABETH LECOURT** UK
Vintage Maps

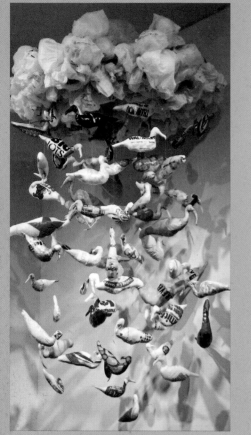

**410 I CAROL SOGARD** USA
Assorted Plastic Bags

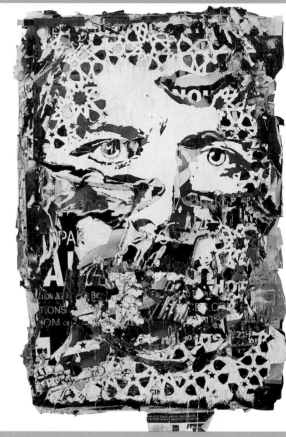

**411 I ALEXANDER FARTO** PORTUGAL Reclaimed Billboards

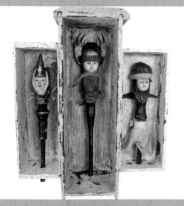

**412 I JENIFER J. RENZEL** USA
Assorted Found Objects

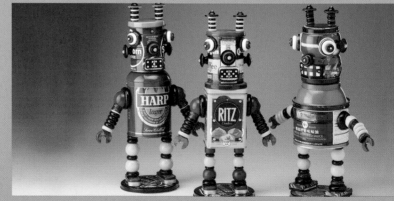

**413 I BOSS BROWN ART** USA Reclaimed Objects

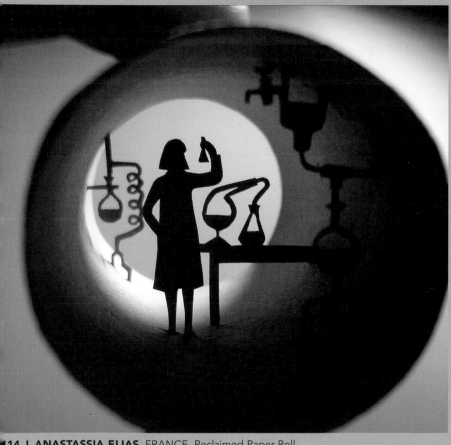

**414 I ANASTASSIA ELIAS** FRANCE Reclaimed Paper Roll

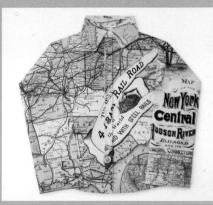

**415 I ELISABETH LECOURT** UK
Vintage Maps

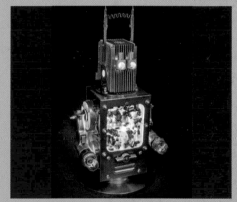

**416 I +BAUER** FRANCE
Reclaimed Objects

**17 I DIANA CORVELLE** USA New York City MetroCard

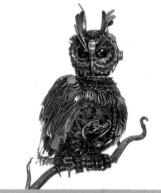

**418 I ALAN WILLIAMS** UK
Assorted Metal Objects

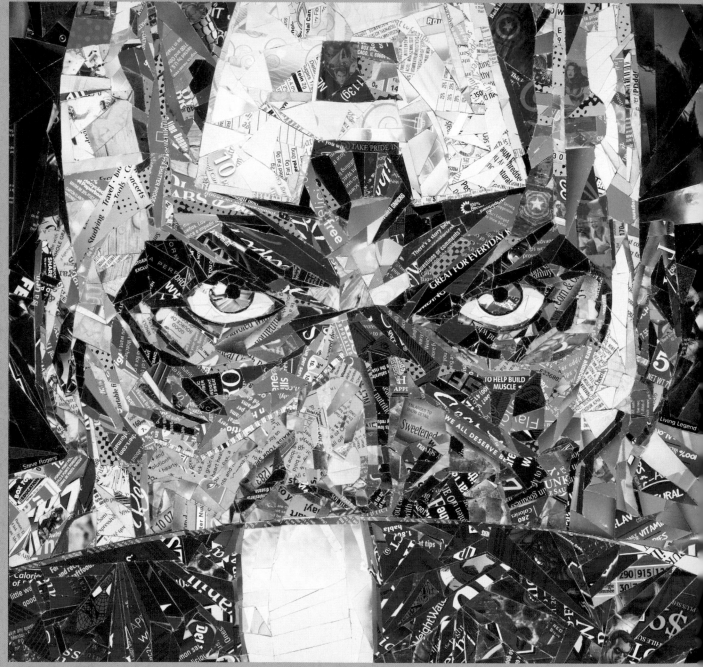

**419 I JEFFREY BALLARD** USA Reclaimed Packaging, Junk Mail

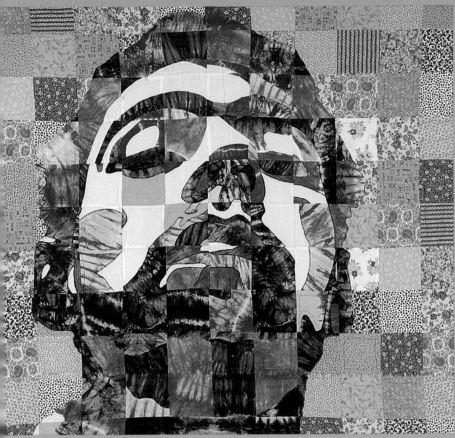

**20 I LUKE HAYNES** USA Reclaimed Clothes & Linens

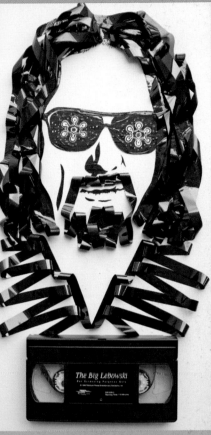

**421 I IRI5** USA Videotape

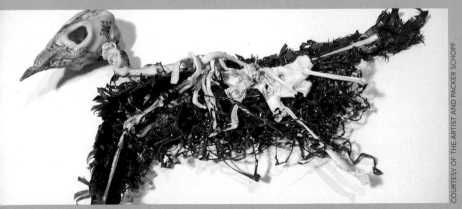

**22 I BRIAN DETTMER** USA Reclaimed Cassette Tape

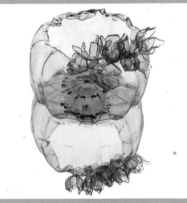

**423 I GULNUR OZDAGLAR** TURKEY
Plastic Bottles

COURTESY OF THE ARTIST AND PACKER SCHOPF

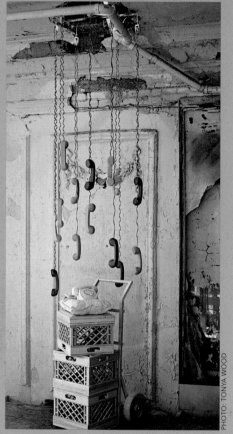

PHOTO: TONYA WOOD

**424 I JASON ACKMAN** USA Reclaimed Lumber, Clay & Phone Cords

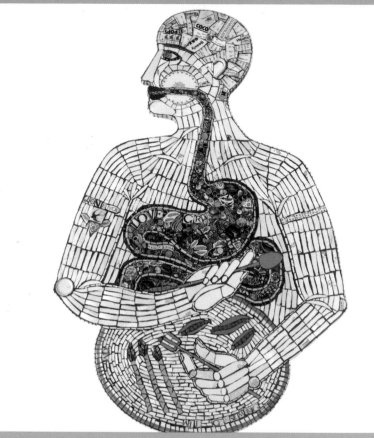

**425 I CLEO MUSSI** UK Assorted Ceramic Pieces

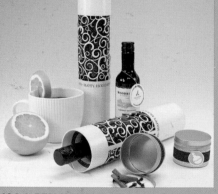

**426 I BEN HANNAM** USA Mailing Tube

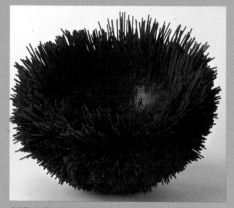

**427 I DAVE MEEKER** USA Swizzle Sticks

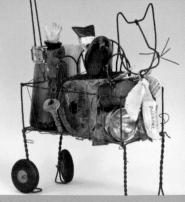

**428 I KARIN K MUELLER** USA Reclaimed Objects

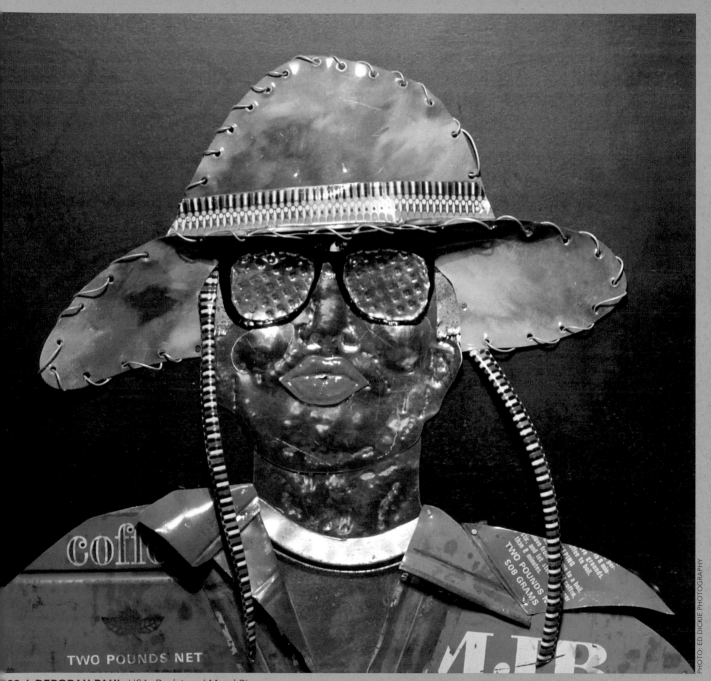

429 I **DEBORAH PAUL** USA Reclaimed Metal Pieces

PHOTO: ED DICKIE PHOTOGRAPHY

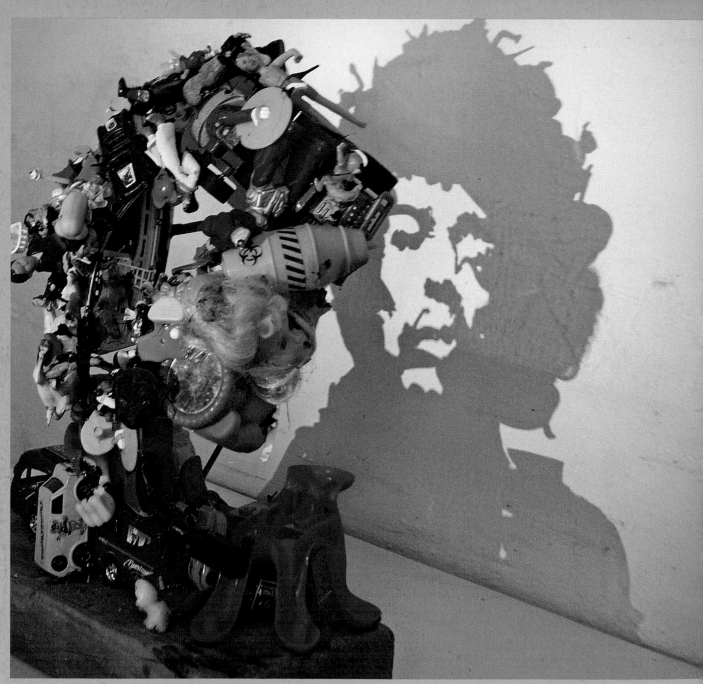

**430 I DOROTHEA PREHN** SPAIN Reclaimed Refuse

**431 I ECOCYCLED** USA Vintage Book Page

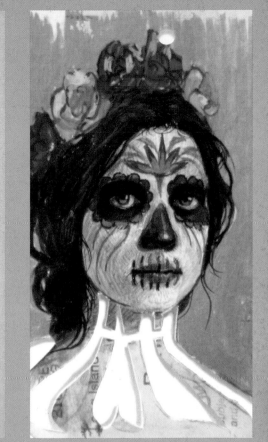

**432 I DIANA CORVELLE** USA
New York City MetroCard

**433 I ANASTASSIA ELIAS** FRANCE Reclaimed Paper Roll

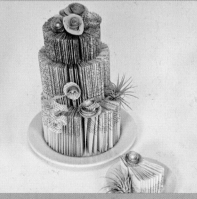

**434 I MONICA LEE** USA
Reclaimed Books

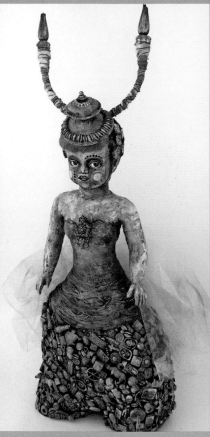

**435 I CLARISSA CALLESEN** USA
Assorted Found Objects

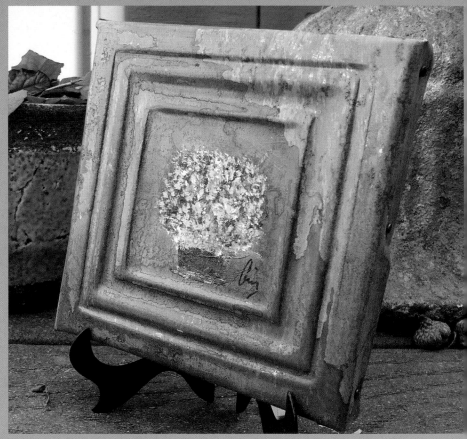

**436 I HEARTWORKS STUDIO** USA Reclaimed Tin Ceilings

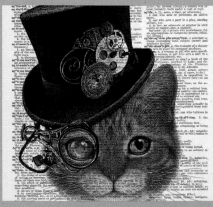

**437 I ECOCYCLED** USA
Vintage Book Page

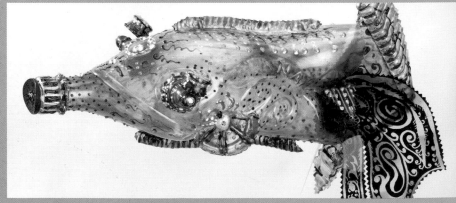

**438 I FINTASTICPLASTIC** USA Plastic Bottles

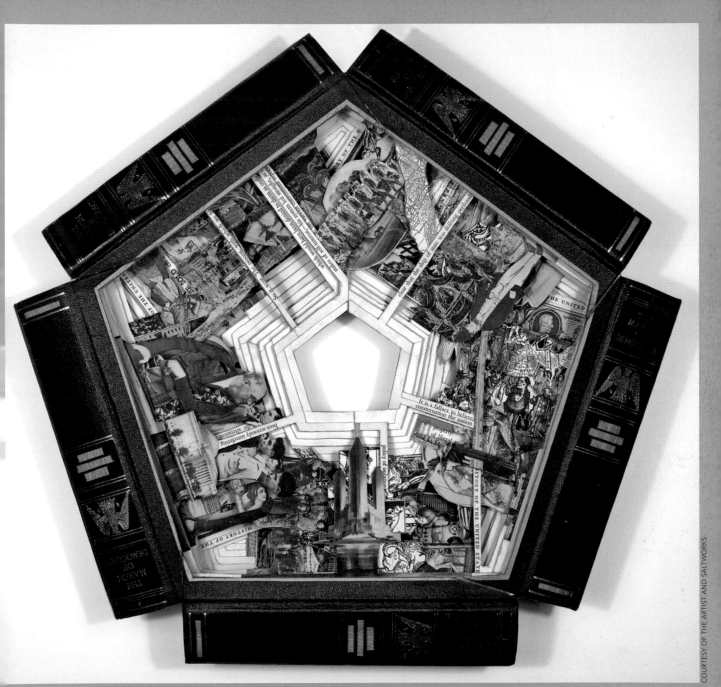

**439 I BRIAN DETTMER** USA  Reclaimed Book

COURTESY OF THE ARTIST AND SALTWORKS

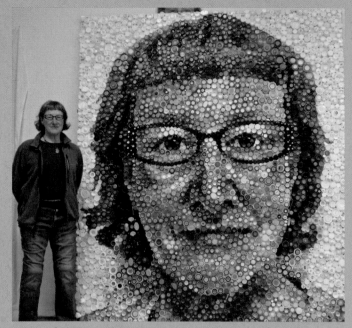

**440A I MARY ELLEN CROTEAU** USA Plastic Bottle Caps

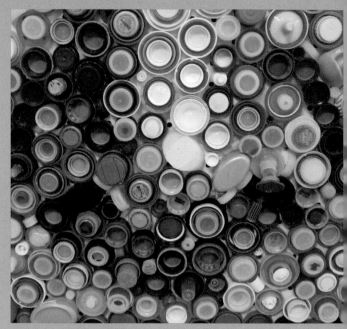

**440B I MARY ELLEN CROTEAU** USA Plastic Bottle Caps

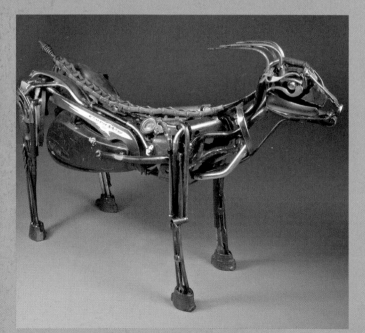

**441 I JUD TURNER** UK Assorted Found Objects

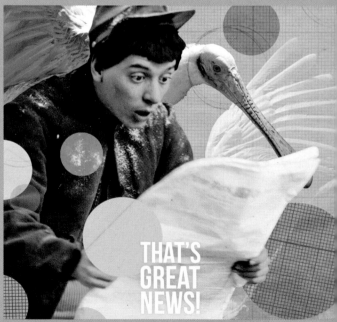

**442 I KATELIJNE DE MUELENAERE** BELGIUM
Assorted Scrap Papers, Findings

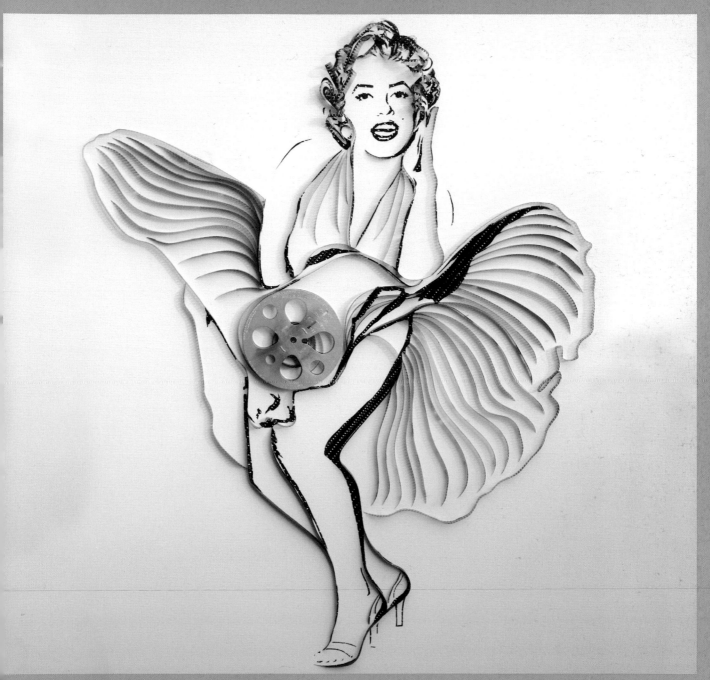

**443 I IRI5** USA  8-mm Celluloid Film

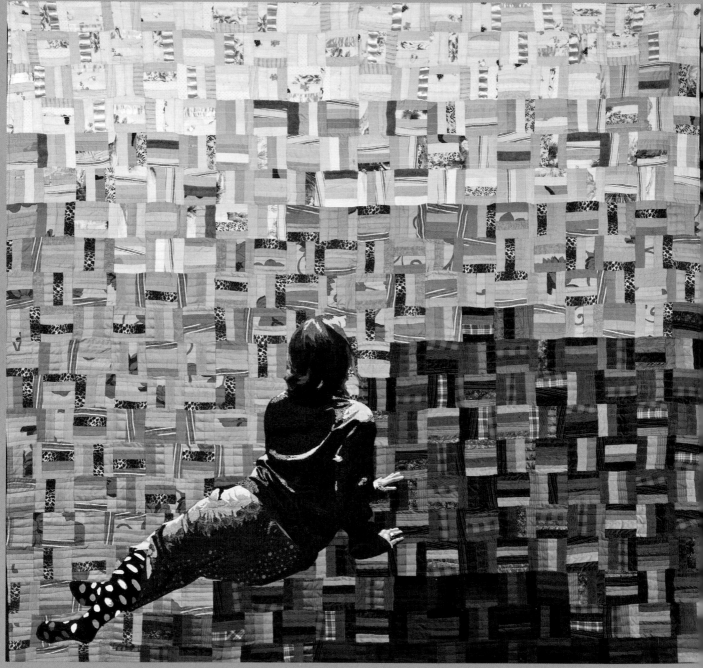

**444 I LUKE HAYNES** USA Reclaimed Clothes & Linens

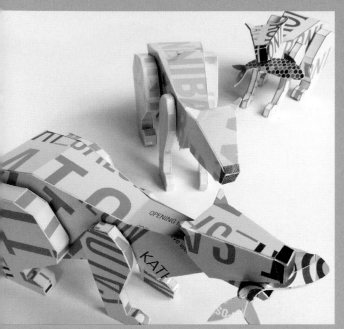

**445 | KIRSTY LOVES CARDBOARD** AUSTRALIA
Reclaimed Packaging

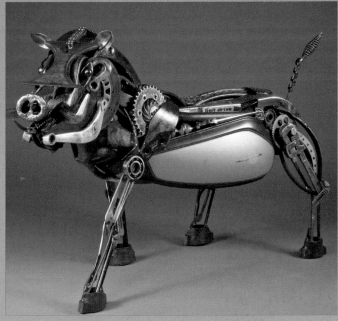

**446 | JUD TURNER** UK Assorted Found Objects

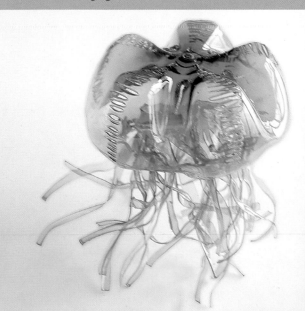

**447 | MIWA KOIZUMI** USA Plastic Bottles

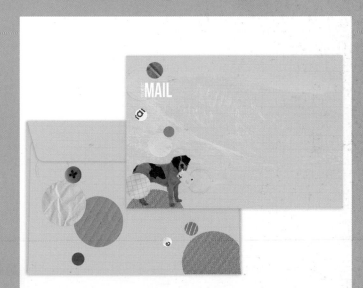

**448 | KATELIJNE DE MUELENAERE** BELGIUM
Assorted Scrap Papers, Findings

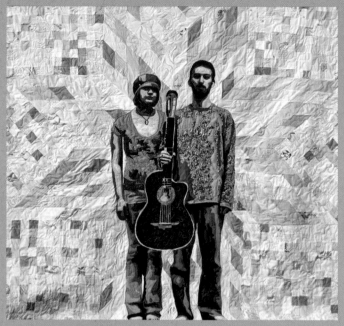

**449 I LUKE HAYNES** USA  Reclaimed Clothes & Linens

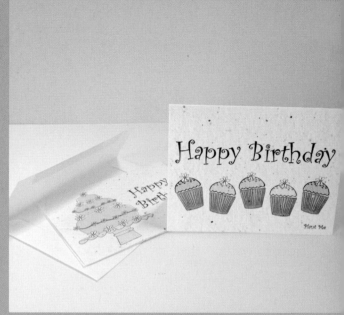

**450 I SPROUTS!** USA  Handmade Seed Infused Paper

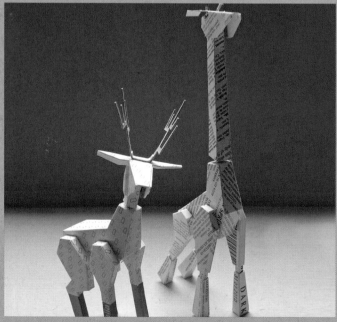

**451 I KIRSTY LOVES CARDBOARD** AUSTRALIA
Reclaimed Packaging

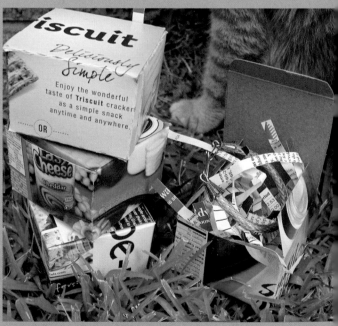

**452 I MITZI BRANDON** USA  Discarded Packaging

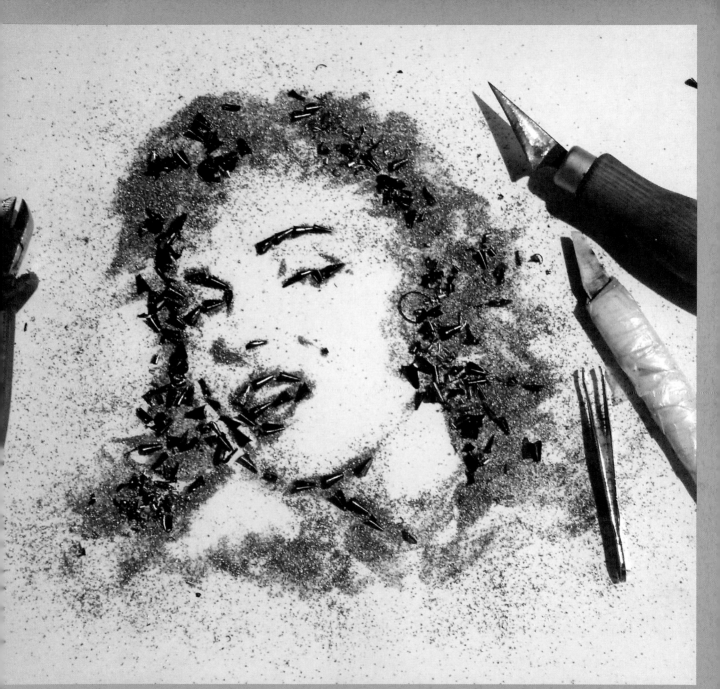

**453 I KARGIN VLADIMIR** REPUBLIC OF TATARSTAN Metal Shavings

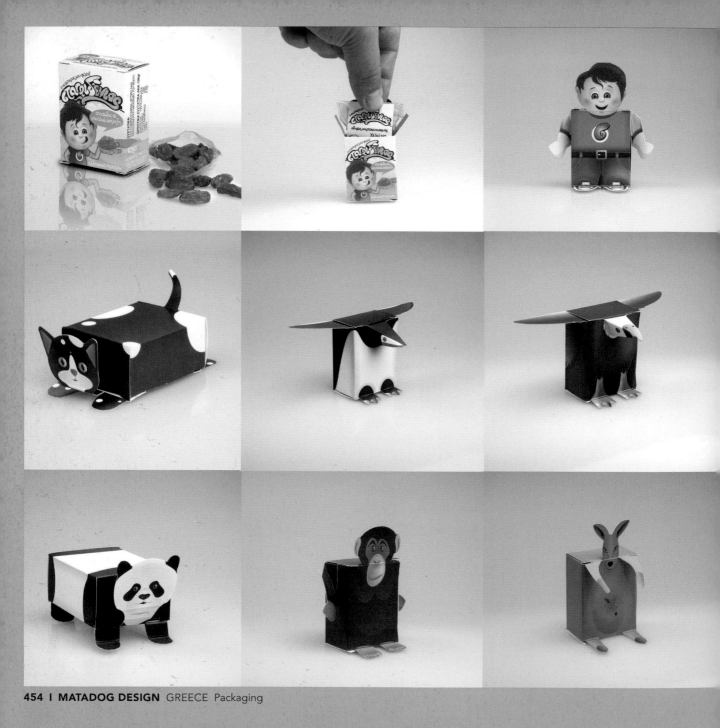

**454 I MATADOG DESIGN** GREECE Packaging

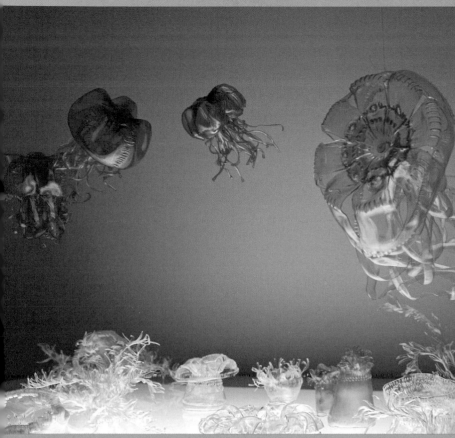

**455 I MIWA KOIZUMI** USA Plastic Bottles

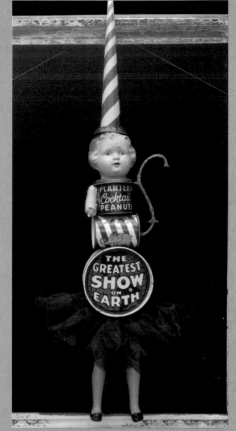

**456 I PRIMITIVE TWIG** USA
Reclaimed Objects

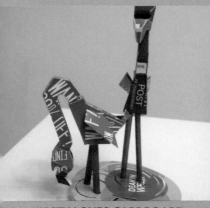

**57 I KIRSTY LOVES CARDBOARD**
AUSTRALIA Reclaimed Packaging

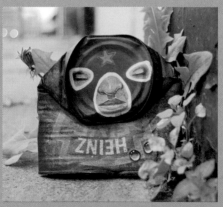

**458 I MY DOG SIGHS** UK
Reclaimed Tin Cans

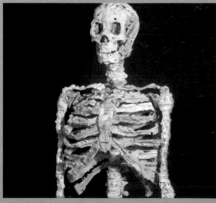

**459 I BRIAN DETTMER** USA
Reclaimed Cassette Tape

COURTESY OF THE ARTIST AND PACKER SCHOPF

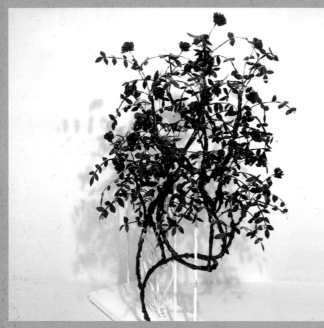

**460A | BRIAN DETTMER** USA Reclaimed Videotape

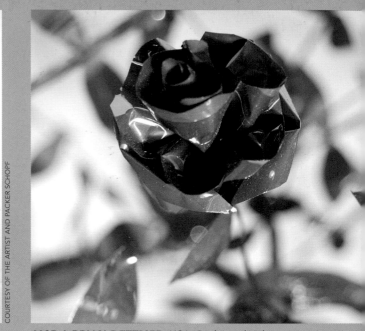

COURTESY OF THE ARTIST AND PACKER SCHOPF

**460B | BRIAN DETTMER** USA Reclaimed Videotape

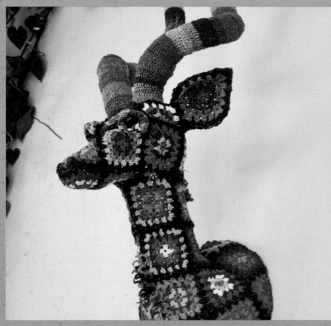

**461 | MAGDA VAN DER VLOED** SOUTH AFRICA Plastic Bags

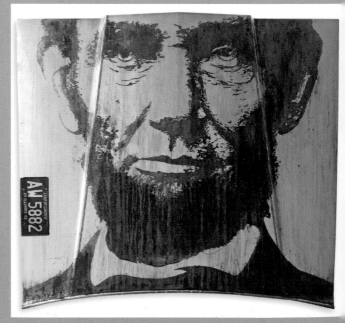

**462A | MILWAUKEE MODERN** USA 1978 Lincoln Hood

**462B I MILWAUKEE MODERN** USA  1978 Lincoln Hood

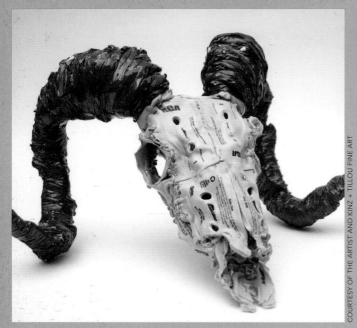

COURTESY OF THE ARTIST AND KINZ + TILLOU FINE ART

**463 I BRIAN DETTMER** USA Reclaimed Cassette Tape

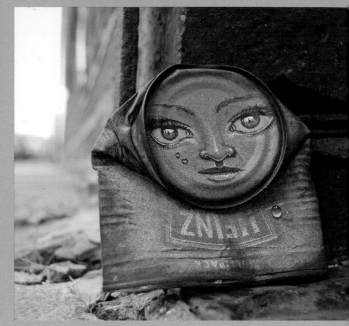

**464 I MY DOG SIGHS** UK Reclaimed Tin Cans

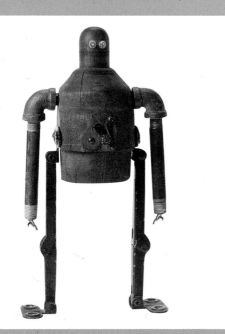

**465 I SHAWN MURENBEELD** CANADA Reclaimed Objects

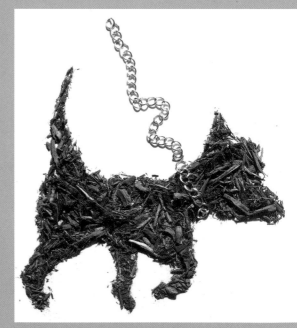

**466 I SARAH ROSADO** USA Organic Material

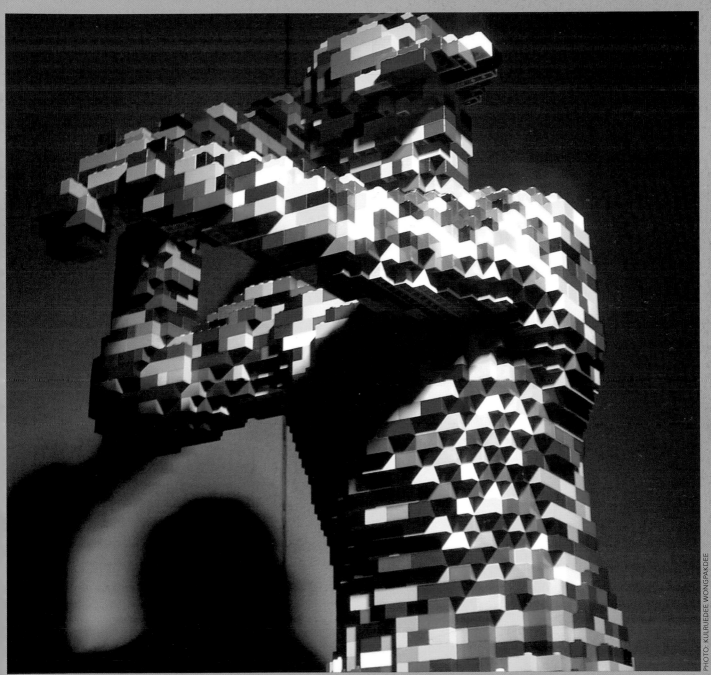

**467 I NATHAN SAWAYA** USA Reclaimed LEGOs

PHOTO: KULRUEDEE WONGPAKDEE

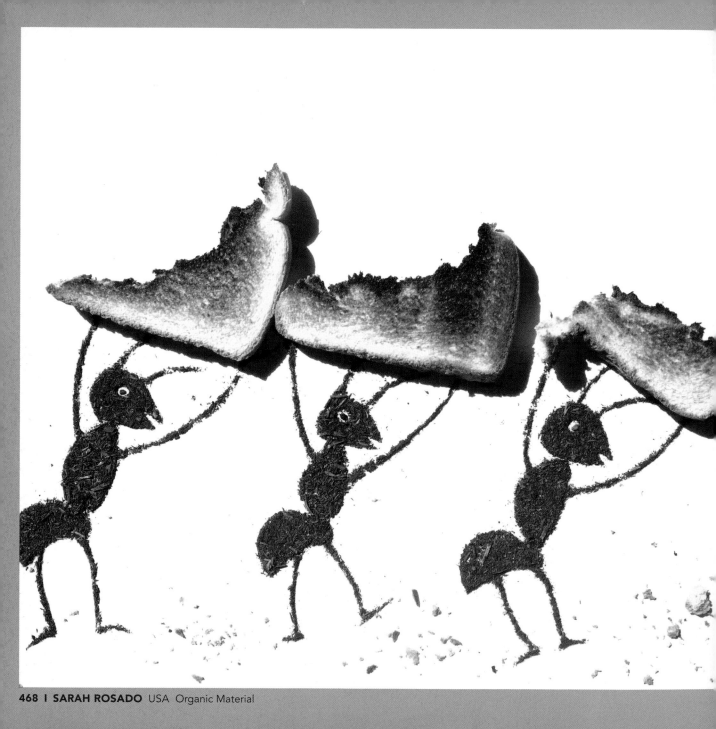

468 I **SARAH ROSADO** USA Organic Material

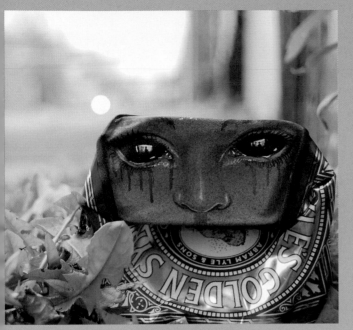

**469 I MY DOG SIGHS** UK  Reclaimed Tin Cans

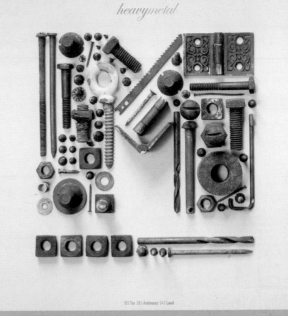

**470 I STUDIOTWENTYSIX 2** USA  Assorted Found Objects

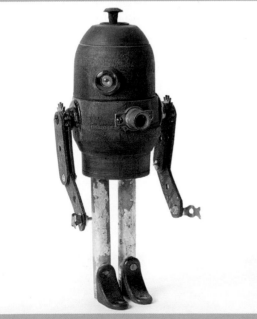

**471 I SHAWN MURENBEELD** CANADA  Reclaimed Objects

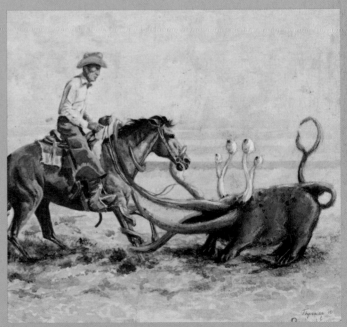

**472 I THYRZA SEGAL** CANADA  Reclaimed Oil Paintings

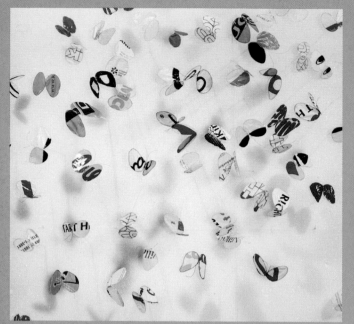

**473 | YUKO ODA** USA Reclaimed Plastic Bags

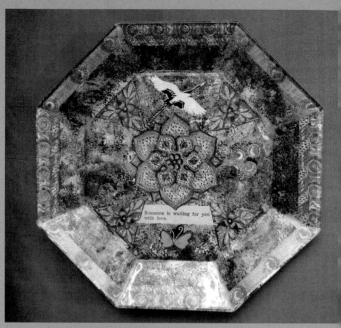

**474 | DEBORAH SOWRAY** USA Reclaimed Plate and Scrap Paper

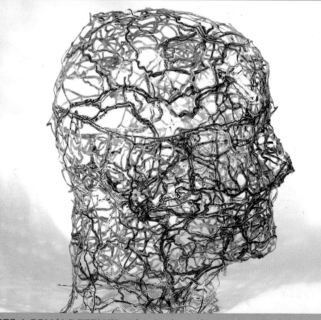

**475 | BRIAN DETTMER** USA Reclaimed Map

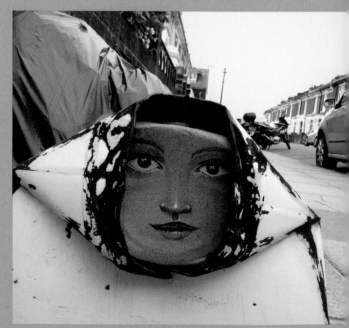

**476 | MY DOG SIGHS** UK Reclaimed Bucket

COURTESY OF THE ARTIST AND KINZ + TILLOU FINE ART

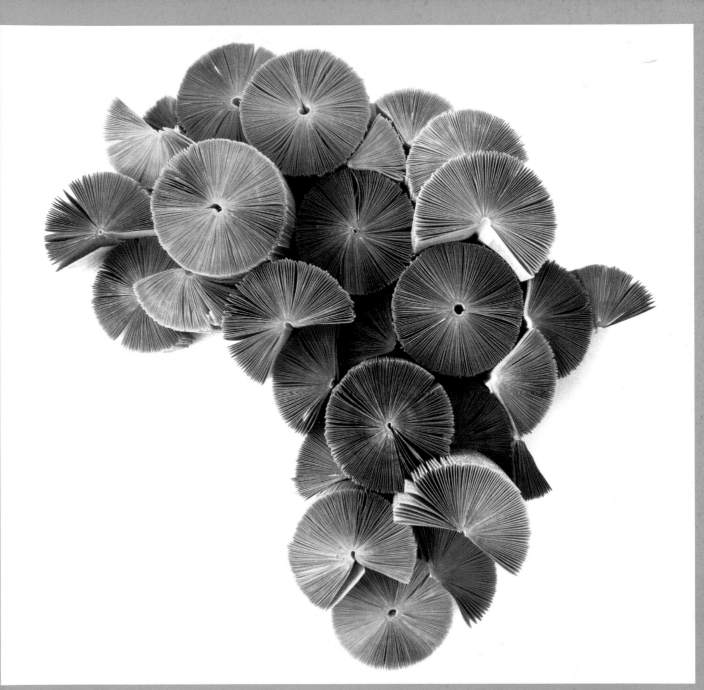

**477 I SIMPLE INTRIGUE** SOUTH AFRICA Reclaimed Books

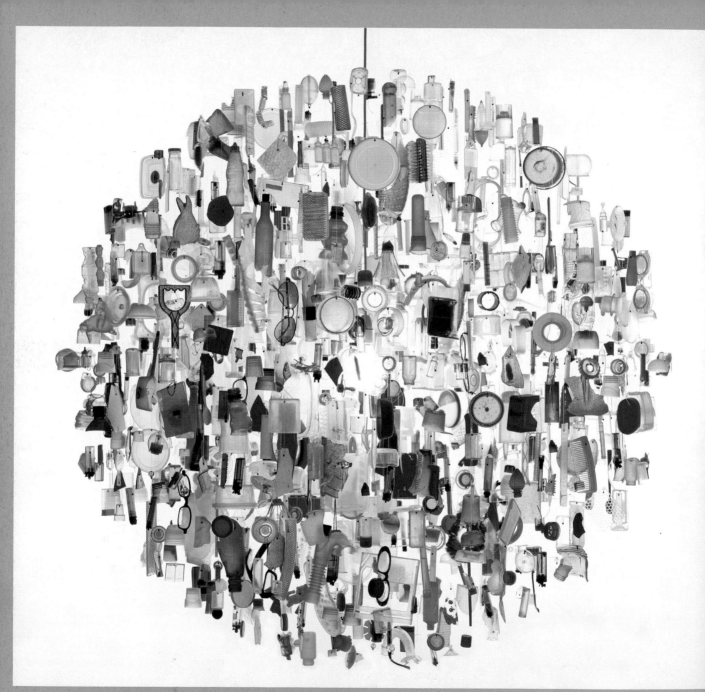

**478A I STUART HAYGARTH** UK  Assorted Found Objects

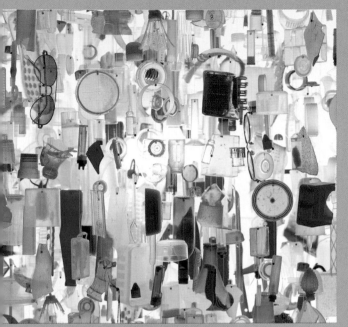

**478B | STUART HAYGARTH** UK Assorted Found Objects

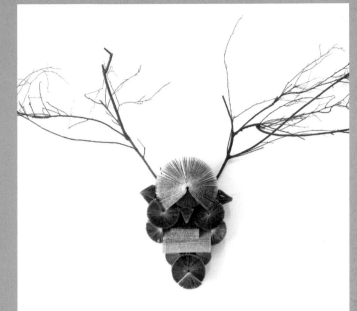

**479 | SIMPLE INTRIGUE** SOUTH AFRICA Reclaimed Books

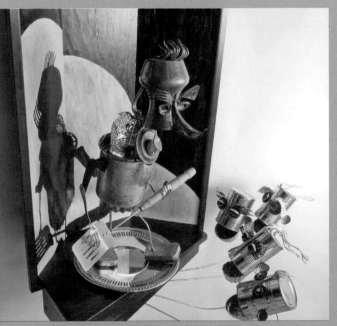

**480 | STANGMONT DESIGN** USA Assorted Found Objects

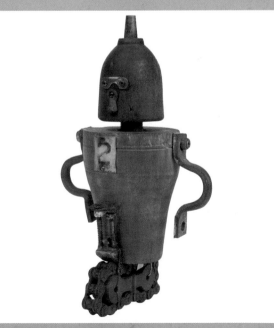

**481 | SHAWN MURENBEELD** CANADA Reclaimed Objects

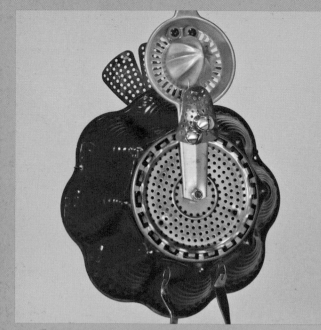

**482 | STANGMONT DESIGN** USA Assorted Found Objects

**483 | THYRZA SEGAL** CANADA Reclaimed Oil Paintings

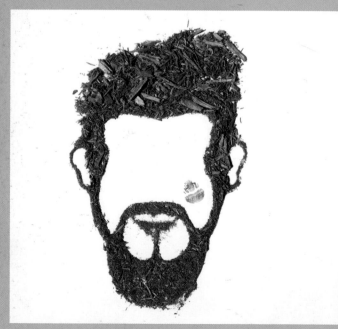

**484 | SARAH ROSADO** USA Organic Material

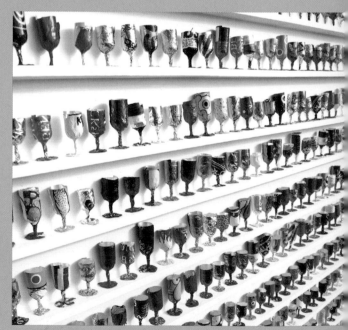

**485 | JOANNE TINKER** UK Candy Wrappers

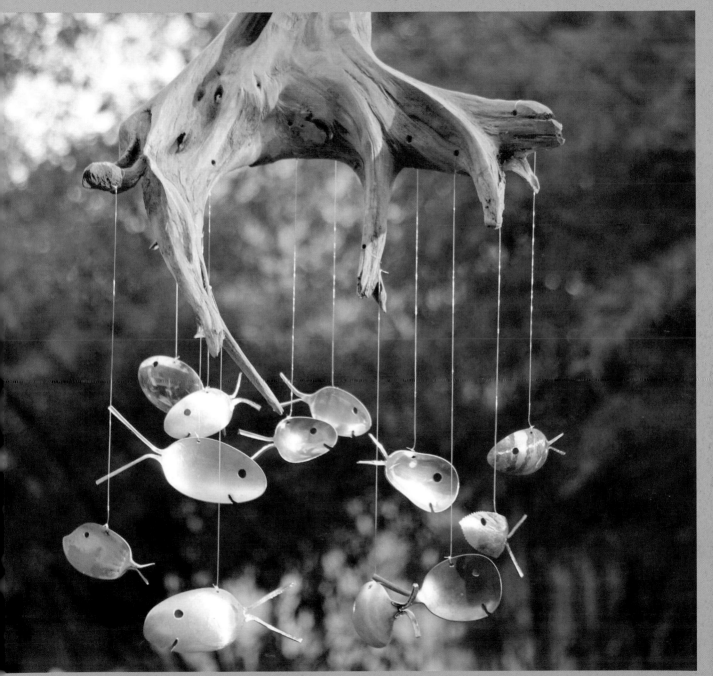

**486 I TWISTED METALS** USA Spoons

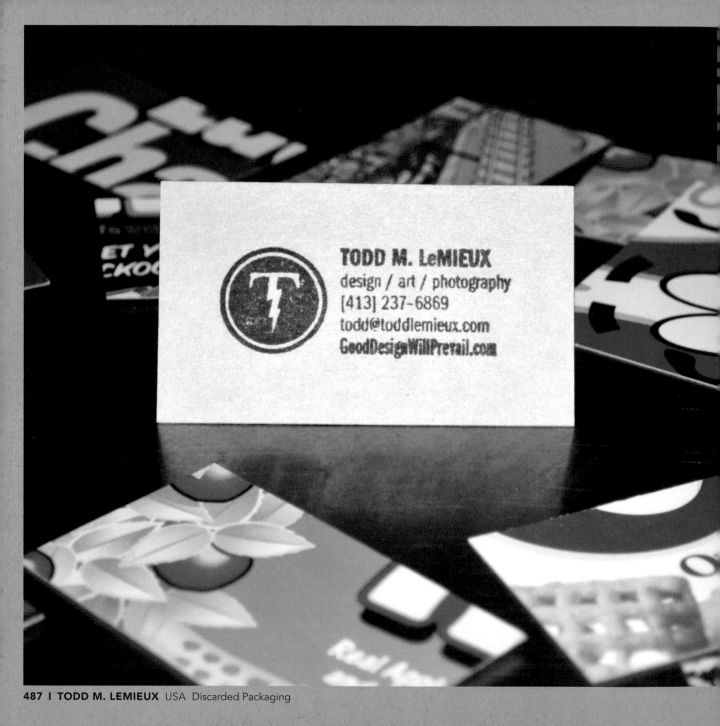

**487 | TODD M. LEMIEUX** USA  Discarded Packaging

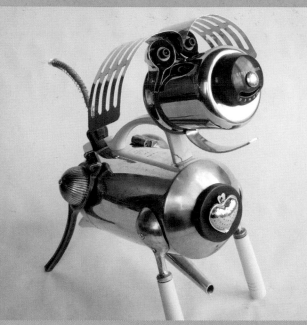

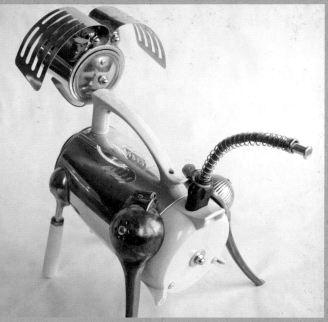

**488A | GRAHAM SCHODDA** USA Reclaimed Objects

**488B | GRAHAM SCHODDA** USA Reclaimed Objects

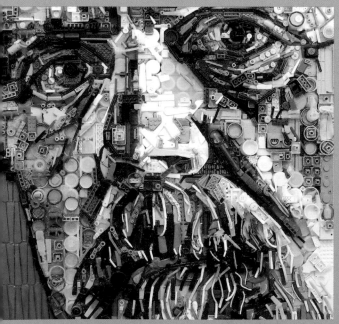

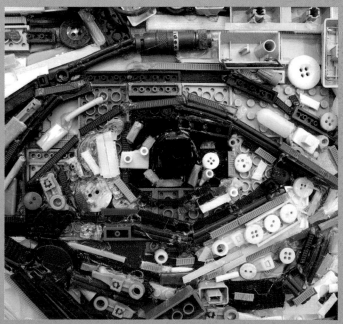

**489A | ZAC FREEMAN** USA Assorted Found Objects

**489B | ZAC FREEMAN** USA Assorted Found Objects

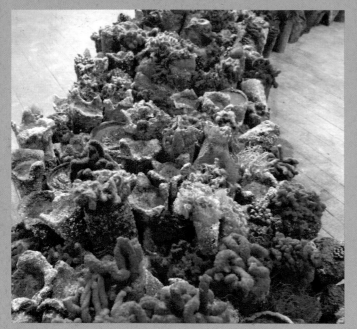

**490A I JONAH JACOBS** USA  Assorted Found Objects

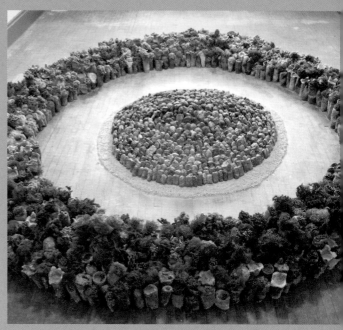

**490B I JONAH JACOBS** USA  Assorted Found Objects

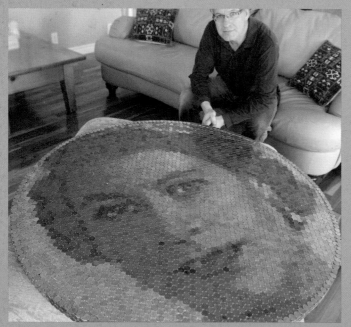

**491 I WILLIAM FRYMIRE** CANADA  Pennies

**492A I ZAC FREEMAN** USA  Assorted Found Objects

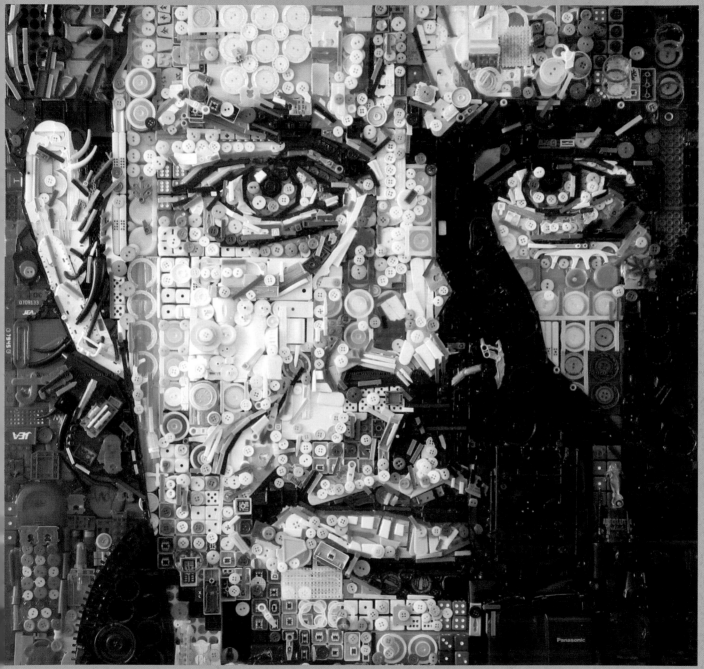

**492B I ZAC FREEMAN** USA  Assorted Found Objects

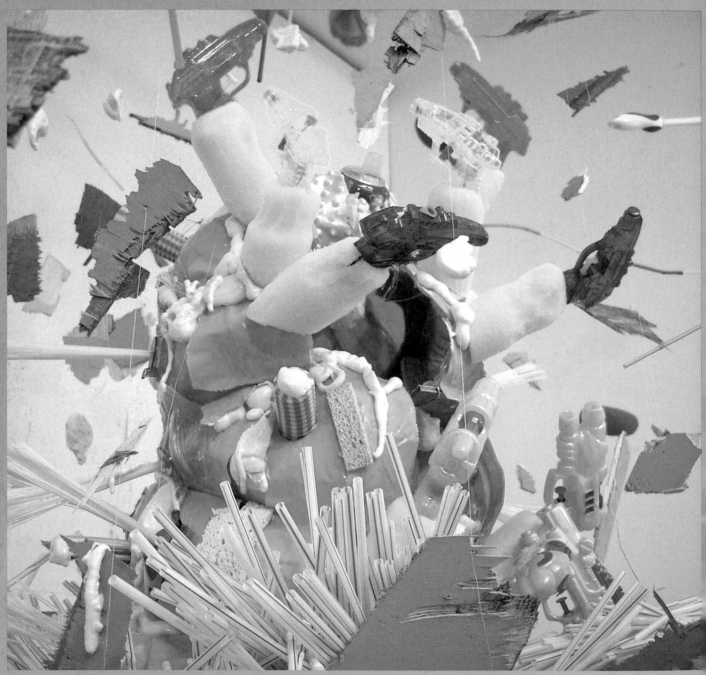

**493A I YUKO ODA** USA  Assorted Found Objects

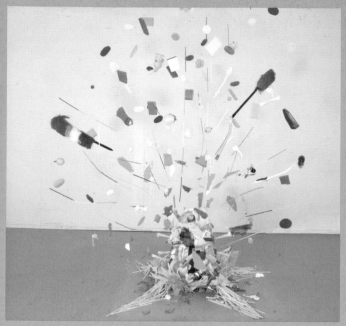

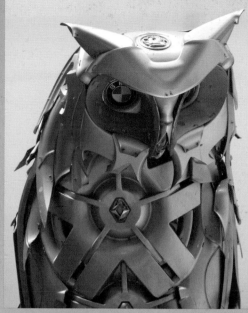

**493B I YUKO ODA** USA Assorted Found Objects

**494 I PTOLEMY ELRINGTON** UK Hub Caps

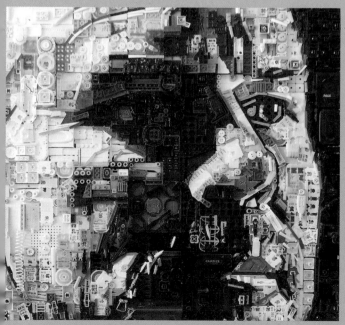

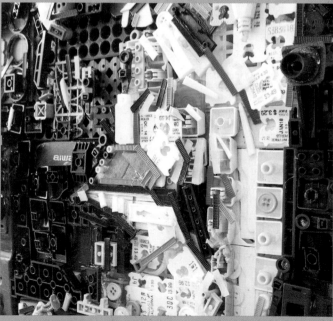

**495A I ZAC FREEMAN** USA Assorted Found Objects

**495B I ZAC FREEMAN** USA Assorted Found Objects

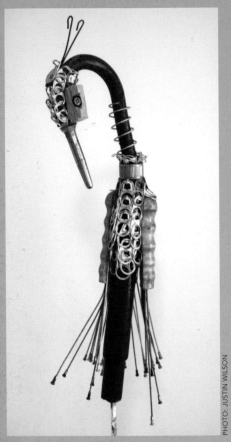

**496 I JAMES GAYNOR** USA
Assorted Found Objects

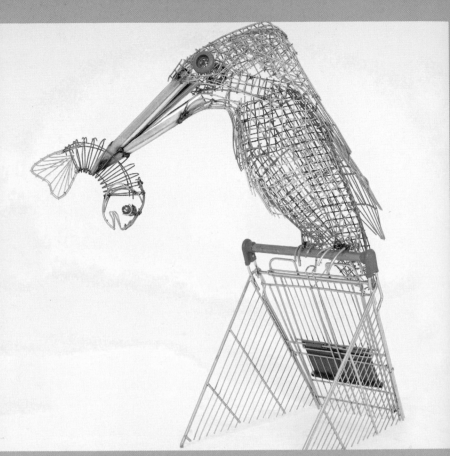

PHOTO: JUSTIN WILSON

**497 I PTOLEMY ELRINGTON** UK  Shopping Cart

**498 I MR. ELLIE POOH** USA
Elephant Dung, Post-Consumer Paper

**499 I DIANA CORVELLE** USA  New York City MetroCard

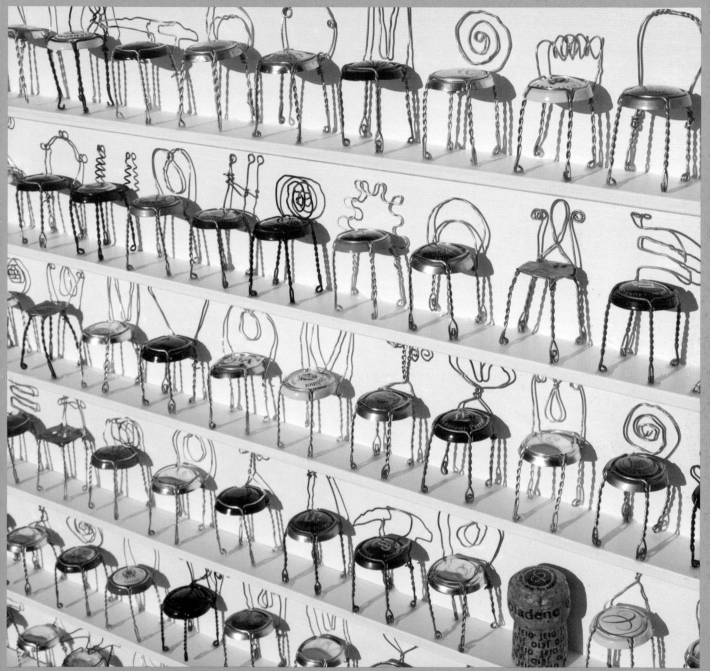

**500 I JOANNE TINKER** UK Beverage Bottle Tops

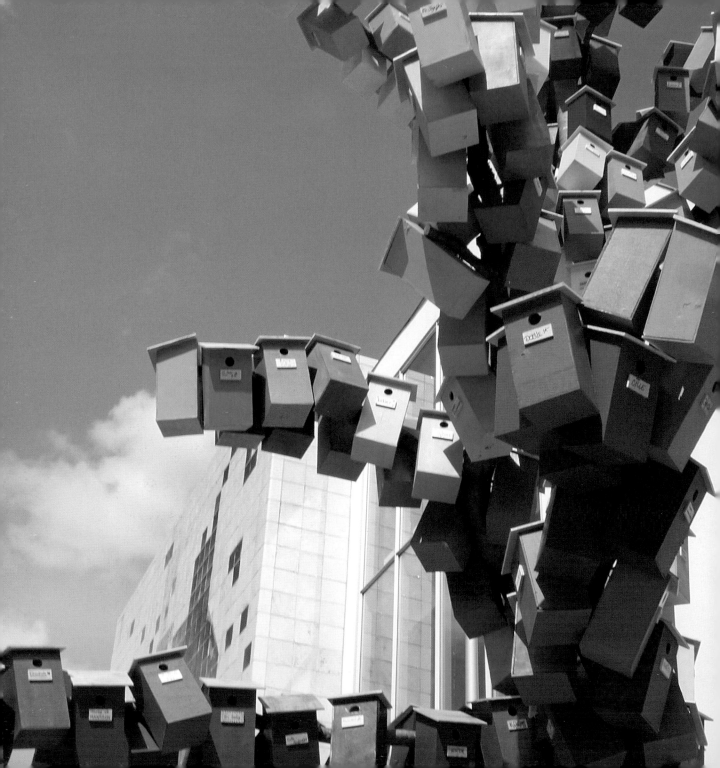

# Contributor Directory

+Bauer
brauer.fr
390, 416

1hipchik
1hipchik.com
009

Aaron Kramer
urban-objects.com
164

Abigail Clark
StayGoldMaryRose.etsy.com
024

Ability by Alyssa
abilitybyalyssa.blogspot.com
143

Adrian Johnson
fridgecouch.com
153A, 153B, 153C, 302

AERO-1946
aero-1946.com
158

Akiko Oguchi
5thSeasonDesigns.com
002A, 002B, 021

Alan Williams
alanwilliamsmetalartist.com
388, 407, 418

Alexander Farto
alexandrefarto.com
348, 366, 393, 411

All Tied Out
AllTiedOut.etsy.com
004, 052

Allan Young
Pixelthis.etsy.com
154, 157, 168

Alpentile
alpentile.com
161A, 161B

Alterior Design
facebook.com/AlteriorDesign
160

Alvaro Catalán de Ocón
catalandeocon.com
155

Alyce Santoro
sonicfabric.com
001, 005

Ama Ryllis
ohoh-blog.blogspot.mx/
178

Anastassia Elias
anastassia-elias.com
414, 433

Andy Heymann Watchstraps
andyheymann-watchstraps.com
026

Angela Gleason
angelagleason.net
020, 075

Angela Johnson
angelajohnsondesigns.com
035, 059, 151

Angelic Glass
angelicglass.net
156, 330

Anna Garforth
annagarforth.co.uk
352, 353, 362

Arnt Arntzen
arntarntzen.com
162, 181, 273

Arte Plastique
arteplastique.etsy.com
179, 405

Atelier Le Dos de la Cuillere
atelierledosdelacuillere.
blogspot.com
006, 067, 126

Atlanta Botanical Garden
atlantabotanicalgarden.org
359, 360, 361

Back Alley Chic
backalleychic.com
030, 056, 203

BeeZ
beezbyscranton.com
027, 037, 053

bel&bel
belybel.com
176, 219

Ben Hannam
bhannam.com
426

Benclif Designs
benclifdesigns.com
395

Benedetto Bufalino
& Benoit Deseille
benedetto.tk
351A, 351B

Benjamin Bullins
thebenjamincollection.com
171

Bike Furniture Design
bikefurniture.com
187, 193, 209

Black Button Studio
blackbuttonstudio.com
034, 051, 061

Blair LaBella
blairlabella.com
045, 050, 064

Bomdesign
bomdesign.nl
165, 185A, 185B, 186, 244

The BoomCase
theboomcase.com
200, 263A, 263B, 283

Boris Bally
borisbally.com
159, 217, 221, 234, 235

Boss Brown Art
bossbrownart.com
163, 180, 413

Brandi Couvillion
waregardenstudio.com
017, 040

Brian Dettmer
briandettmer.com
398, 422, 439, 459, 460A,
460B, 463, 475

Bruketa & Zinic OM
bruketa-zinic.com
350

Bubbadesign
bubbadesign.com
167

CAKE Vintage
hesterandcook.com
175, 224

Carol Sogard
carolsogard.com
191, 410

Carolina Fontoura Alzaga
facaro.com
170, 194

Choi Jeong Hwa
choijeonghwa.com
357

Chris Giffin
giffin@peak.org
029, 406

Chris Ruhe
chrisruhe.nl
195

Christiane Diehl
christianediehl.de
065

Christine Terrell
adaptivereuser.com
033

Chun-Lung Hsieh
chunlung0513@gmail.com
036, 043

CineScape Studios
cinescapestudios.com
082, 197

Clarissa Callesen
clarissacallesen.blogspot.com
435

Claudia Zimmer
poptoplady.etsy.com
015

Cleo Mussi
mussimosaics.co.uk
394, 425

Clive Roddy
cliveroddy.co.uk
212

Coffin Couches
coffincouches.com
172, 228

Colin Selig
colinselig.com
206, 270

Daniel Grady Faires
danielgradyfaires.com
295

Daniel Maher
dmstainedglass.com
391, 397

Dave Meeker
davemeekerart.com
392, 427

Deborah Paul
Deborahpaulart.com
408, 429

Deborah Sowray
scruffycatshaggydog.com
474

Dee Puddy
deepuddy.co.uk
213

Diana Corvelle
Dianacorvell.com
417, 432, 499

Dock Artisan
dockartisan.com
324, 335

Dominic Wilcox
dominicwilcox.com
184

Doreen Catena
dordesignonline.com
198, 215, 225

Dorothea Prehn
Doraprehn@yahoo.de
430

Dstressed
dstressedhome.com
201

DVELAS
dvelas.com
202, 211, 242

EcoCycled
EcoCycled.etsy.com
399, 431, 437

EcodesignEureka
ecodesigneureka.blogspot.it
196

EDM Designs
edmdesigns.com,
edmdesigns.etsy.com
003, 010, 044, 049

Ekaterina Fedotova
katrinshine.etsy.com
041, 046

Elisabeth Lecourt
elisabethlecourt.com
396, 409, 415

Elise Morin
elise-morin.com
364A, 364B

Emiko Oye
rewarestyle.com
025, 144

Emily Boyle
accordingtoboyle.com
220

en tu punto
entupunto.blogspot.com.es
146A, 146B, 307A, 307B

Erin Keck
ekcreations.etsy.com
208

Etienne Reijnders
etiennereijnders.blogspot.com
218, 230, 258

Ex Libris Anonymous
jacob@bookjournals.com
032A, 032B

Farrell Woods
fwpens.com
013

Fat Tomato Designs
fattomatodesigns.com
189

FintasticPlastic
paulacardiasart.com
403, 438

The Flying Fox Art and Design
TheFlyingFoxArts.etsy.com
326

Fran Addison
frannaddisonjudaica.com
188, 231

Gary Harvey Creative
Garyharveycreative.com
012, 028, 110

Genanvendt
genanvendt.dk
204

George Tzafolias
geoartcrafts.etsy.com
199

GG2g
gg2g.com
048, 216, 229, 233

Good Deed Audio
gooddeedaudio@gmail.com
222

Graham Schodda
gschodda.com
334, 488A, 488B

Great Bottles of Fire
greatbottlesoffire.com
205

Groovy Green Glass
groovygreenglass.com
243

Gulnur Ozdaglar
gulnurozdaglar.com
018, 038, 423

Haley Holeman
haleyholeman.com
054, 123

Harriete Estel Berman
harriete-estel-berman.info
031, 057, 401

Heartworks Studio
heartworkspainting.com
436

Hilary Greif Recycled Designs
Hilarygreifrecycleddesigns.com
011, 014, 019, 039, 060

Hironaka Ogawa and
Associates
ogaa.jp
365A, 365B

Hoist Away Bags
hoistawaybags.com
062, 246

Holy Island of Lindisfarne
lindisfarne.org.uk
372

HoseWear
hosewear.com
022, 042, 068, 084

Hudson Blue Artisans
hudsonblueartisans.etsy.com
007, 066

Hugh Hayden
hughhayden.com
182, 236

Inakadate
ajw.asahi.com/article/
behind_news/social_affairs/
AJ201208190010
381, 382

Iñigo Cañedo
coroflot.com/inigo_canedo
262

iri5
iri5.com
421, 443

Ivel Stoneware Designs
ivelstoneware.co.uk
190

Ivorilla
twrd.de
073

JacQ
jacqvon.etsy.com
086, 120

James Gaynor
400, 496

Jan Reymond
janreymond.ch
354, 363

Jason Ackman
jasonackman.org
404, 424

Jay Watson Design
jaywatsondesign.com
232, 237, 238, 275

Jeffrey Ballard
facebook.com/
BLENDEDimages
402, 419

Jenifer J. Renzel
bugatha1.deviantart.com
412

Jennifer Hansen
jenzhansenart.com
375A, 375B

Jennifer Meeks
FourCrazyBoys.etsy.com
063, 087, 095

Jerry Kott
jerrykott.com
239, 253, 257

JIRObelt
jiro-belt.com
069, 078

Joan Nadal
zecodesign.com
214

Joanne Tinker
woolffgallery.co.uk
485, 500

Jonah Jacobs
jonahjacobs.com
490A, 490B

Jud Turner
woolffgallery.co.uk
441, 446

Junk Munkez
xavierbaghdadi.com
240, 256

Junktion
junktion.co.il
247, 255, 336

Karen Hackenberg
karenhackenberg.com
252, 368

Kargin Vladimir
kargin1983@mail.ru
453

Karin K Mueller
rejectart.weebly.com
428

Kate Fisher
fisherclay.com
245

Katelijne De Muelenaere
designsense.be
442, 448

Katie Pietrak
vintagevinyljournals.com
106

Kelly Nedderman
kellynedderman.com
079

Kevin Wakelam
osgoldcrossphotography.co.uk
372

Kirsty Loves Cardboard
kirstylovescardboard.com
445, 451, 457

La Firme
lafirme.ca
271

Launi Lucas
launilucas.com
389

Lina Austė
linaglass.com
272

Littlefly
littlefly.co.uk
070, 089, 102, 150

Loyal Loot
loyalloot.com
260

LSTN Headphones
lstnheadphones.com
008

Luke Haynes
lukehaynes.com
420, 444, 449

Made By One Girl
madebyonegirl.com
071

Made From Coins
Jessiedriscoll.etsy.com
088, 116

Mado©
peace4you.net
077A, 077B, 081

Magda van der Vloed
vandervloed@absamail.co.za
461

Mama Pacha
Mamapacha.etsy.com
100A, 100B

Manoteca
manoteca.com
264A, 264B

Margaux Lange
margauxlange.com
094, 097, 099

Mariya Donskaya
donskaya.it
169, 210

Mary Ellen Croteau
maryellencroteau.net
440A, 440B

Matadog Design
matadog.com
454

Matt LeBeau
theartofdrinkingbeer.tumblr.com
267A, 267B

Meike Harde
meikeharde.com
251, 274, 300

Melanie Thompson
saltspringartistdirectory.com
269

Merry-Go-Round Handmade
MerryGoRoundHandmade.
etsy.com
090, 101

Michael Hannaford
mkhor@optusnet.com.au
183, 223

Michael Khor
177

Michelle Luo
Facebook.com/pearlreef
092, 112, 119

Michelle Morales
jmjcmorales@yahoo.com
072

Milwaukee Modern
milwaukeemodern.com
462A, 462B

Mipola
Mipola.etsy.com
076, 105, 148

Miss Manos
gg2g.com
093, 096

Mitzi Brandon
mitbebe@msn.com
104, 452

Miwa Koizumi
miwa.metm.org
447, 455

Monica Lee
artfulrecrafter.com
083, 108, 434

Mosstika
mosstika.com
356, 373, 374

Mr. Ellie Pooh
mrelliepooh.com
498

Mr. Fox Productions
wreckedwritings.etsy.com
266

Musée du Quai Branly
377

My Dog Sighs
mydogsighs.co.uk
458, 464, 469, 476

Nadeau Hahne
njhahne@gmail.com
227

Nathan Sawaya
brickartist.com
467

Ned Hobgood
nedhobgood@gmail.com
265

Neozoon
neozoon.org
349, 376, 379, 380A, 380B

Nita Stacy
modvintagelife.com
294

Oddbirds
oddbirds.nu
254, 322

OneMoreUse by
Create My World Designs
createmyworlddesigns.
blogspot.com/
107, 109

OOO My Design
cassetteisnotdead.com
268, 304

OOOMS
oooms.nl
115, 173

Organelle Design
organelledesign.com
280, 282

Out of the Ashes
outoftheashes.etsy.com
085, 111

Palettenmoebel
palettenmoebel.at
276

Patturn Studio
patturnstudio.com.au
248, 278, 291

The PDF Files
ThePDFfiles.etsy.com
298, 319, 343

Perfect Tin
PerfectTin.etsy.com
016, 118, 140

Perro De Mundo
anguloibo@gmail.com
091

Platinum Dirt
platinumdirt.com
114A, 114B, 117, 130

Primitive Twig
primitivetwig.com
250A, 250B, 456

Ptolemy Elrington
hubcapcreatures.com
494, 497

Rachel Baker
nancysteashop.com
279, 281

Re:form Designs
reform-designs.com
261

Redux Tubs
Reduxx.etsy.com
284, 301

Reigruche Studio
reigruchestudio.com
241, 287

RescuedRetroVintage
rescuedretrovintage.co.uk
249, 277A, 277B, 286

Robert Johnson &
Johnson Furniture
johnsonfurniture.co.uk
370

Rock Pot Originals
rockpotoriginals.com
314

Rodrigo Piwonka A.
piwonka.cl
339

Rupert McKelvie
rupertmckelvie.com
285

Ryan Frank
www.ryanfrank.net
290

Sally Nencini
sallynencini.com
259A, 259B

Sander Reijgers
sanderreijgers.nl
058, 122

Sarah Rosado
sr-artwork.com
466, 468, 484

Scott Sherwood
289

**Second Shot**
2ndshot.ca
121, 129, 133

**Sep Verboom**
fantasized.eu
293, 309

**Seven One Eight Design**
Seven-One-Eight.com
174

**Shawn Murenbeeld**
touchwooddesign.com
465, 471, 481

**Shwood Eyewear**
shwoodshop.com
098, 124

**Silvia Ramalli**
unwaste.it
288

**Simple Intrigue**
simpleintrigue.com
477, 479

**Skate Guitar**
facebook.com/sktgtr
113

**SkyPak**
skypak.de/en
292A, 292B, 318

**Spacebarn**
Spacebarn.etsy.com
226

**Spoonman Creations**
spoonman.com
192

**Sprouts!**
sproutem.com
450

**Stacy Lee Webber**
staceyleewebber.com
134, 145, 296

**StangMont Design**
stangmont.com
480, 482

**String Tinkers**
stringtinkers.com
074, 127, 136

**Stuart Haygarth**
stuarthaygarth.com
305, 310, 321, 344, 478A, 478B

**Studio Tinman**
ronentinman.com
299, 317

**Studiotwentysix 2**
studiotwentysix2.com
470

**Sycamore Hill**
sycamorehill.etsy.com
166, 207

**t.o.m.t.**
tomtinc.com
312, 346, 347

**Tania Covo**
taniacovo.com
132

**Tara Locklear**
taralocklear.com
103, 135

**Techcycled**
techcycled.com
128, 137, 141

**TerraCycle, Inc.**
terracycle.com
023, 047, 152, 303, 315

**This Into That**
ThisIntoThat.com
325, 338

**Thomas Dambo**
thomasdambo.com
371, 383, 385

**Thyrza Segal**
thyrza.ca
472, 483

**Tiffanie Turner**
bloggingcornerblog.
blogspot.com
316

**TING**
tinglondon.com
313

**Todd M. LeMieux**
toddlemieux.com
487

**Tommy Conch Design**
tommyconch.com
080, 125

**Trattotempo**
trattotempo.it
311, 341

**Trendy-Tub**
trendy-tub.com
327, 345

**Twiceloved China**
twiceloved.com.au
138, 323, 329

**Tu Delft Architecture
Bibliotheek**
bk.tudelft.nl/en
358

**Twisted Metals**
Nevastarr.etsy.com
486

**Undone Clothing**
undoneclothing.etsy.com
139, 337

**Vintage 180**
Vintage180.etsy.com
149A, 149B

**Vinylize**
vinylize.com
147

**Wat Pa Maha Chedi Kaew**
oknation.net/THAMRONG
386A, 386B

**Whisky Ginger**
whiskyginger.com
308, 328, 340

**Willem Heeffer**
willemheeffer.nl
367, 369, 378, 387

**William Frymire**
www.frymire-art.com
384, 491

**Wrecords By Monkey**
wrecordsbymonkey.com
055, 131, 142, 320

**Yuko Oda**
yukooda.com
473, 493A, 493B

**Yvonne Ellen**
yvonneellen.com
297, 306, 342

**Zac Freeman**
facebook.com/zacfreemanart
489A, 489B, 492A, 492B, 495A,
495B

# About the Author

Patty K. Wongpakdee is a New York City–based graphic artist and a tenured associate professor of graphic design at New York Institute of Technology, New York. She creates graphics for various clients and enjoys doing pro-bono graphic design work for the American Cancer Society, New York City.

Prior to teaching, Patty was a senior designer/art director for Ernst & Young in New York City. In that capacity, she designed the artistic components for business proposals, brochures, and invitations for corporate functions. Clients included CBS, General Electric, IBM, SUNY University Hospital, and MaxMara.

She has received an award for Outstanding Design for a Corporate Publication in the 58th Annual Graphics Arts Exhibition. She is also a recipient of the In-house Design Award from *Graphic Design USA*. The award recognizes her print designs for the American Cancer Society. Her art and design work has been shown in several juried exhibitions in both traditional and online galleries and also featured in a variety of print and digital publications. Patty is committed to applying her creative skills toward professional work and art exhibitions. She can be reached at kulruedee@aol.com. ■

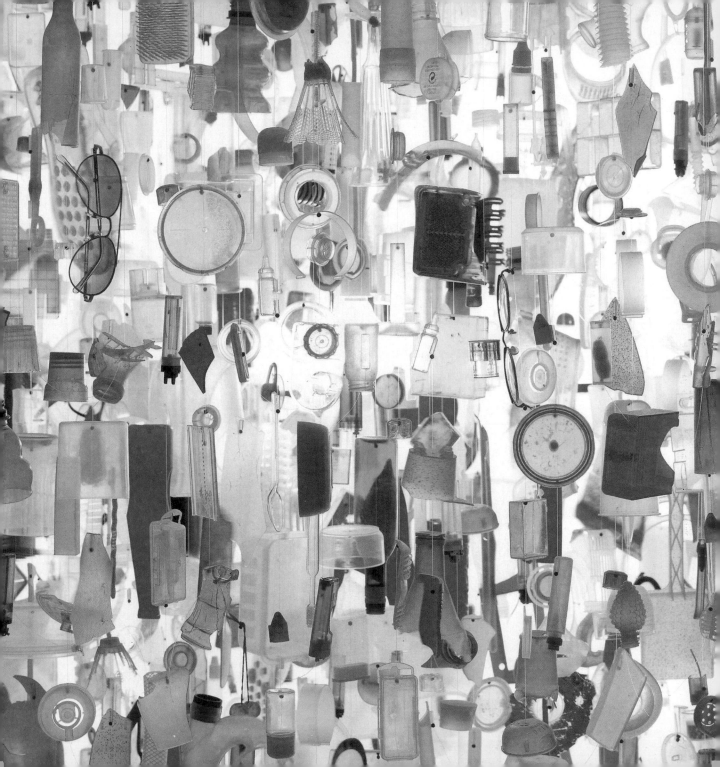